BRITAIN
FROM ABOVE
MONTH BY MONTH

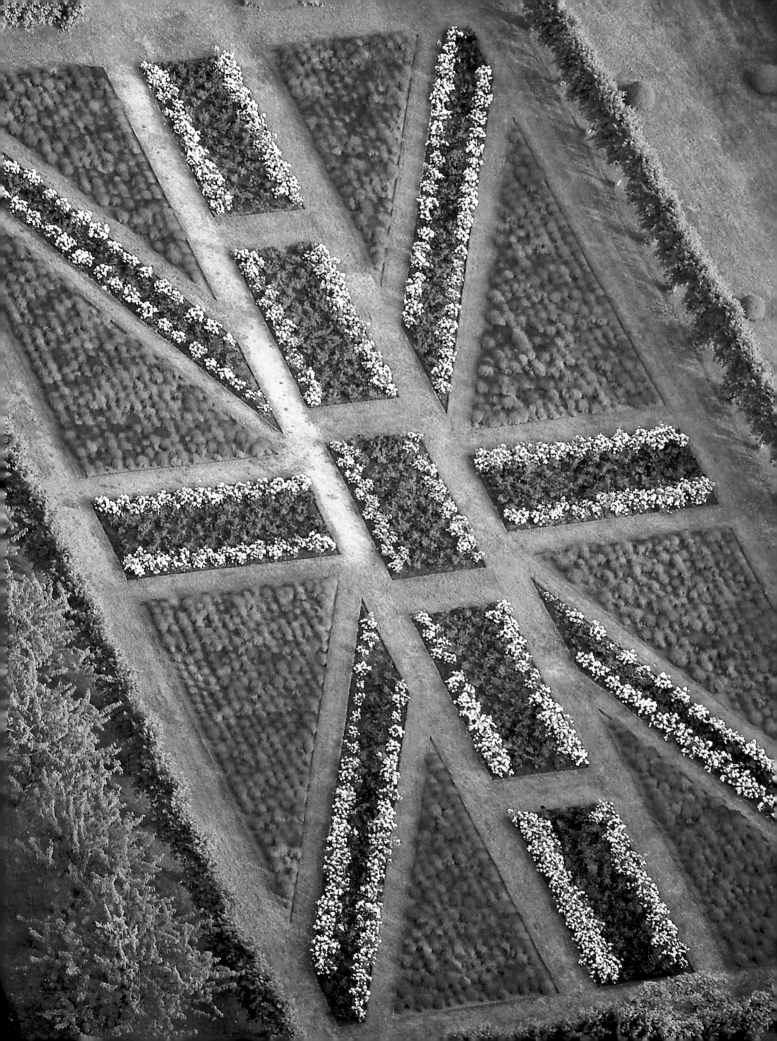

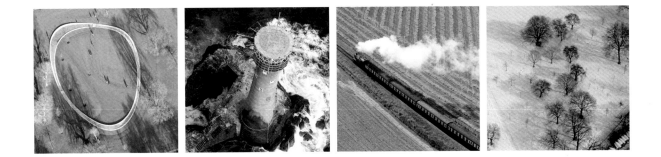

BRITAIN

FROM ABOVE

MONTH BY MONTH

JASON HAWKES

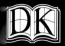

London, New York,
Munich, Melbourne, Delhi

Senior Editor Nicky Munro
Senior Art Editor Gillian Andrews
Designer Phil Gamble
Jacket Designer Laura Brim
Production Editor Luca Frasinetti
Production Controller Mandy Innes

Managing Editor Stephanie Farrow
Managing Art Editor Lee Griffiths

First published in Great Britain in 2012
by Dorling Kindersley Limited
80 Strand, London WC2R 0RL

Penguin Group (UK)
2 4 6 8 10 9 7 5 3 1
001 – 183124 – May/2012

A CIP catalogue record for this book is
available from the British Library.

ISBN 978-1-4053-9433-8

Printed and bound by
Hung Hing, China

Discover more at
www.dk.com

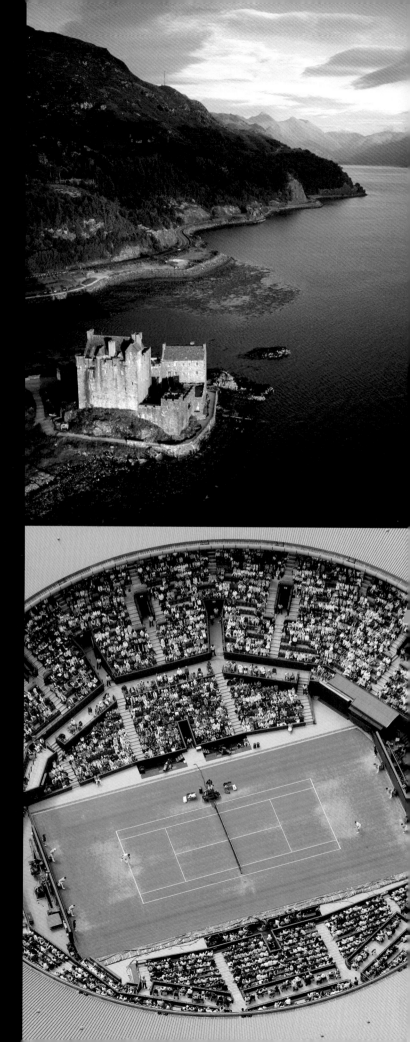

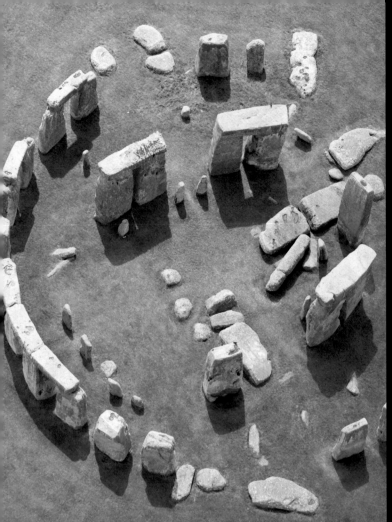

Contents

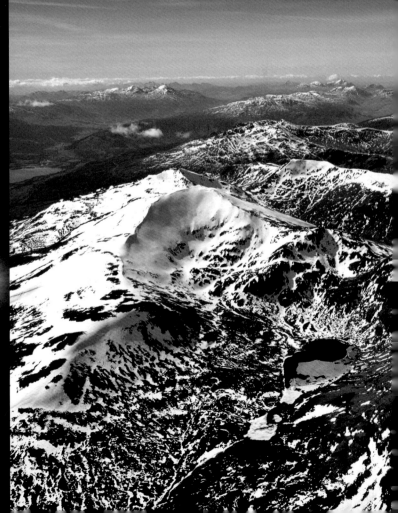

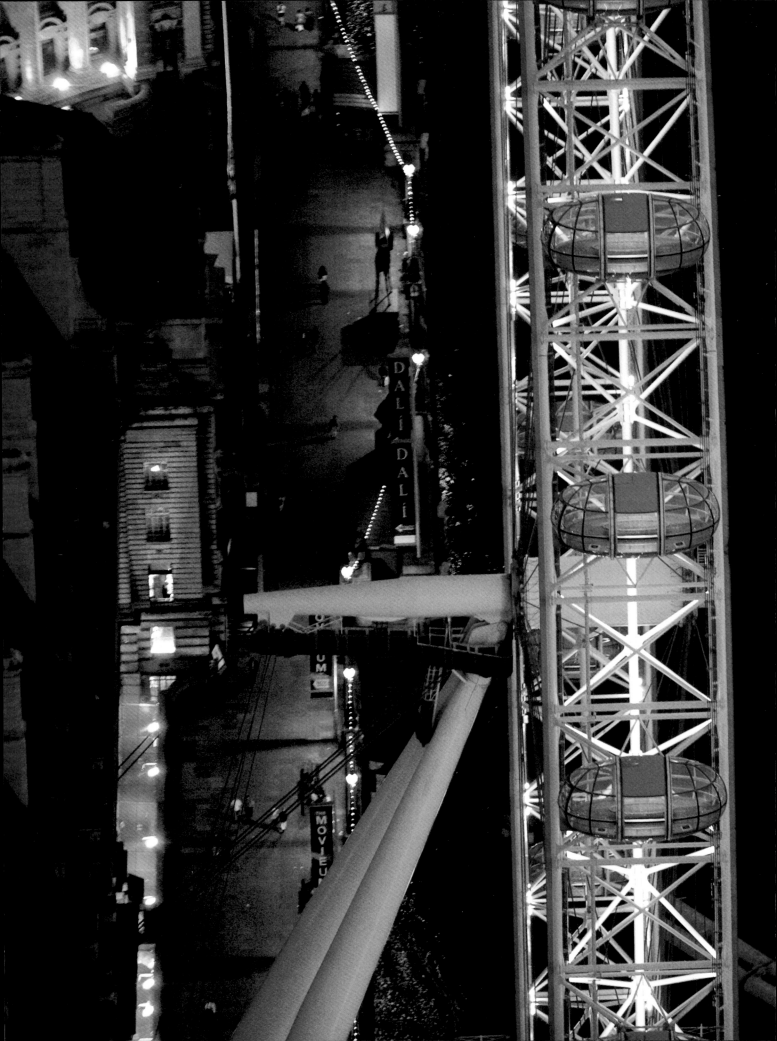

Introduction

"The City is yours": these were the exact words spoken to us by an air traffic controller one night after we'd been circling above London for a couple of hours. It's at times like these when I really think this job is the best. I am perched by the open door of a helicopter at 1400 feet looking down on the dazzling lights of the city. You might think the word "dazzling" is a little over the top, but honestly, flying over cities at night is just breathtaking.

There's no denying it, I'm lucky to be able to spend my time doing something that brings me so much pleasure. I've been flying in Britain and other places around the world for the last 20 years and I'm still passionate about the sense of freedom it brings and the fascinating sights you can see from the sky.

If you've ever thought about taking a trial lesson in a light aircraft, or even just a one-off trip, but have never got around to it, I urge you to find your local aerodrome and have a go. I still remember my very first trial flight, which I took in a tiny micro-light. The machine hove into view sounding something like a lawn mower and landed in the field where we were standing. Ten minutes later and I was 1000 feet above the fields of Kent, trying to get my bearings and loving every second of it. A couple of months after this first flight, having well and truly caught the flying bug, I purchased a micro-light of my own. (Nowadays I mainly shoot from a Eurocopter AS355, or, if the budget's tight, an R44 helicopter.)

Although we go up throughout the year, the summer months in the UK are particularly good for flying as the weather's a little more predictable and the daylight hours seem endless. In fact, on some days when I'm in the air for hours on end, circling around and gazing through the viewfinder, I can end up feeling a little bit queasy (it may seem strange, but I do suffer from vertigo). Once, down in Cornwall, I couldn't take it anymore and asked the pilot I was with to fly straight and level for a while so I could just sit back and concentrate on the horizon (unfortunately for him and his lovely helicopter, it didn't work...). But thankfully that kind of thing is pretty rare – most of the time I'm absolutely in my element and there's nothing in the world I'd rather be doing.

I hope you enjoy the book as much as I've enjoyed making it. Britain is a stunning country to photograph – the topography is so varied. In just a morning's flight you can go from busy towns and cities to tiny rural villages, from rugged mountain scenery to the flattest broads, and from meandering inland waterways to remote coastlines. And as for the history and heritage – it's surely one of the richest landscapes in the world for ancient monuments and magnificent architecture, both old and new. It's a thrilling place to discover on foot, but perhaps all the more intriguing from the air.

JASON HAWKES

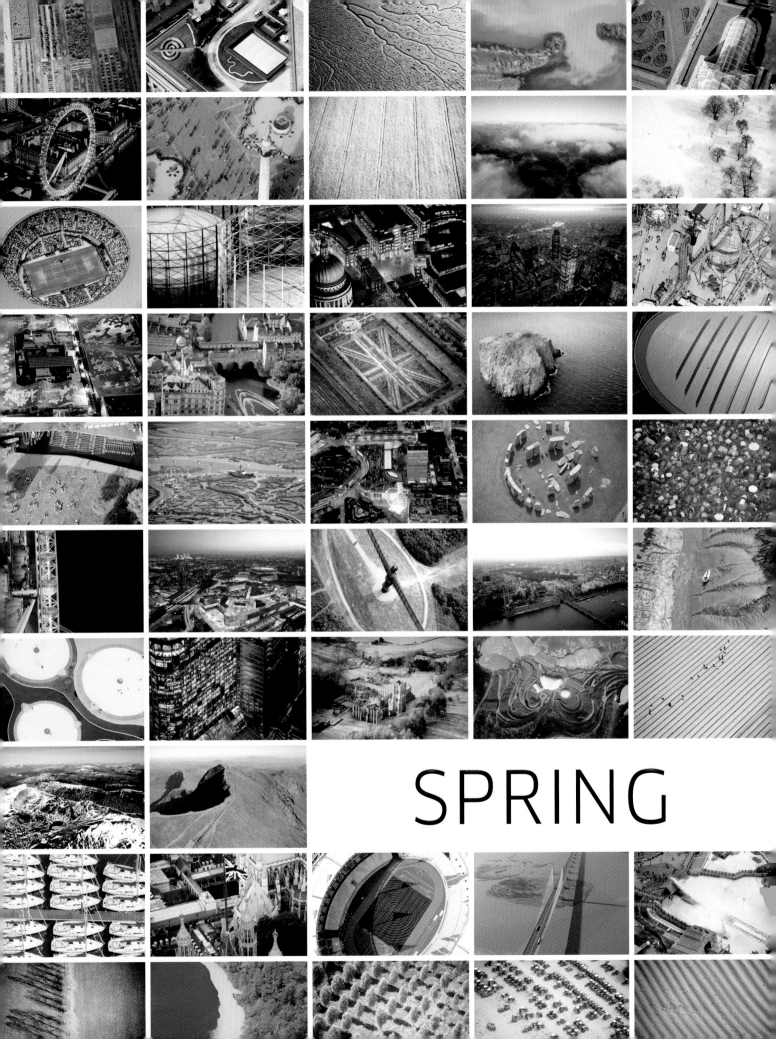

SPRING

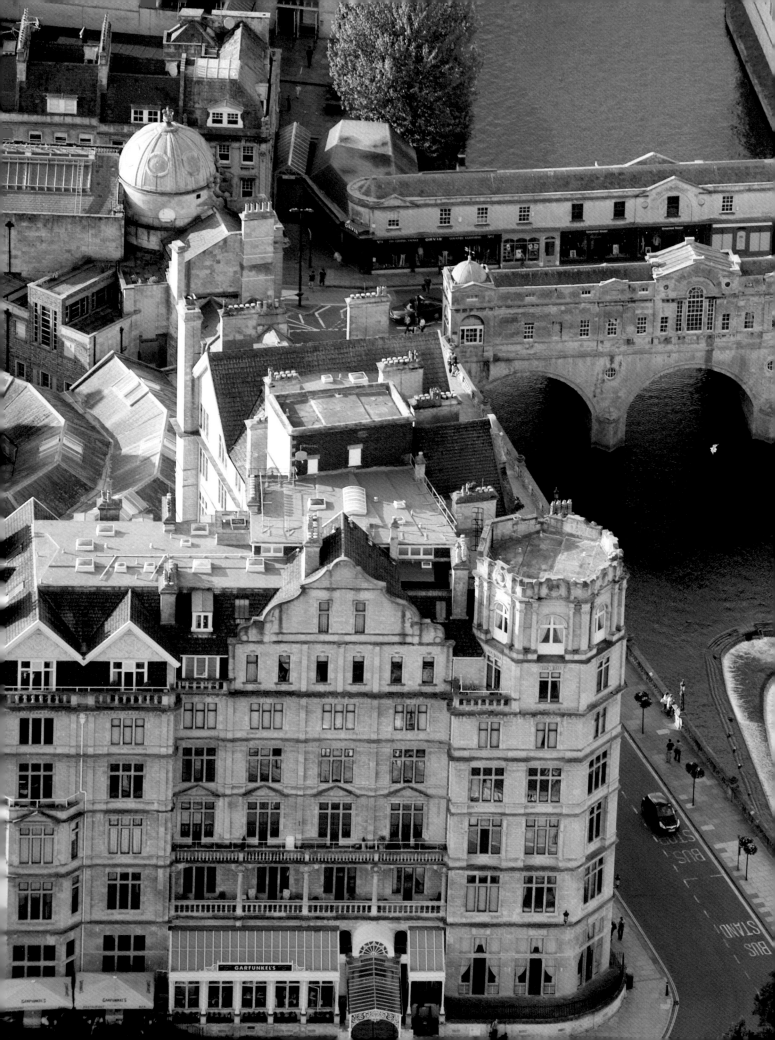

The city of Bath looks tiny from the air; in a helicopter you've flown over it in 30 seconds. Pulteney Bridge is one of only four bridges in the world with shops on it, and it looks as though it might have been transported from 16th-century Italy. The ripples in the water are created by a weir.

Taking photographs like this at night has only recently been possible. I used to see these views all the time and wish I could capture them. Once the cameras improved and I could, it was so exciting. When the sun sets over the city and the lights come on, I feel as though I'm inside an amazing computer game.

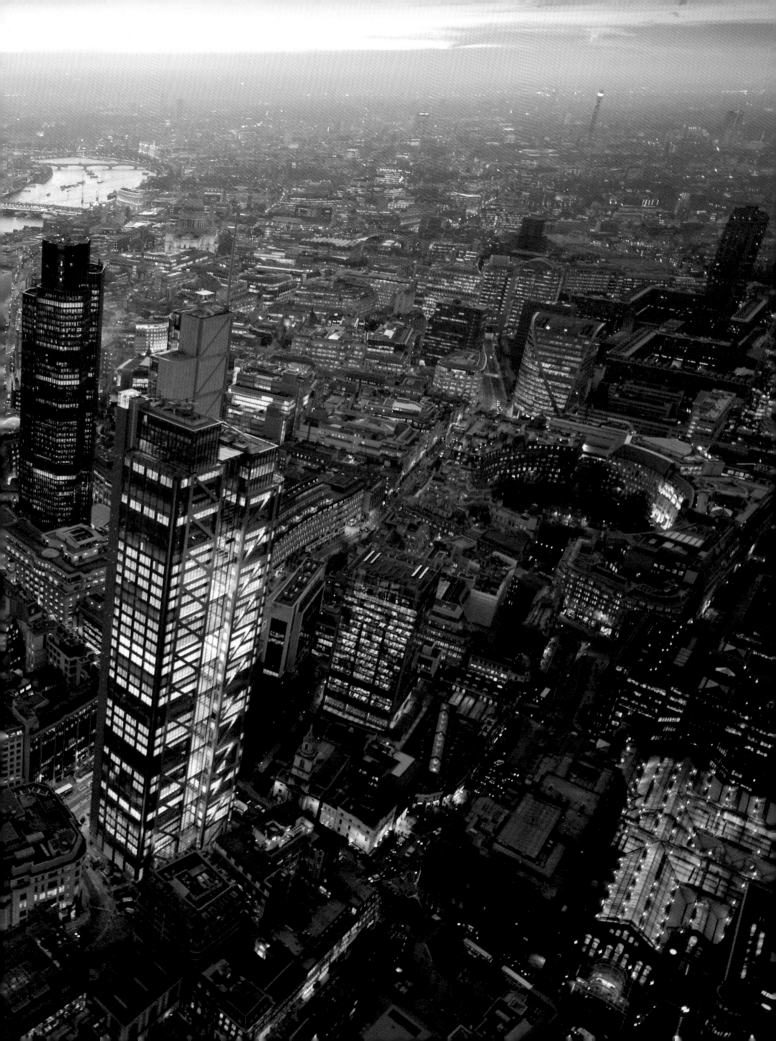

Inspired by Greek temples, the opulent Belsay Hall in Northumberland is surrounded by 30 acres of gardens that explode with colour in the spring as the rhododendrons burst into life. I get very used to seeing extensive swathes of green, so when I spot rich clumps of colour I have to investigate.

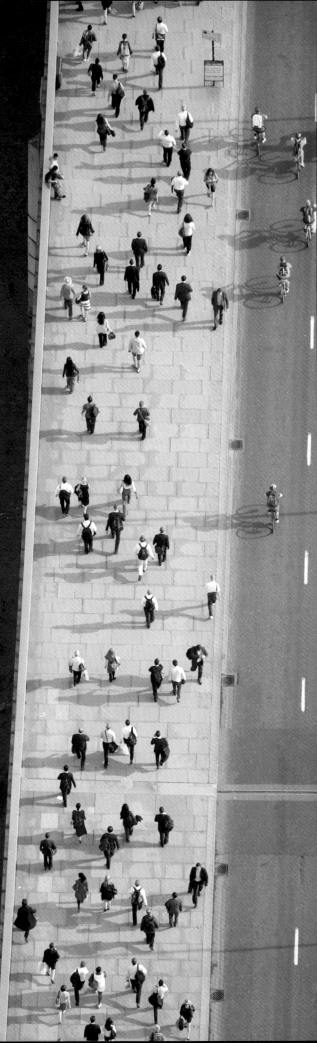

It's quite strange, but when you fly over London you hardly ever see people, so when I do I always make a point of photographing them. Bridges isolate the people and vehicles usually hidden in the maze of streets and buildings. Here on London Bridge the ebb and flow of city life is fully exposed.

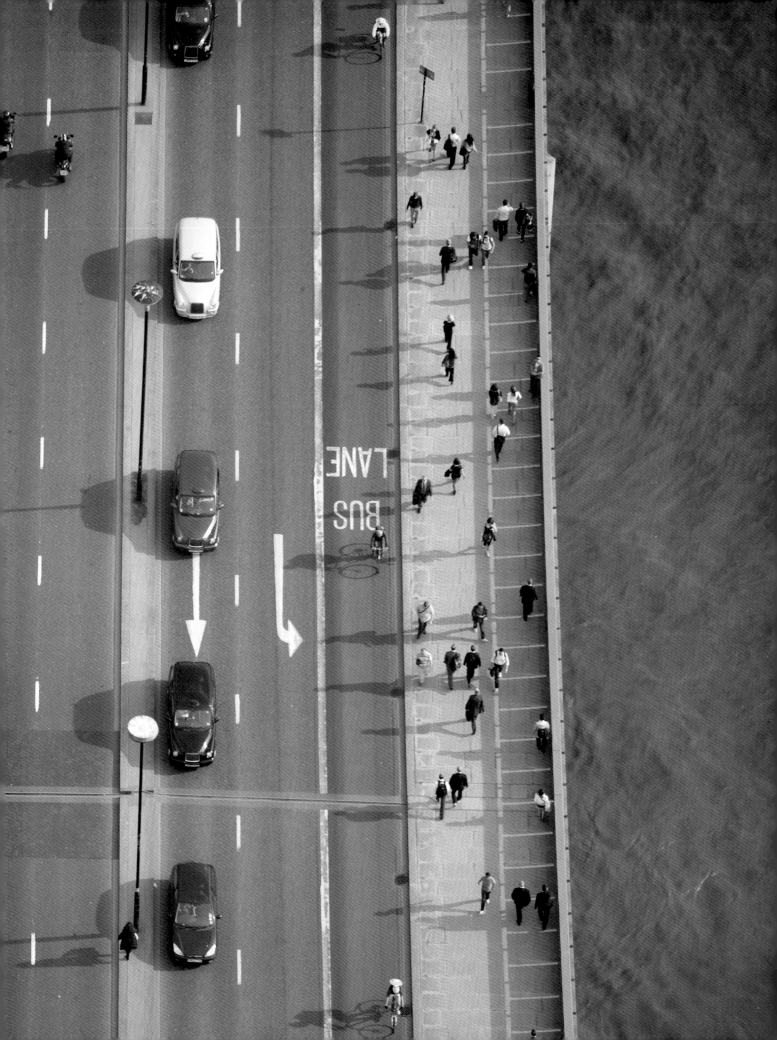

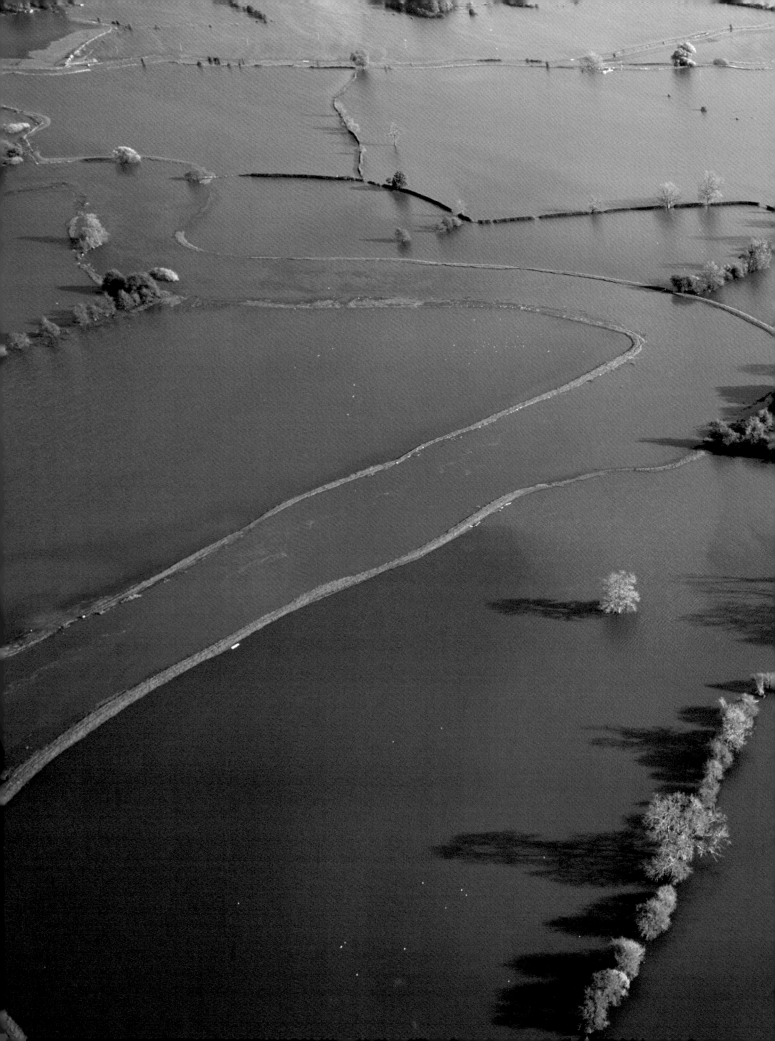

I came across this scene on my way to a job for a client. Of course I spent far more time photographing these flooded fields in Yorkshire than I did on the assignment. Its green raised banks trace the curve of a river that just days before would have flowed peacefully through the landscape.

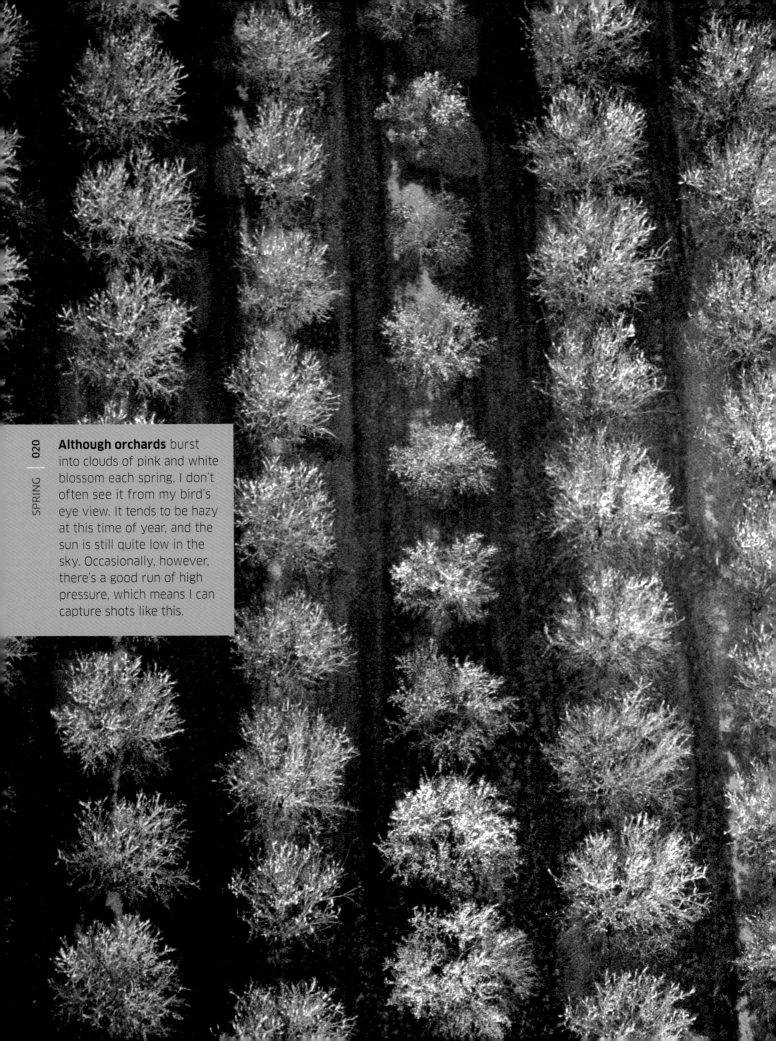

Although orchards burst into clouds of pink and white blossom each spring, I don't often see it from my bird's eye view. It tends to be hazy at this time of year, and the sun is still quite low in the sky. Occasionally, however, there's a good run of high pressure, which means I can capture shots like this.

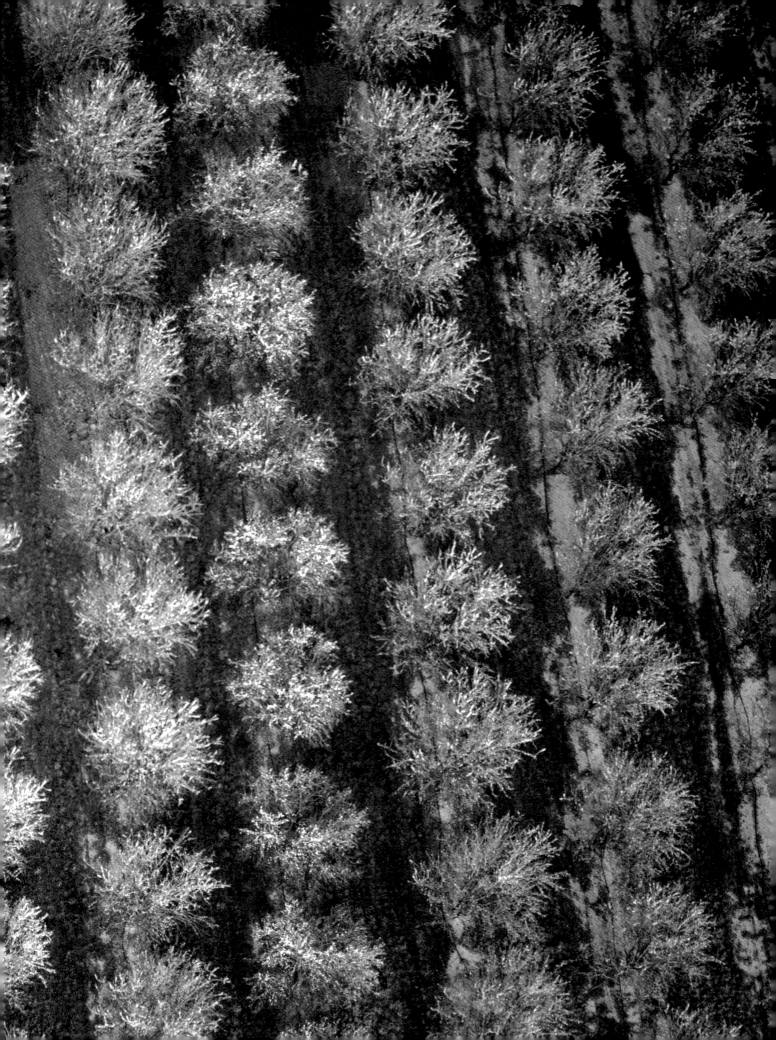

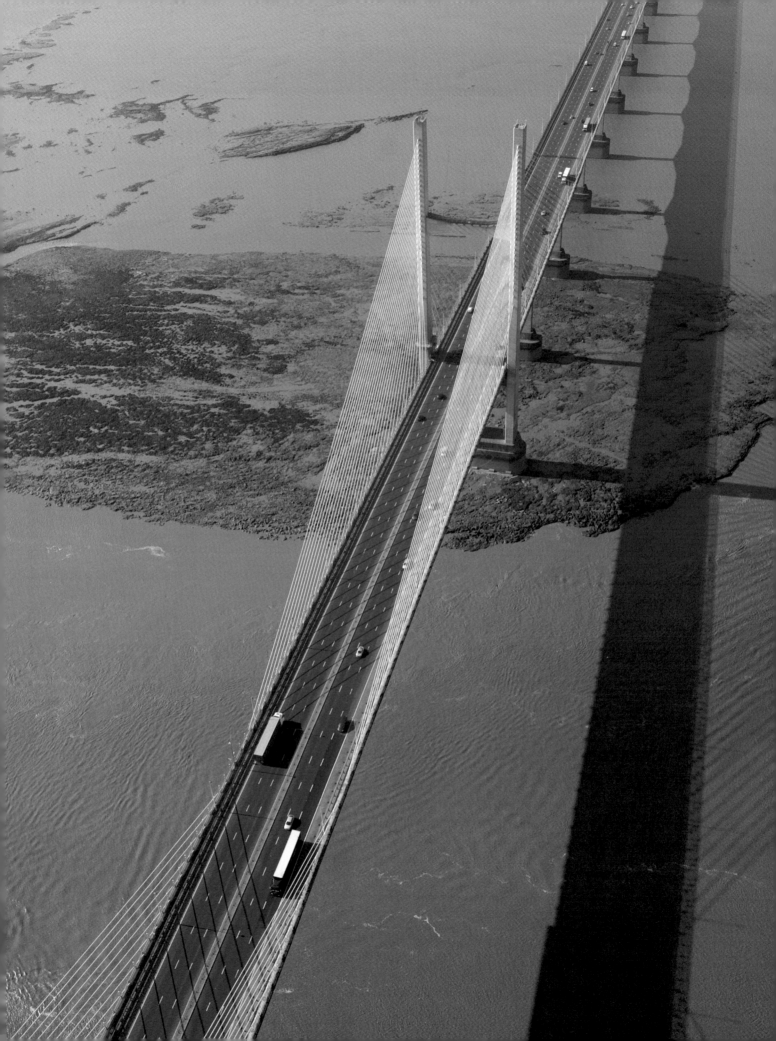

Large bridges and viaducts appear just as impressive from the air as they do from the ground. The New Severn Bridge (opposite) looks rather delicate, while the Ribblehead Viaduct (this page) has a menacing feel – it's in a very remote area, and from the air it looks eerily similar to one of the trains that pass over it.

I was on my way to an offshore wind farm and was about two miles off the Kent coast when I spotted these seals on a sandbank. It was quite unexpected, you don't immediately notice what the shapes on the ground are. I had to get quite low down to get this shot, but they didn't seem remotely bothered.

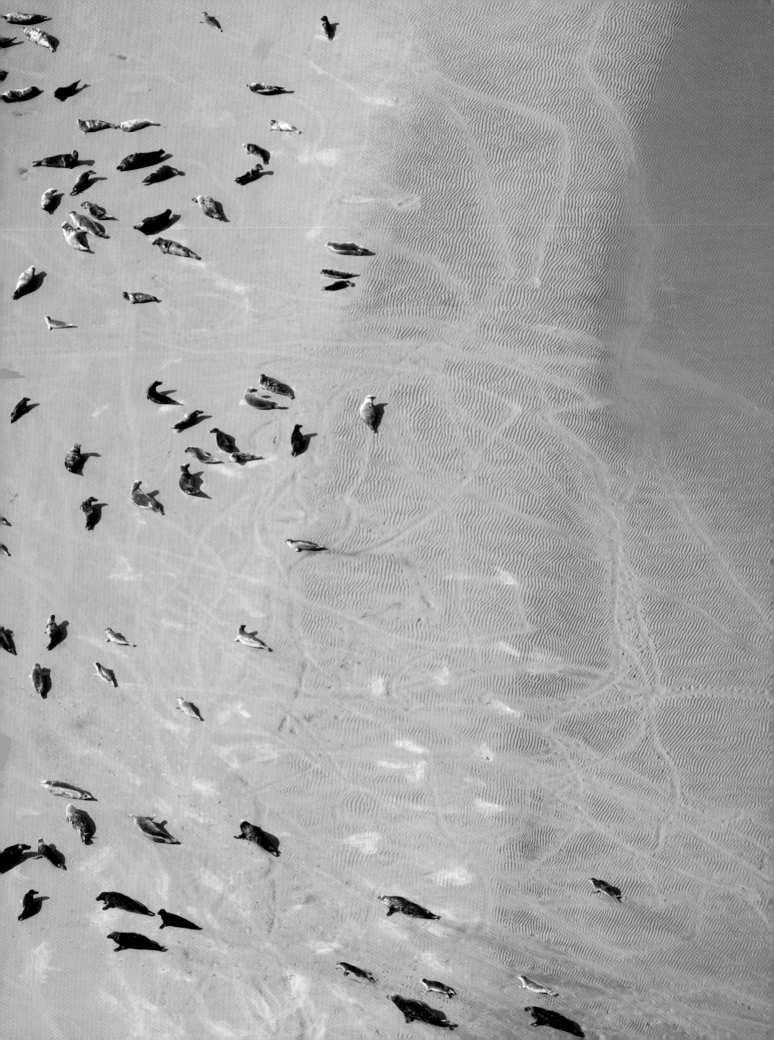

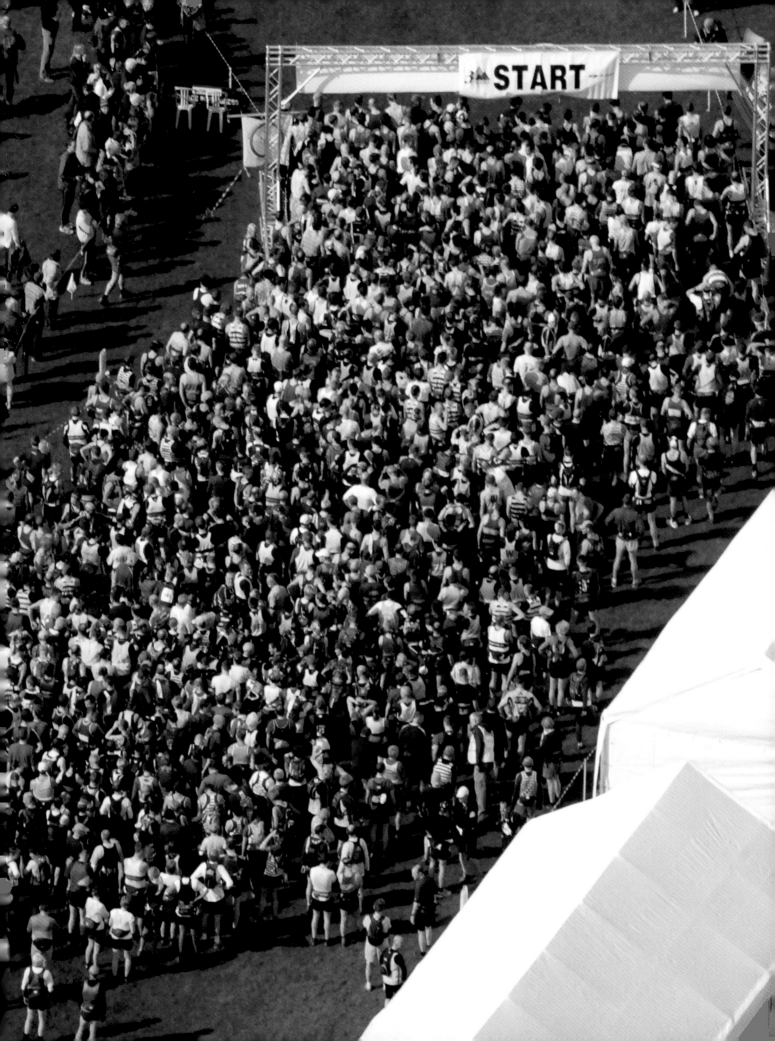

All over Britain, throughout the year, people from all walks of life take part in a wide variety of sporting events to raise money for charity. The Three Peaks Challenge involves climbing the highest peaks in England (Scafell Pike), Scotland (Ben Nevis), and Wales (Snowdon) over the course of a weekend.

Britain is littered with ancient sites. Knowlton Circles (this page), with its Norman church within a Neolithic henge, is typically intriguing. Maiden Castle (opposite, below) is one of the world's greatest Iron Age hill forts, while Dun Beag Broch (opposite, above) still divides opinion on its purpose some 2,000 years on.

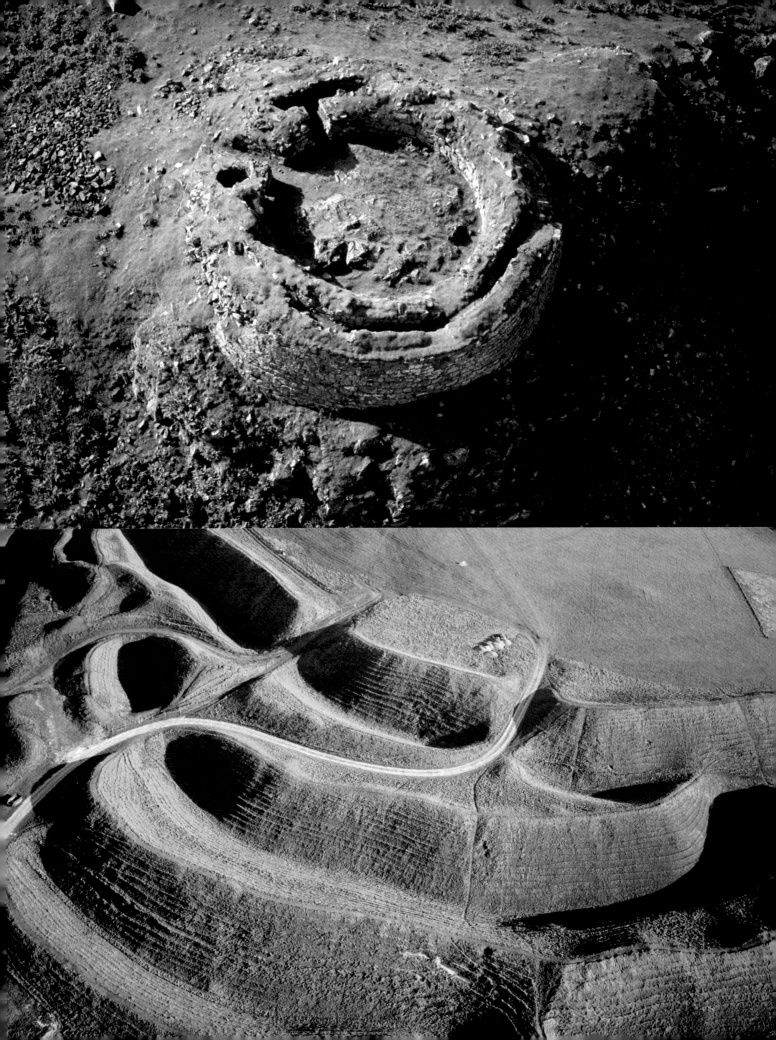

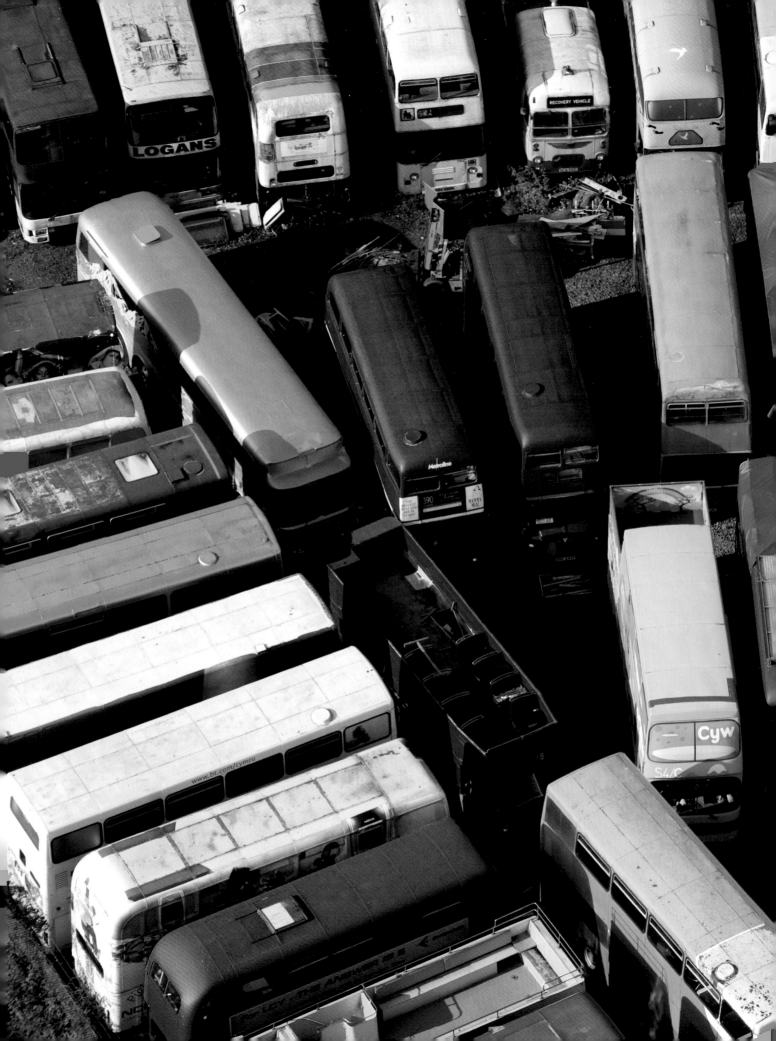

Tucked behind a railway station, these slabs of colour immediately caught my eye. On closer inspection I realised they were 50 or 60 double decker buses. I've since discovered that this is a storage yard for a bus export company and that the Spice Girls tour bus (below) is now a mobile disco in Canada.

With its huge open skies, stunning landscapes, and spectacular lochs, Scotland is a treasure trove of glorious aerial views. Pictured like this, the Firth of Forth takes your breath away; but the Forth Railway Bridge steals the show, its ironwork looking like an intricate cat's cradle spanning the water.

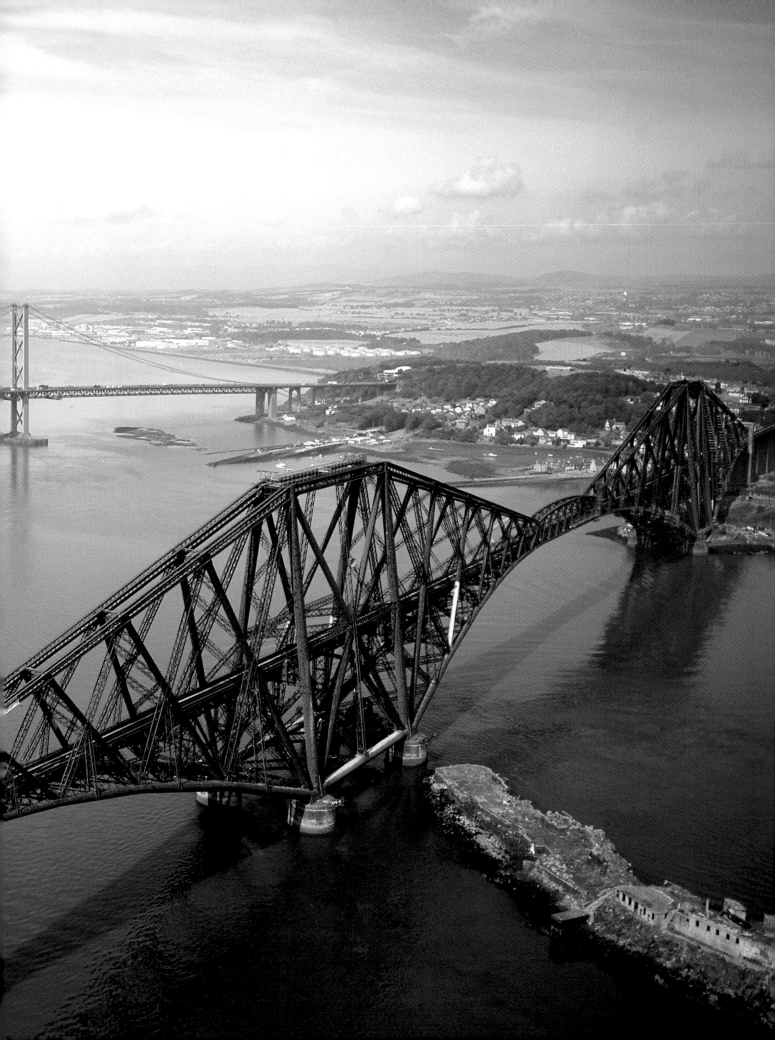

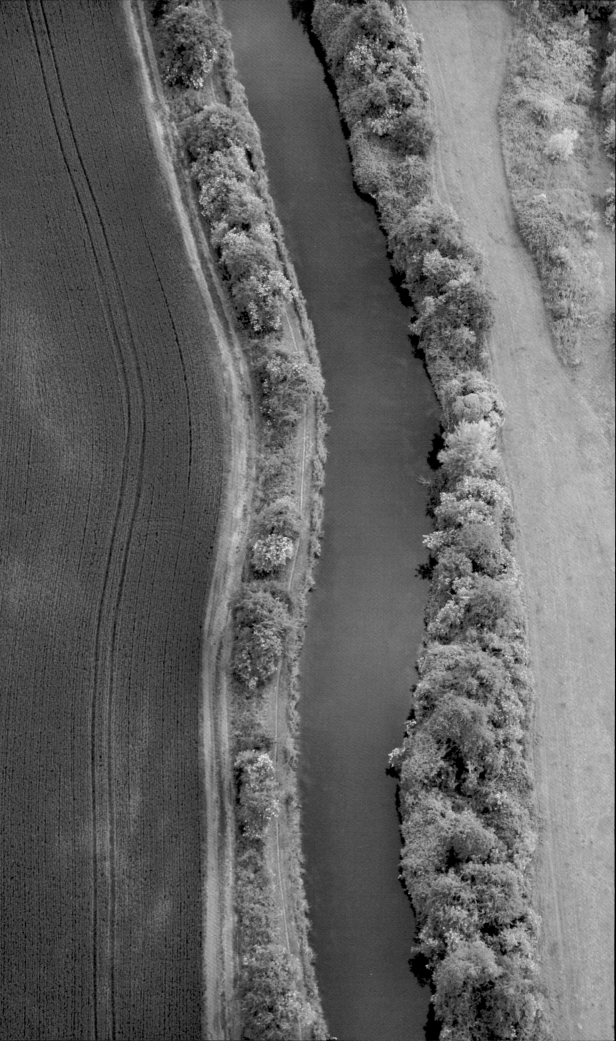

The sense of rhythm you get from the repeating lines in this picture of an Epping Forest waterway make the overall scene very pleasing on the eye. The meandering river paths directly match the shape of the water lines, and these in turn are delicately echoed by the tractor tyre trails in the field.

Manchester's Central Library immediately stands out from its angular surroundings. Its columns and the dome in the centre were inspired by the Pantheon in Rome. The building's neoclassical grandeur might explain why people think it's much older than it actually is – it was built only in the 1930s.

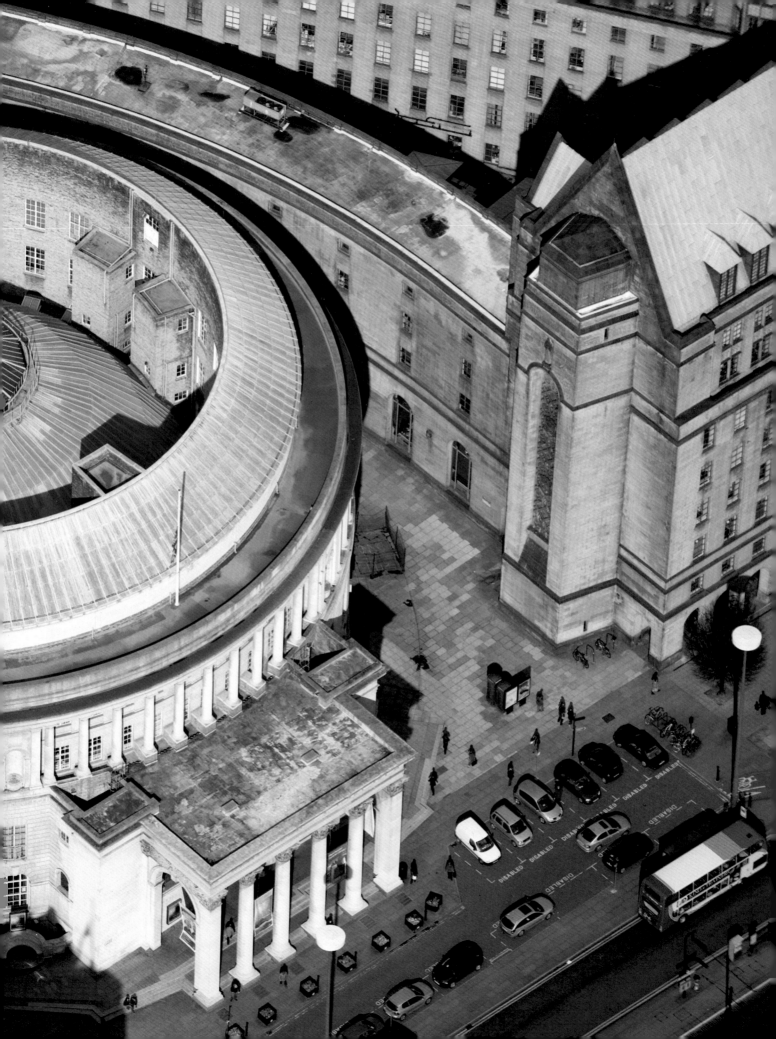

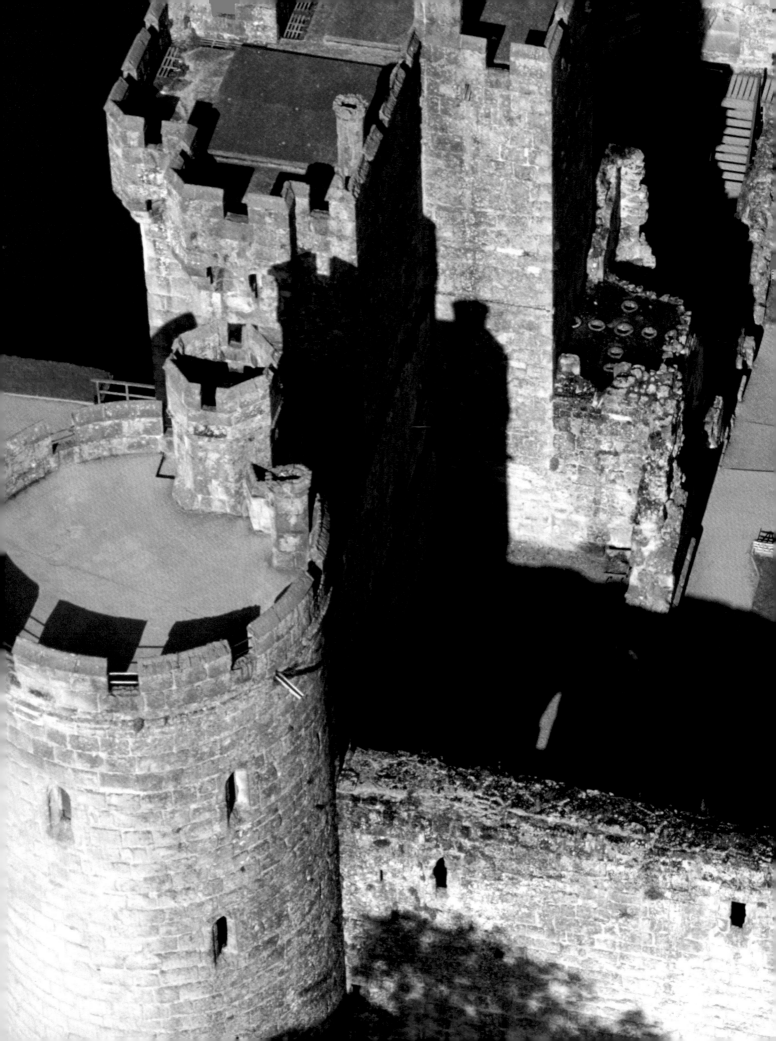

Flying over the medieval Bodiam Castle in East Sussex, I was struck by the bold, blocky shadows that it casts, and how they add to its dark, brooding nature. Looking down on the massive stone walls and battlements, you gain an understanding of how difficult it would have been to breach these strongholds.

This picture's all about the late afternoon light. When you're looking directly down onto these hockey pitches, the players themselves are reduced to no more than tiny, brightly coloured dots, but their hugely elongated shadows make them look like giants.

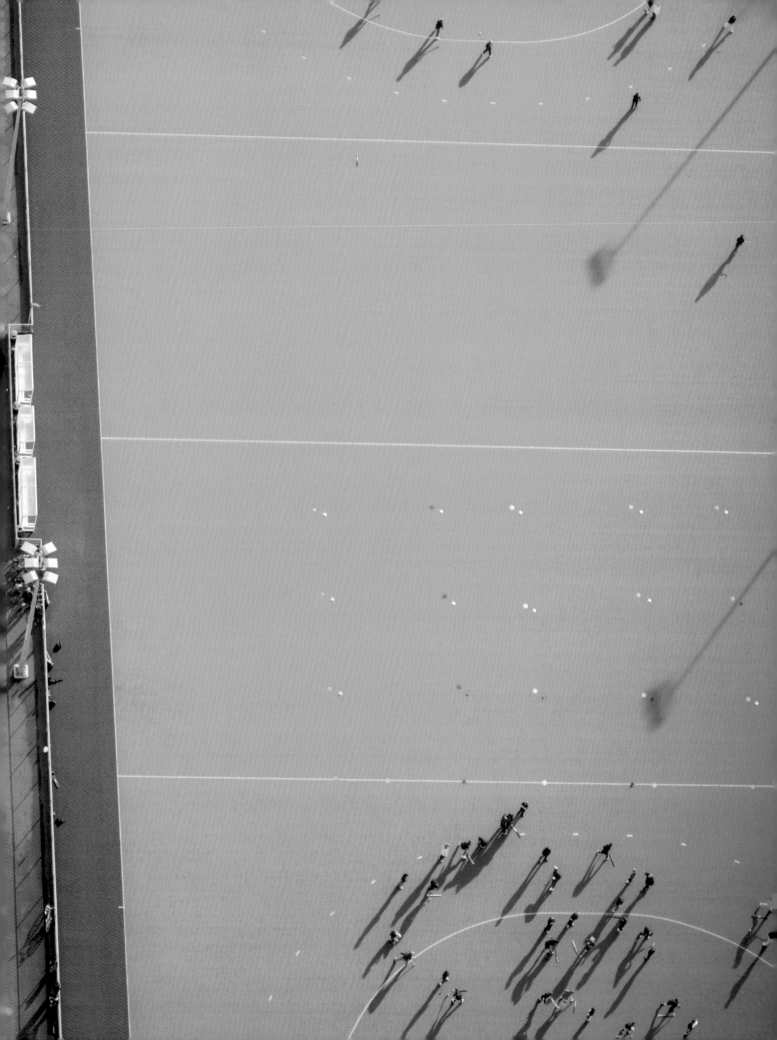

Nature never fails to please when it comes to its habit of creating images that you would happily hang on your wall. With the beautiful, deep blue of the loch – so quiet and undisturbed – edged by the dappled greens of the tree tops, this composition feels very much like an abstract painting.

Early morning is the best time to photograph mountains, as the distant haze only adds to the drama. Flying close to mountains can be perilious; one side may be perfectly still, while on the other the wind might be gale-force. Even the best pilots, many of whom are ex-military, can find it testing.

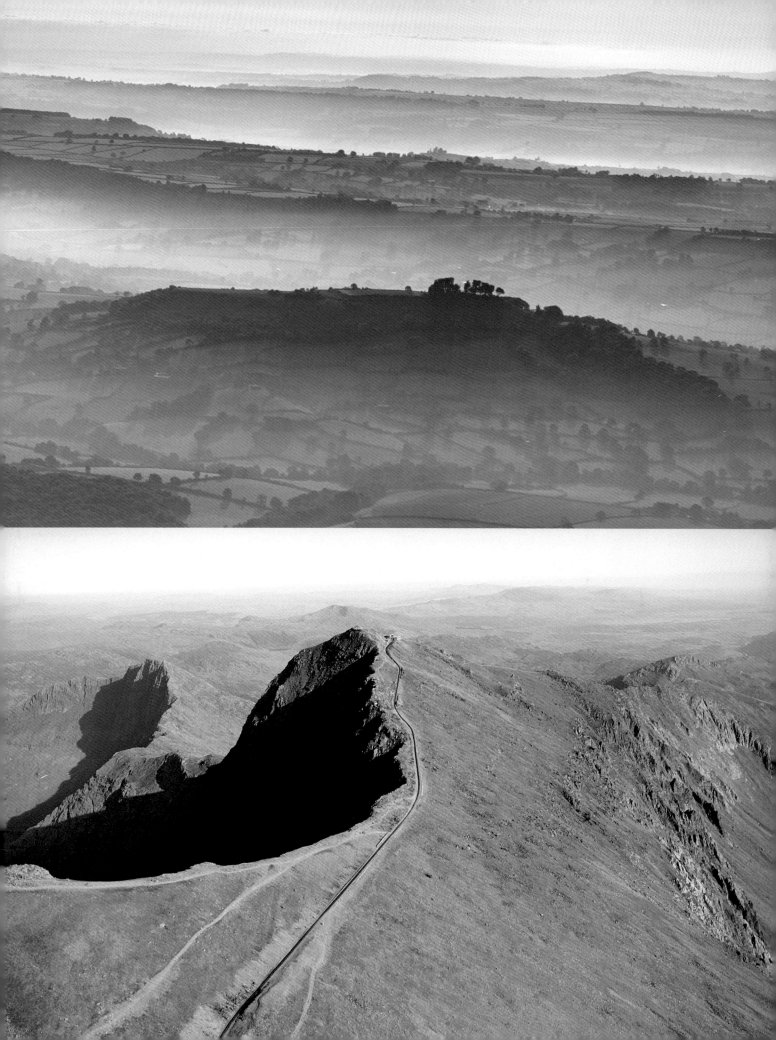

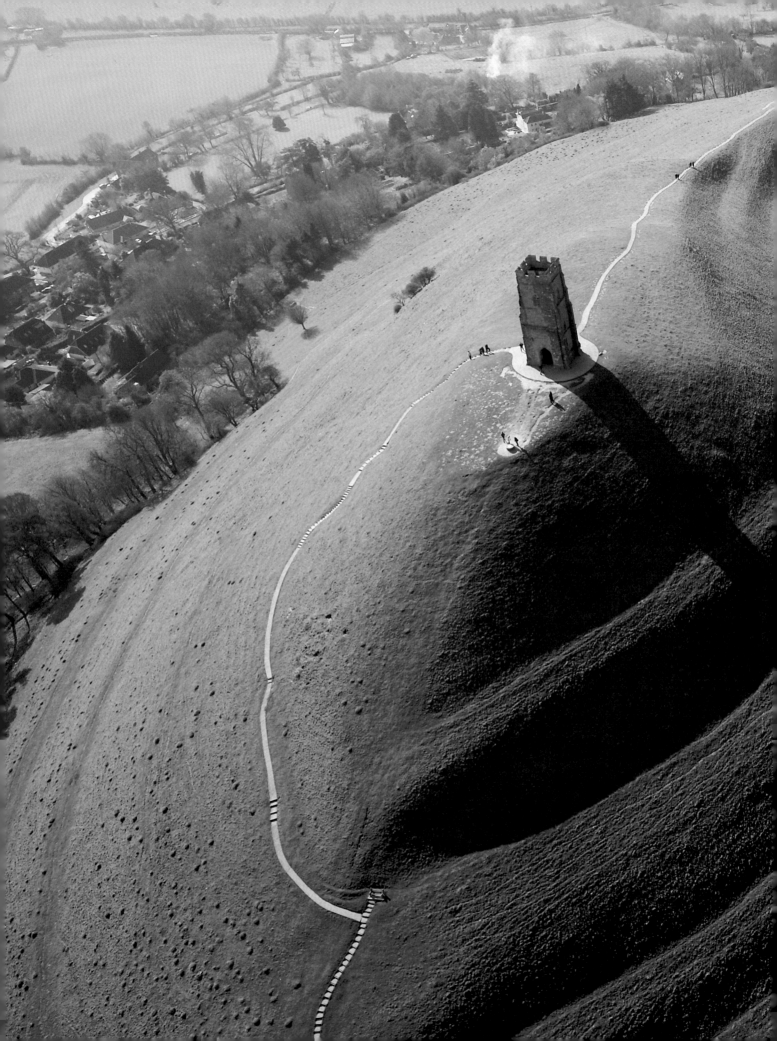

Glastonbury Tor is awash with myths and legends: the last resting place of King Arthur; the entrance to Avalon; its association with The Holy Grail; the criss-crossing of ley lines. The long shadow cast across its terraces by the ruins of St. Michael's Church only adds to its timeless, mystical qualities.

I'm always looking for intriguing patterns and shapes, and while industrial landscapes such as sewage works and power stations aren't the most inspiring views at ground level, they come to life when you're in the sky. The vats at this clay works in Cornwall look like gigantic pots of paint.

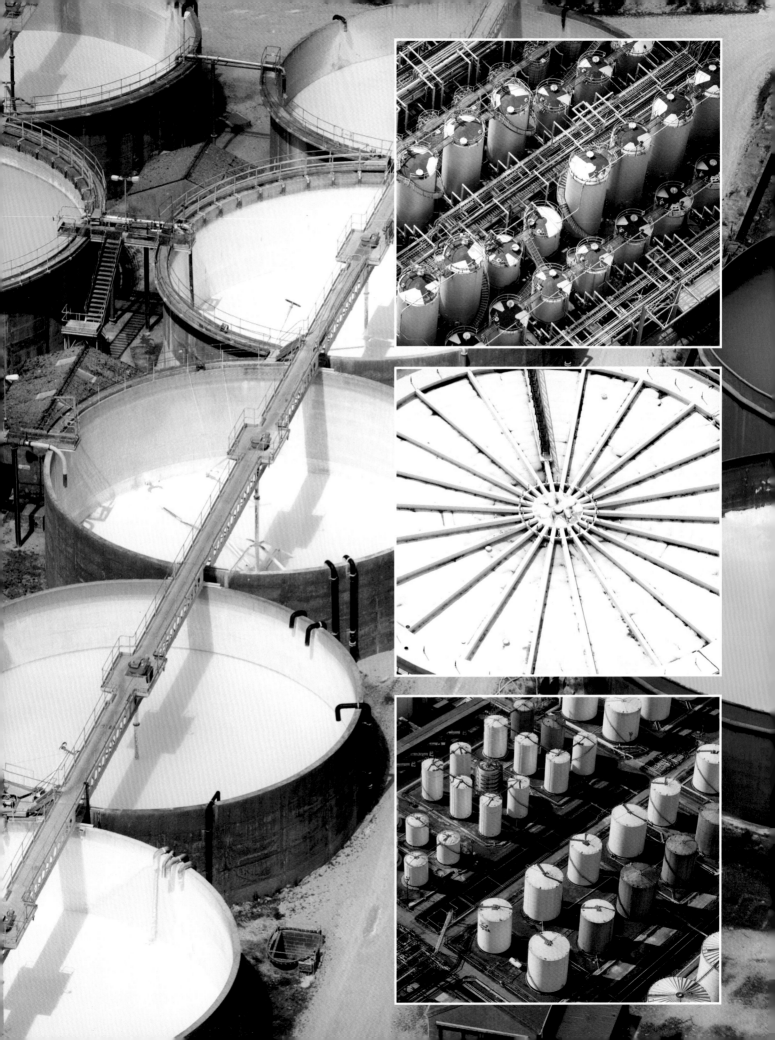

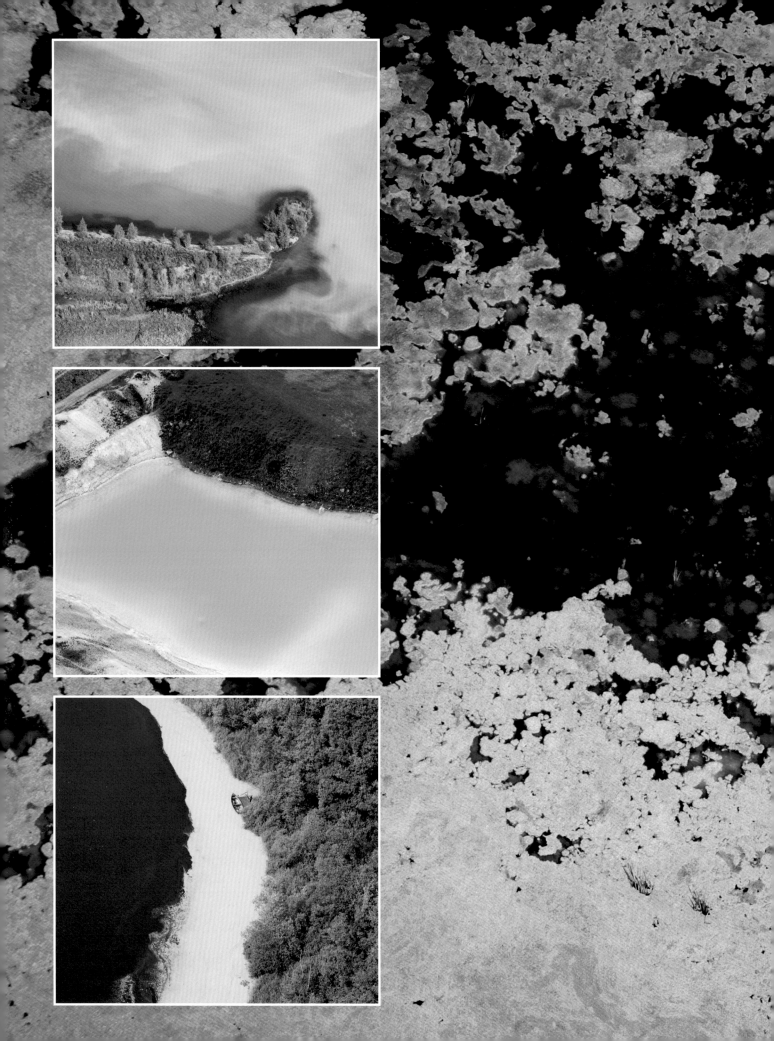

Water can take on the most startling colours (opposite), from the emerald seascape and the iridescent blue clay pit to the vivid river weed. However, it's the many hues of green and gold, and the white swans navigating the mysterious dark depths of the water channels, that makes this main image so vibrant.

Because Stonehenge is near a military base, you're only allowed to fly to one side of it. As a result, all aerial shots are taken from the same side. Nevertheless, the spectacle of the world-famous 5,000-year-old stone circle and its monumental geometry is all the more awe-inspiring from the air.

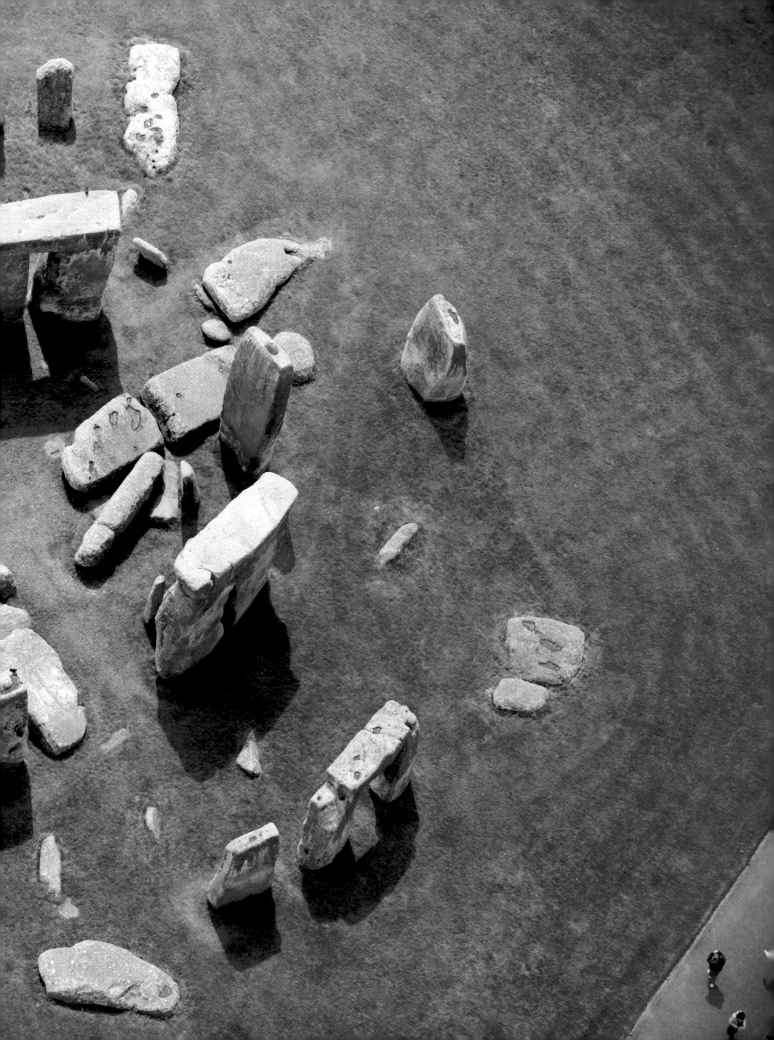

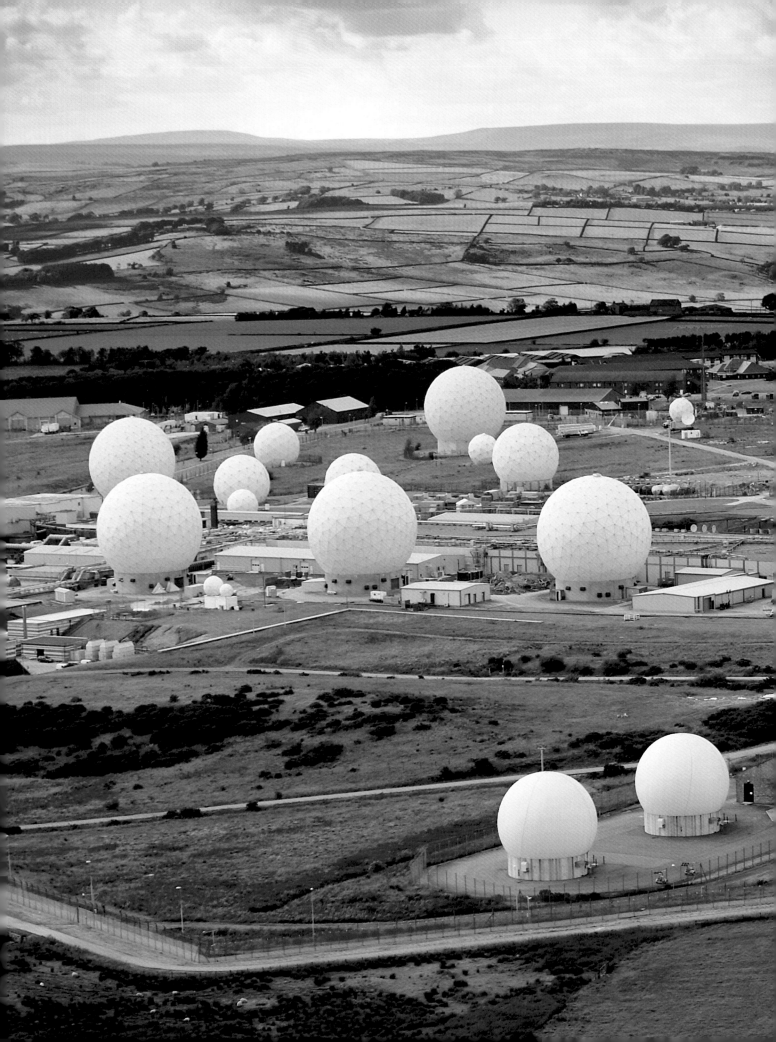

Menwith Hill is the largest electronic monitoring station in the world. The distinctive giant "golf balls" that house antennae are a bizarre sight in the middle of the rolling Yorkshire Moors. Because of its military sensitivity, they don't like you to fly directly above it, even though it's on Google Earth.

As aerial photography has become increasingly accessible, we've come to accept the iconic views of London's landmarks. Being able to capture a completely new view, like the rapidly changing landscape of the Olympic Park and Westfield, Europe's largest shopping mall, is a great thrill.

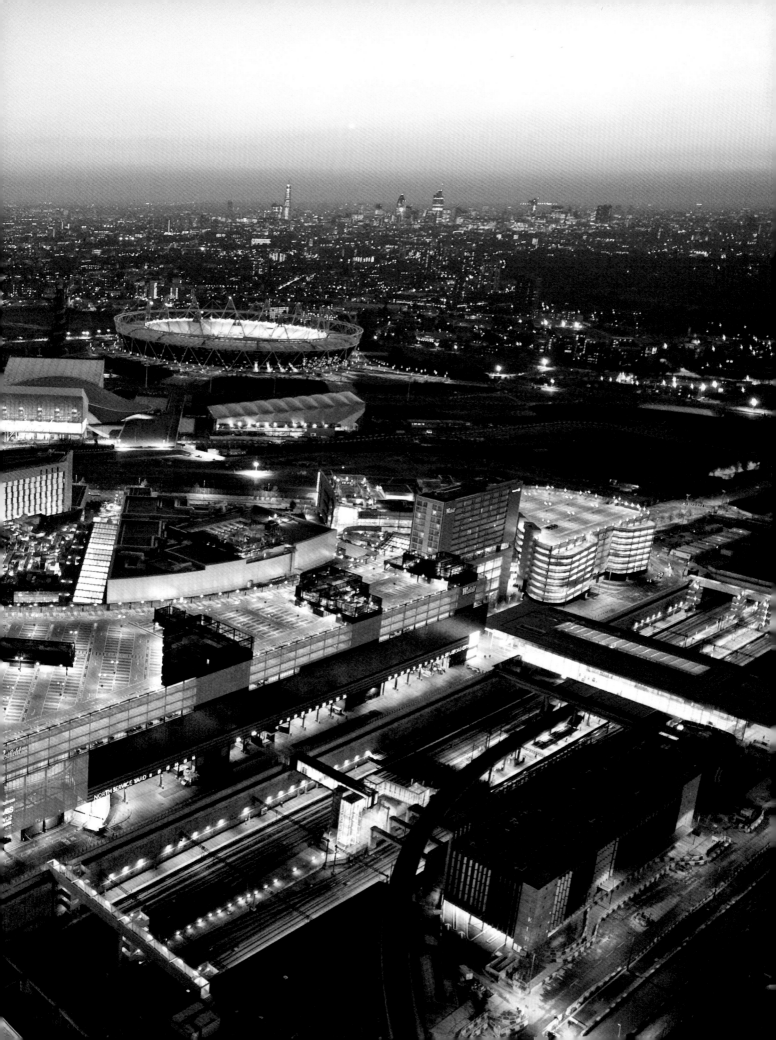

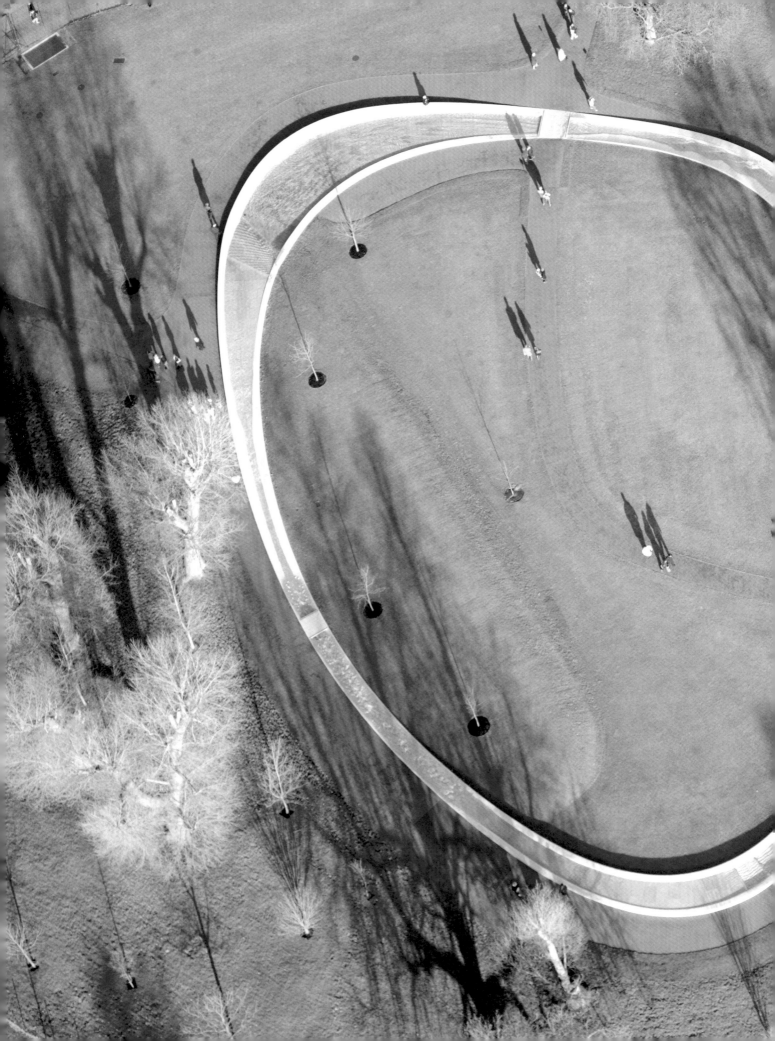

The Princess Diana Memorial Fountain is a hugely popular interactive public sculpture. Its skewed oval shape is simple and elegant. I've shot it in the summer with hundreds of children splashing in the water, but I love this picture with the delicate early spring shadows of the trees and a few people passing by.

Trafalgar Square is one of London's most famous landmarks, but you don't often get to see it from Lord Nelson's lofty viewpoint. The ornate fountains that dominate the view were not in the original plans, but were added to limit the amount of public space that could be used for demonstrations.

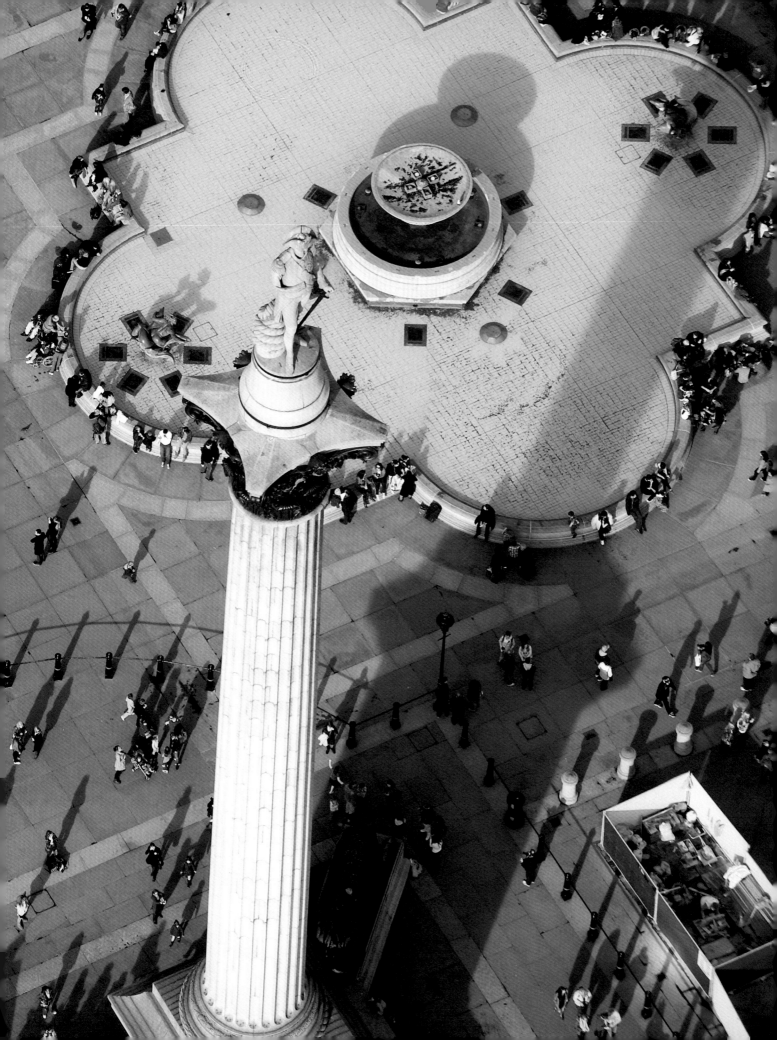

I quite often photograph sandbanks. They're easy to miss because the reflections change as you move round them. If you come from one direction the water may look completely white; from another direction it might be a vivid blue. I always make sure I've seen it from all sides before shooting.

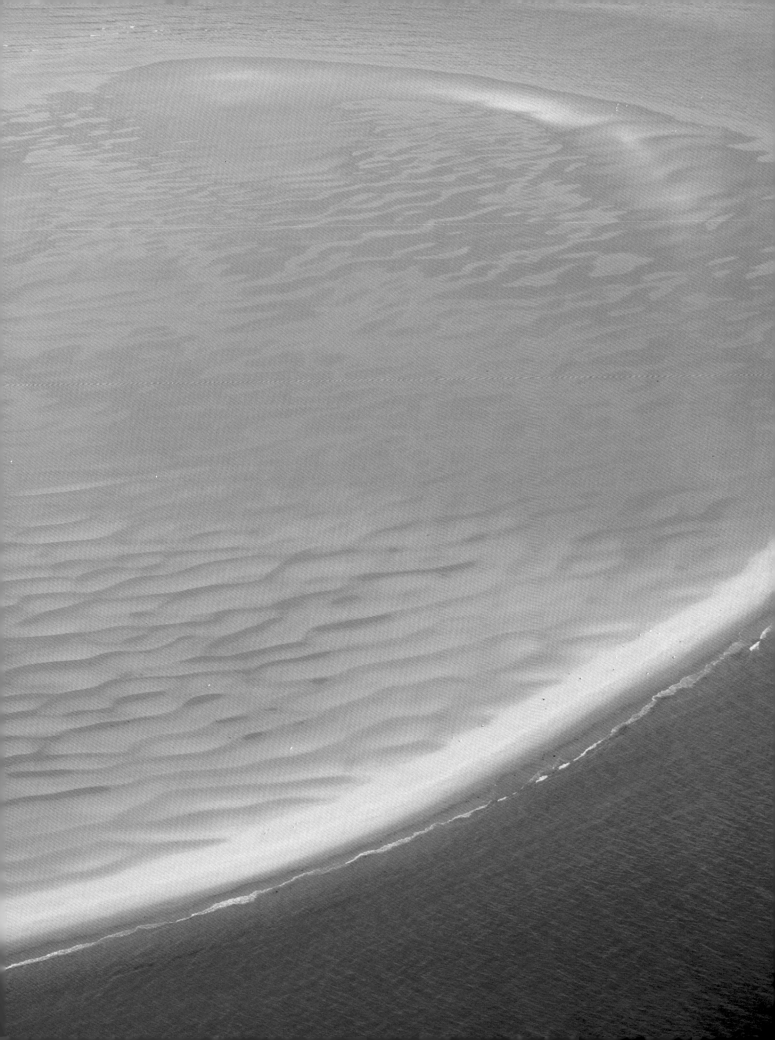

The Eden Project is built in an old quarry near St. Austell, in Cornwall. You can't miss it – as you approach it looks like some sort of moon base. The domes, which house thousands of plant species, are the biggest conservatories in the world – the Tower Of London would fit inside the Rainforest biome.

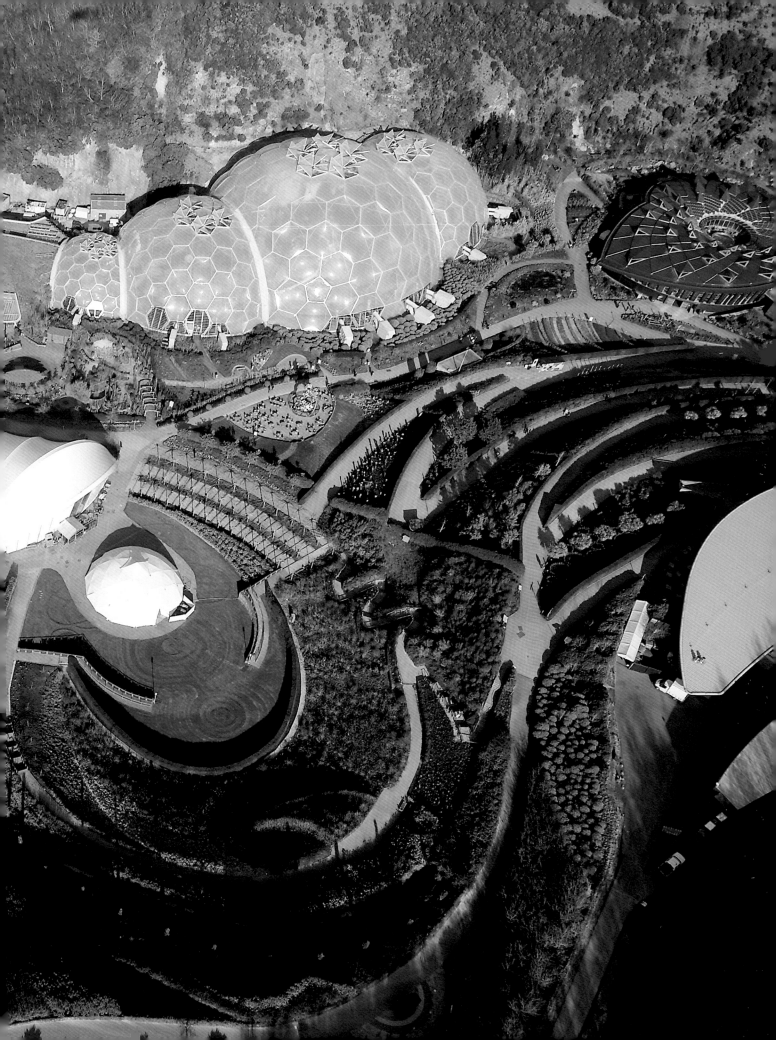

SUMMER

The centrepiece of the British sporting calendar, the Wimbledon Championships are an opportunity too good to miss. When you bank in a helicopter, the noise below is incredible. So as not to distract the players, we fly high, and in straight lines, which makes it more difficult to get a good shot like this.

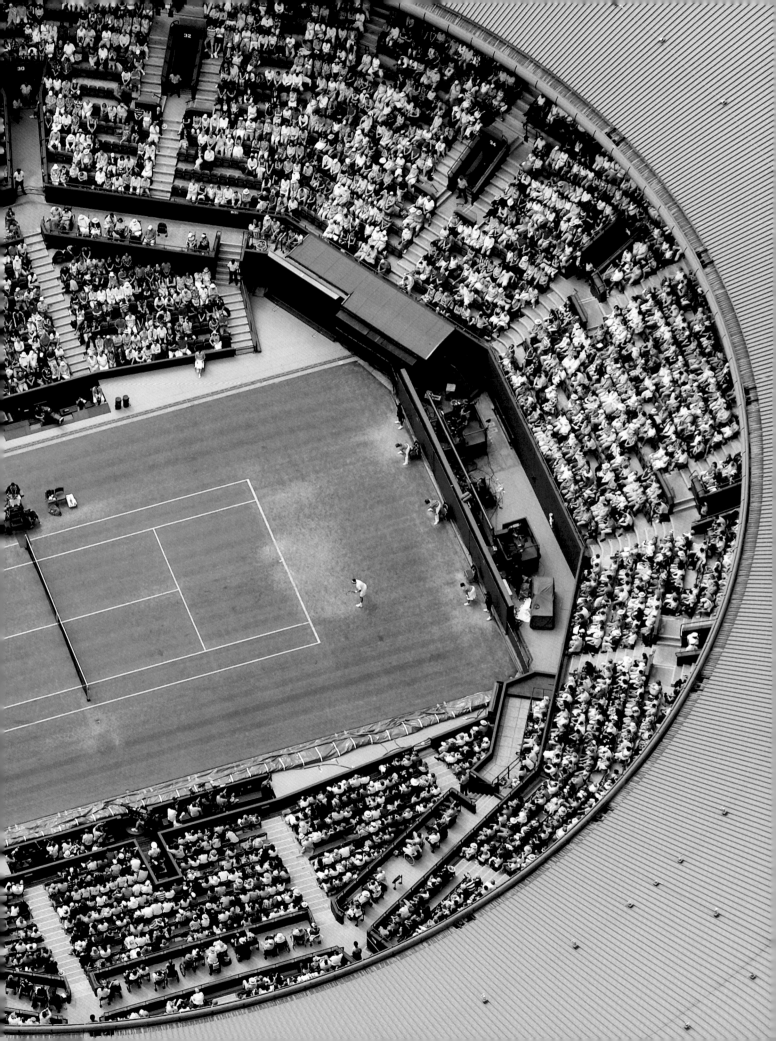

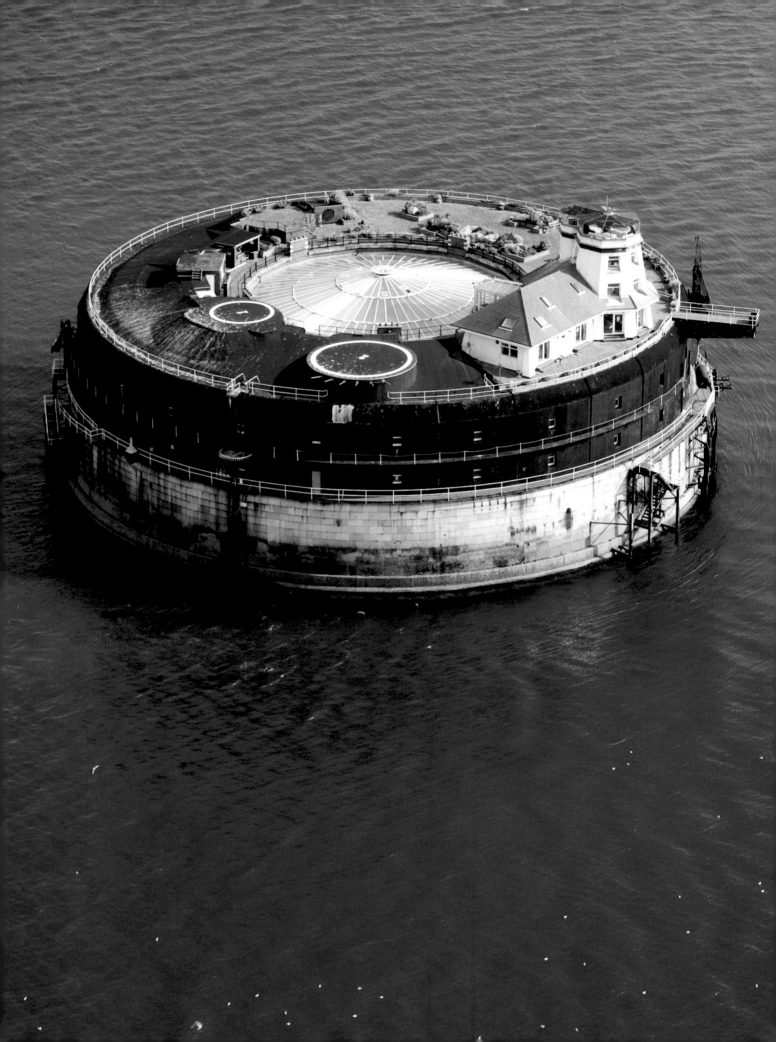

The huge rusting hulks of these sea forts are a gift to photograph because they look so out of place. The No Man's Land Fort (opposite), built in the late 1800s, is 60m (200ft) across. The Maunsell Sea Forts (this page), which were decommissioned in the late 1950s, look like alien machines marching ashore.

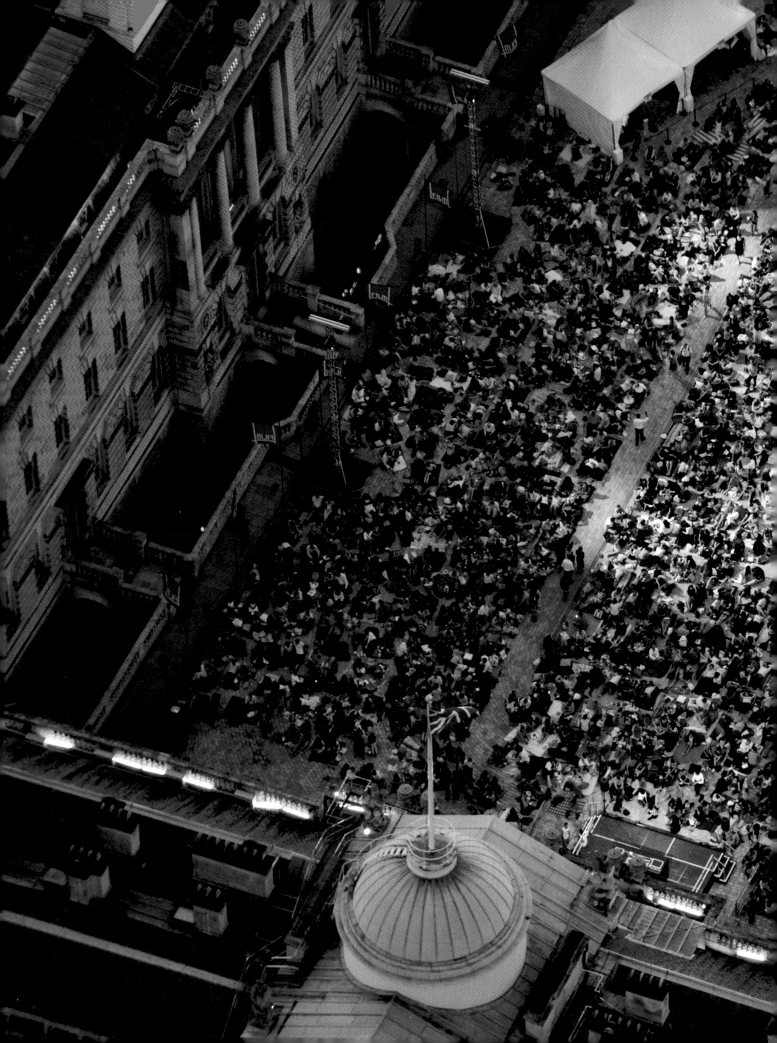

The courtyard at London's Somerset House is a popular location for special events. During the summer it holds open-air concerts, film screenings, and exhibitions, while in the winter it is turned into an ice rink. It's easy to miss at street level, so peering in from above is like spotting a secret hidden world.

The Palm House at Kew Gardens is the world's most important surviving Victorian glass and iron structure. Despite being built in the 1880s, its fantastic shape looks very space-aged from above. Scale is hard to judge with many aerial images, so it's always good to have a few people in the shot.

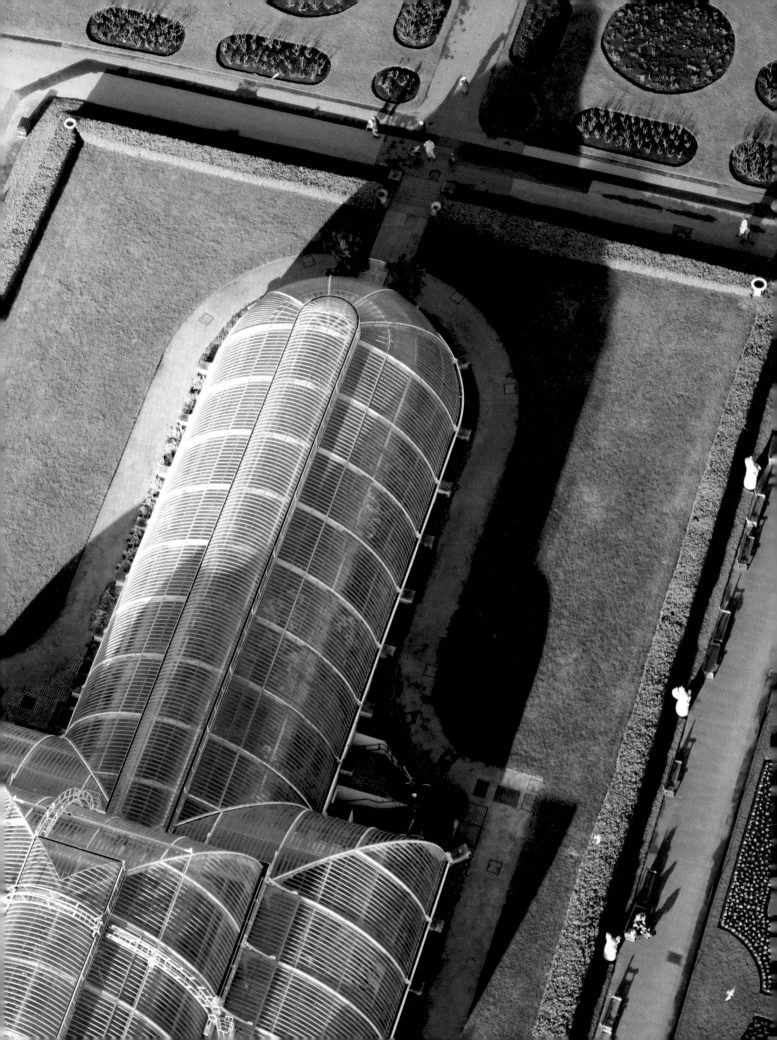

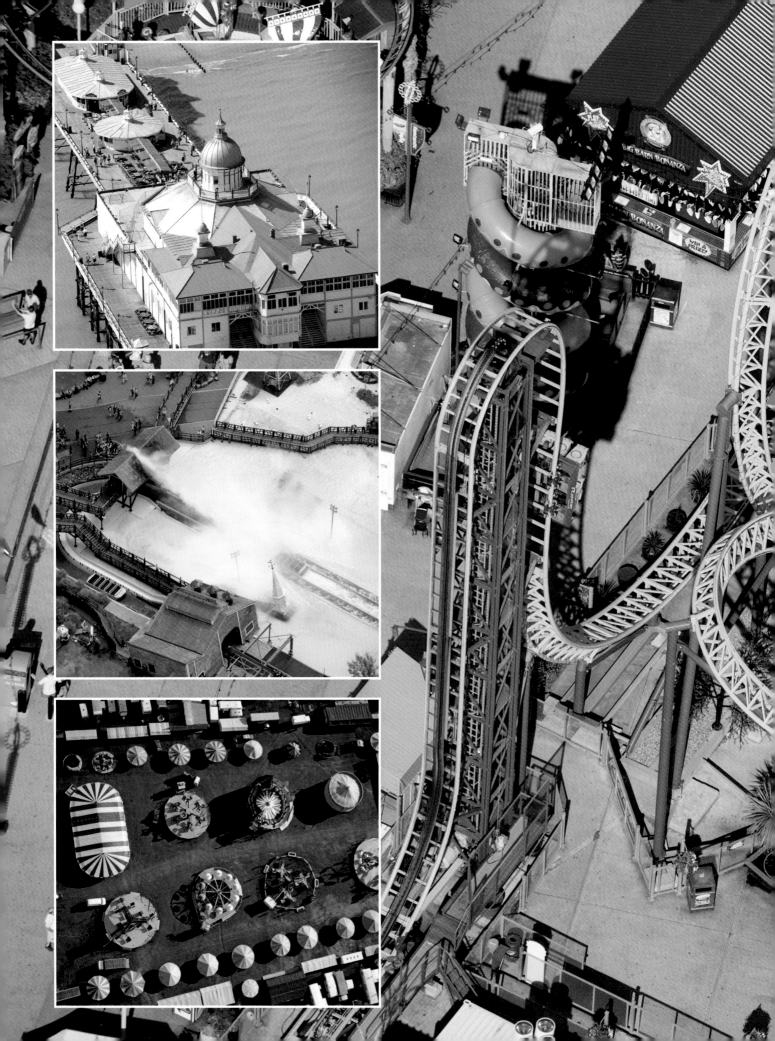

Fairgrounds, theme parks, and piers, with their gaudy colours and tangled shapes, always catch my eye. Although I spend a lot of time buzzing around in helicopters, I'm not keen on heights. Just thinking about plunging down a sheer drop on a rollercoaster makes my stomach turn.

This is an unusual shot of Buckingham Palace (right). It's usually photographed looking down the Mall. Here you can see the palace grounds, where they hold exclusive garden parties in the summer. If you look closely at the party picture (opposite), you can just about make out the Queen.

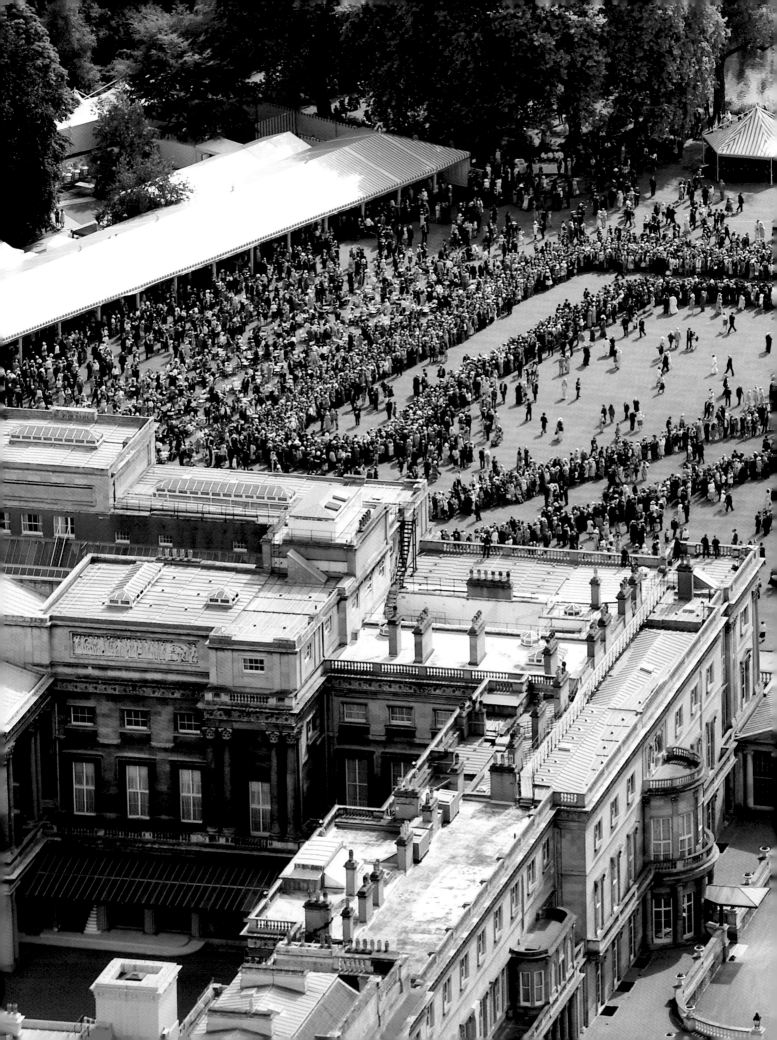

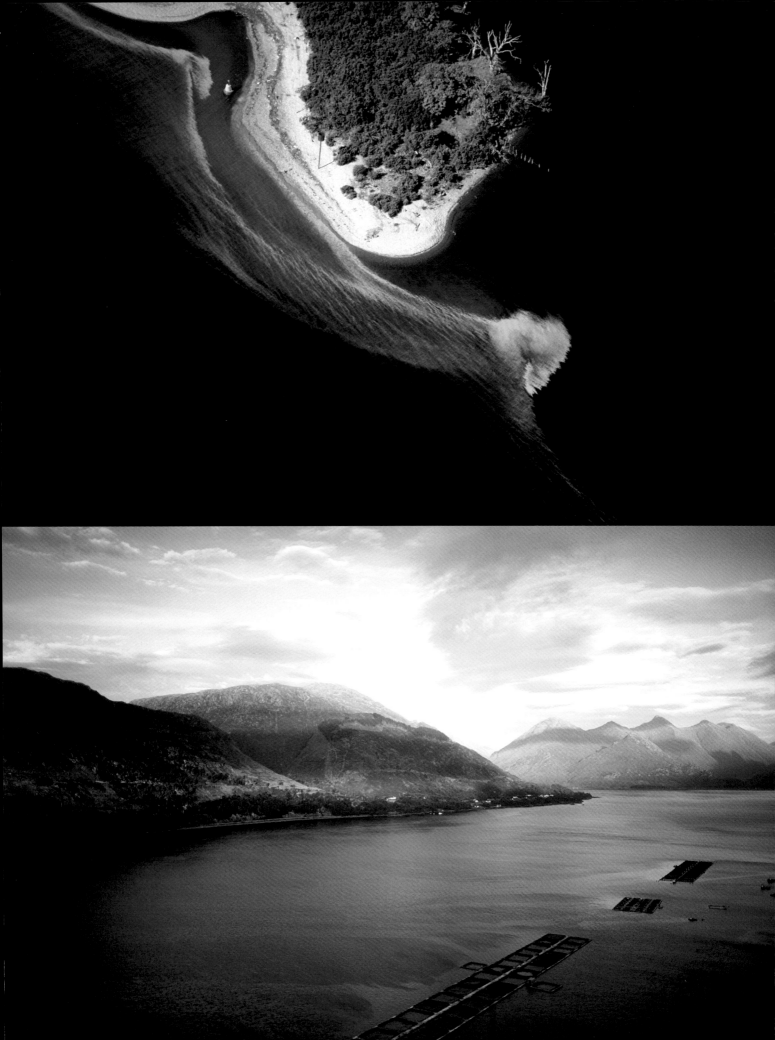

These three views of Loch Ness only hint at its vastness. If there is a monster lurking in its depths, you can understand how it has managed to stay hidden. Urquhart Castle (this page), one of Scotland's largest strongholds, commands magnificent views over the huge expanse of water.

If you ask me whether I prefer to photograph natural or man-made forests, I'd have to say man-made every time. You can spot their neatly planted regimental lines from miles away. The way the foliage and shadows repeat their intersecting pattern in this Essex forest make it look like woven cloth.

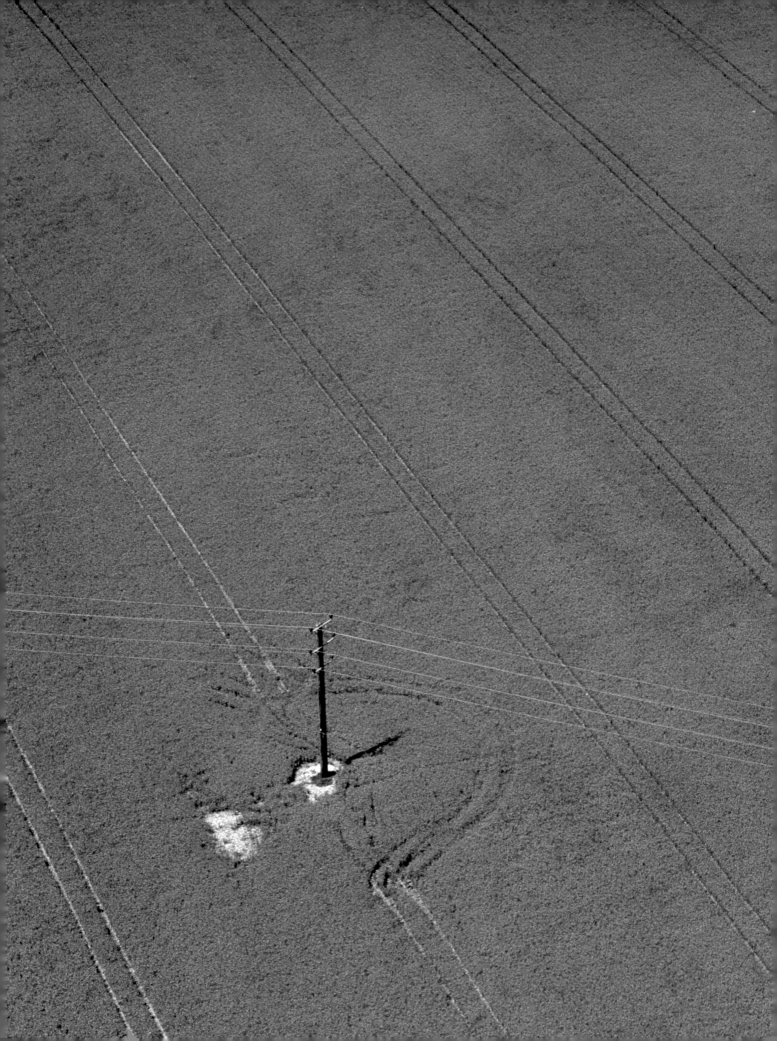

Nature never ceases to amaze me with the incredible colours it conjures up. The vibrant blue of this peaceful sea of flax almost glows. The impact of the scene is only enhanced by the way the tractor tracks and the almost invisible cables strung from the isolated pylon appear etched into the field.

I love photographing views like these, in which the subject isn't immediately obvious. Geometric shapes, such as these greenhouses and the crop-sequencing fields (opposite), look so much like complex technical drawings it's hard to believe they weren't created with a ruler and a pen.

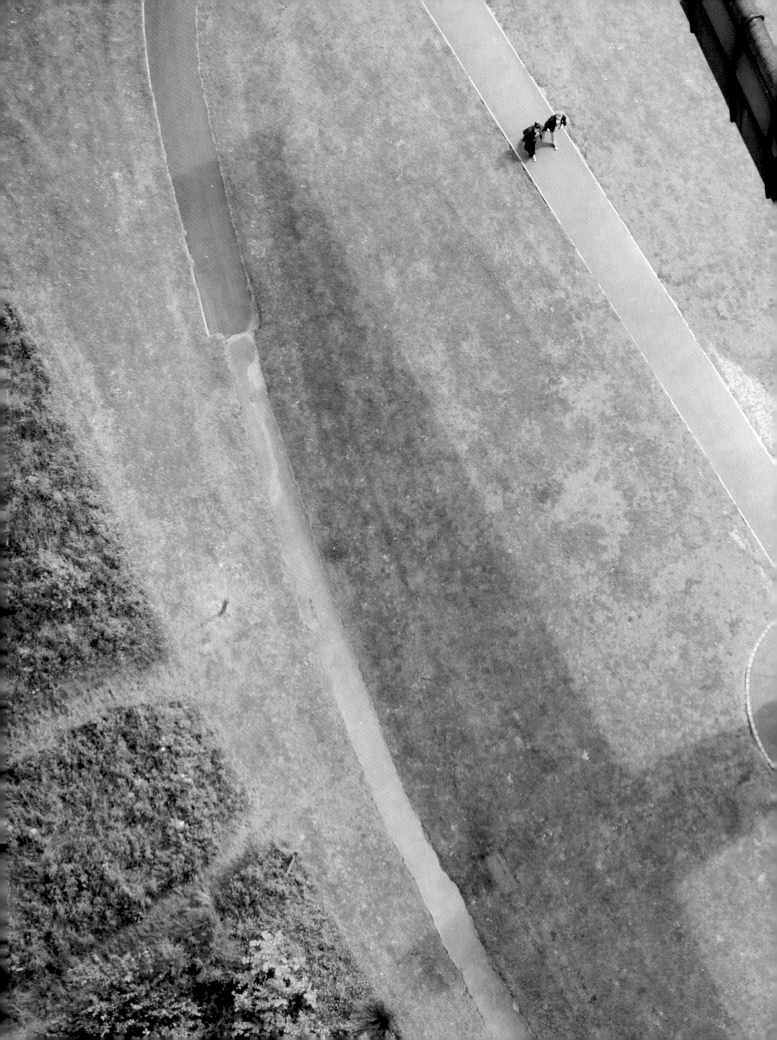

Anthony Gormley's iconic Angel of the North sculpture is massive, but from this height it looks as if you could pick it up and put it in your pocket. It's quite tricky to photograph, and from above this is as wide a view as you'd want – if you pull back just a little, you have the busy A1 motorway in shot.

Stretching for almost 30km (19 miles) along the Dorset coastline, Chesil Beach is a true wonder of the natural world. On one side of the beach is open sea and on the other is a freshwater lagoon, which presents a glorious range of colours. From the air, this World Heritage Site is absolutely breathtaking.

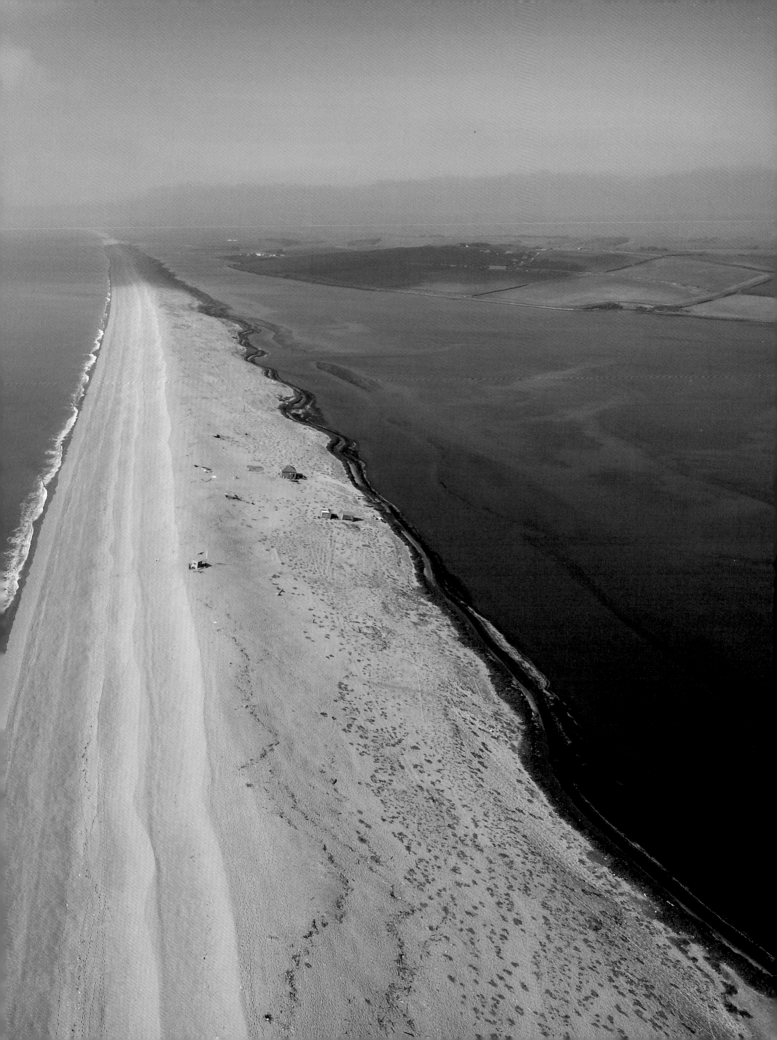

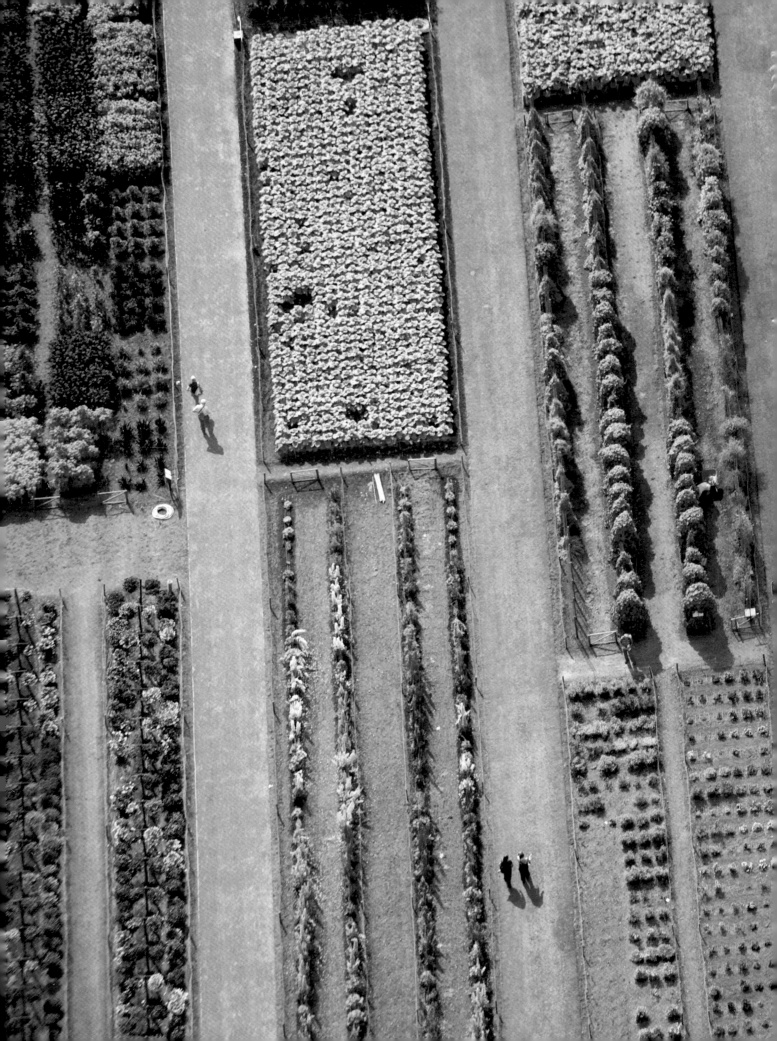

This photograph features the trials fields at RHS Wisley, where new varieties of flowers and vegetables are tested. The British are a nation of gardeners and as I criss-cross the country I can't resist patches of obsessively tended land. Gardens and allotments are always so rich in detail and full of colours.

I think this picture of a lavender field in Essex looks like an Impressionist painting. The colour is so delicate that it appears to be have been sprinkled on. Despite having done this for 20 years, I never tire of gazing down at such magical scenes. I can only imagine the amazing scent at ground level.

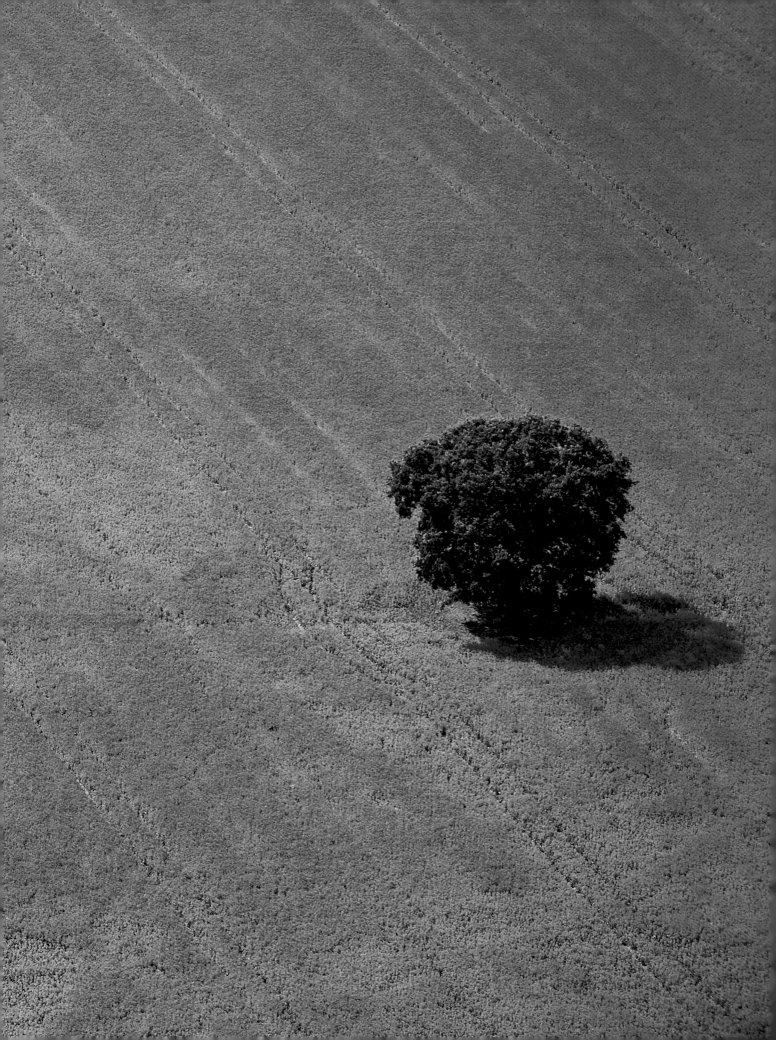

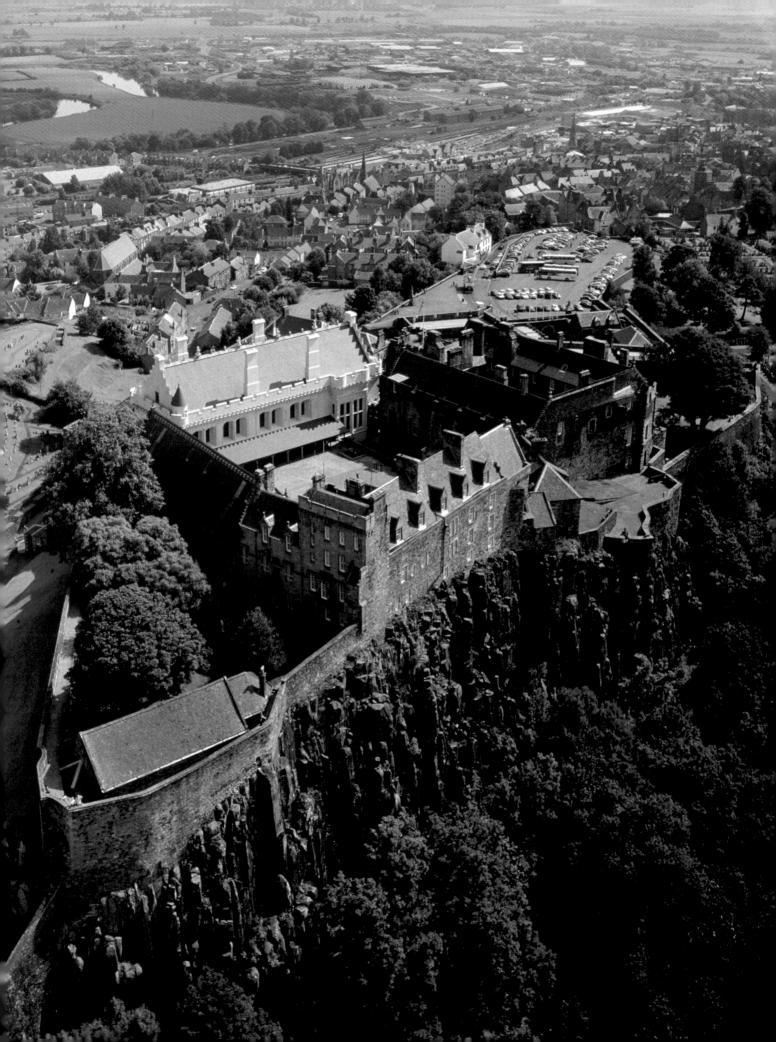

While Edinburgh Castle (this page) and Stirling Castle (opposite) were built as strongholds, perched high on their hills with clear views for miles in every direction, they look more like grand houses than hulking fortifications. These Scottish castles have a much friendlier feel than those south of the border.

From the air you see some unexpected places that at street level you wouldn't know existed. The Bath Spa Project building is a 21st-century take on the open air spas that made the city world famous. Until this pool opened, the mineral-rich thermal waters had been off limits to visitors for 20 years.

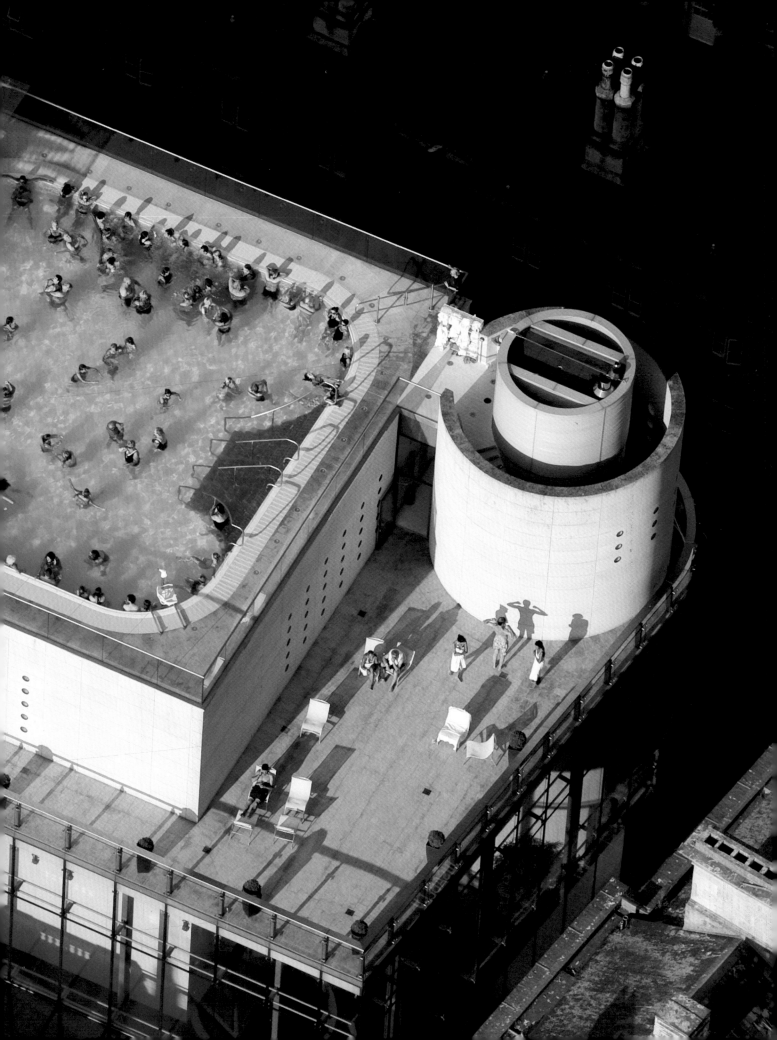

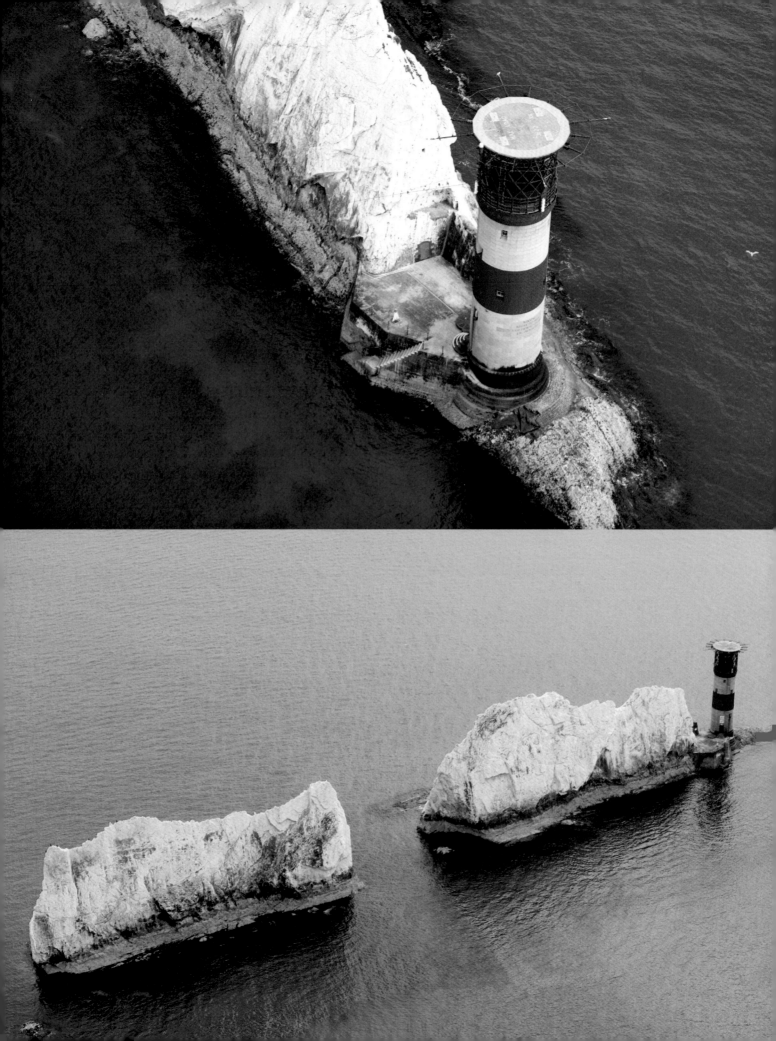

When flying on the coast you don't have the restrictions you have in the city – you can swoop down for closer views. I used to wonder how The Needles, off the Isle of Wight, got their name, as they're not very needle-like. In fact, it comes from a taller chalk pillar that collapsed into the sea in the late 1700s.

Dating back to 1346, the gardens at Penshurst Place in Kent are not only among the oldest in the UK, but some of the most beautiful. The 11-acre walled garden contains one of the estate's seasonal highlights, the Union Flag Garden, where 2,000 roses and a sea of lavender burst into life each summer.

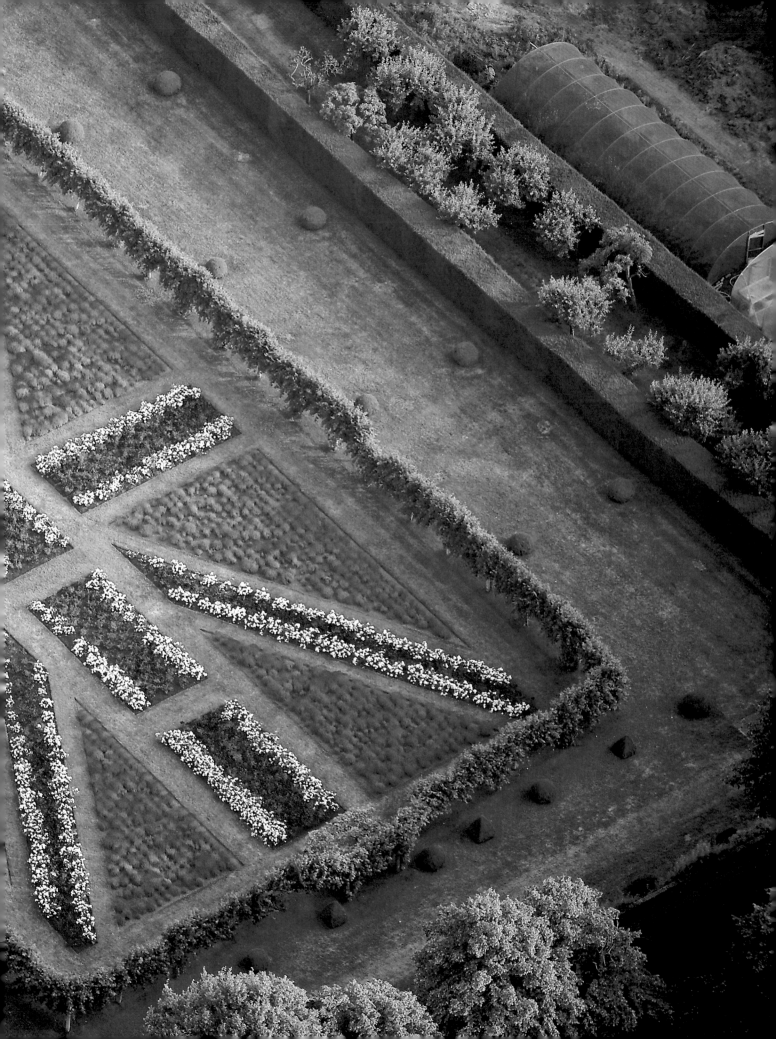

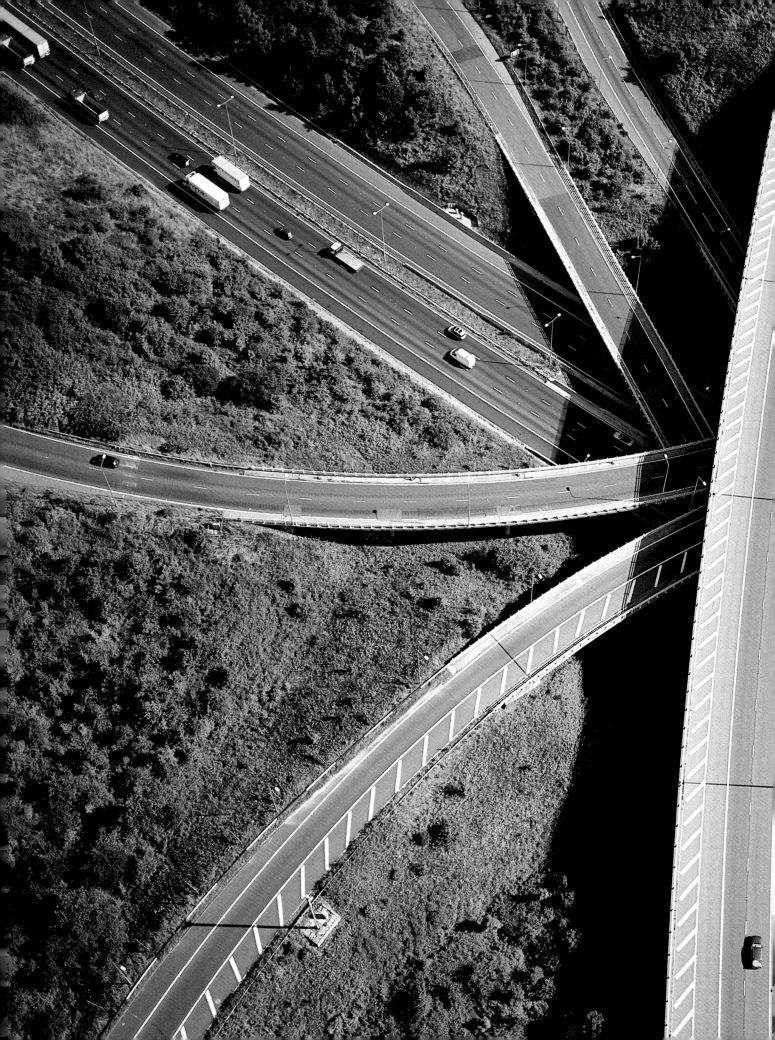

With its greenery and the smooth, sweeping curves of the three tiers of roads, this junction on the M25 is one of the most photographed in the country. Despite being a brutal grey motorway junction, it manages to be incredibly picturesque with the intersections almost creating the Union Flag.

Mazes are among my most popular images – I get requests to take new pictures all the time. With nearly two miles of paths, the maze at Longleat is the largest in Britain, yet from up here it just looks like a page in a puzzle book. It's a different tale on the ground, with six bridges in case you get lost!

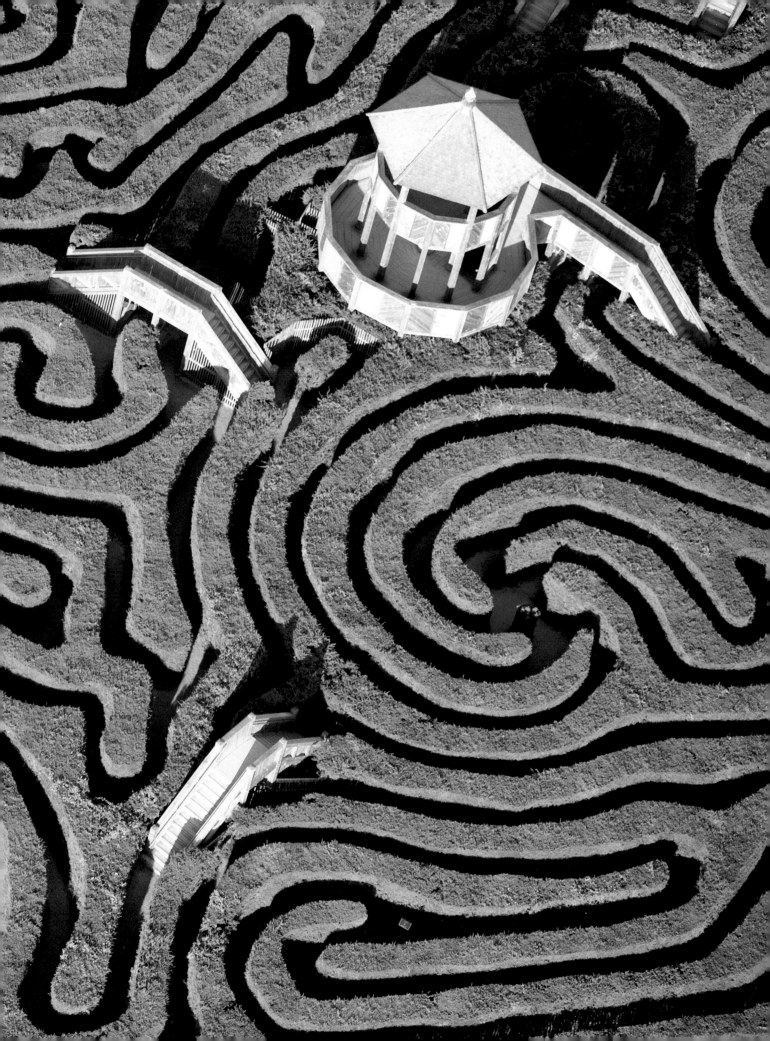

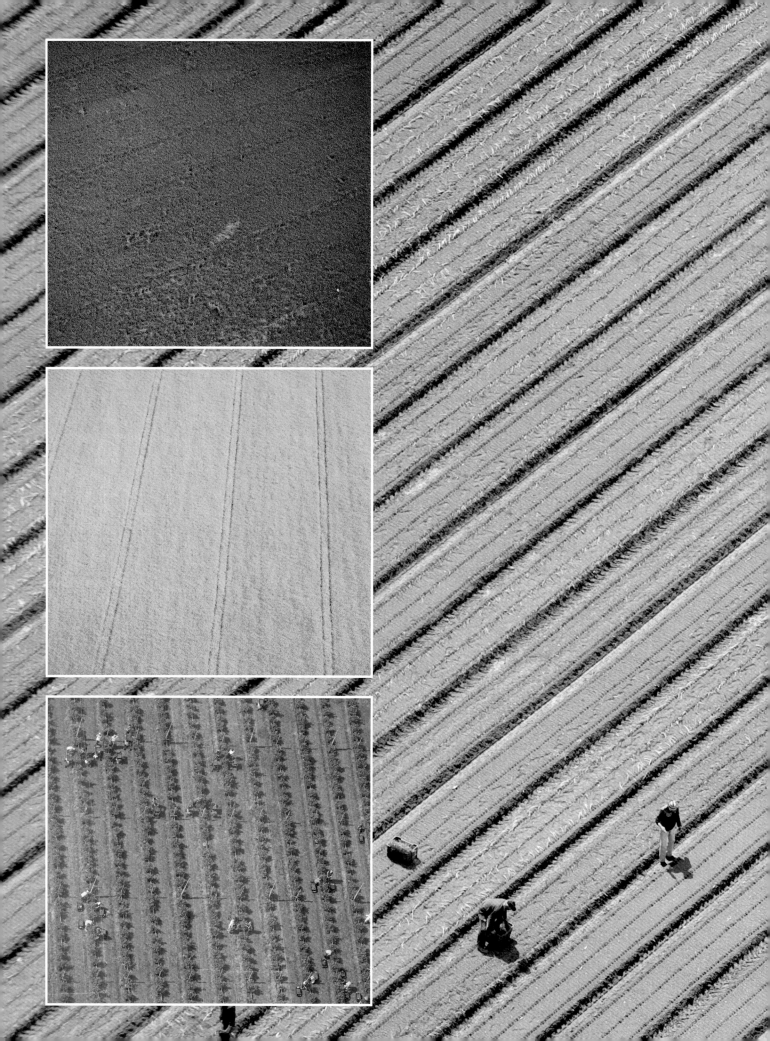

Farming is so automated these days that it's rare to see people in fields. So while the vibrant colours and abstract patterns of fields of poppies or rapeseed are radiant, it's the workers that really catch my eye. The rows of asparagus look like a musical score, with the pickers as the notes.

When you fly in remote areas such as this part of the Scottish Highlands, you will often see military aircraft on manoeuvres. They fly at the same height as helicopters and scare the living daylights out of you as they whip past. We can't hear them, but on the ground the roar of their engines is deafening.

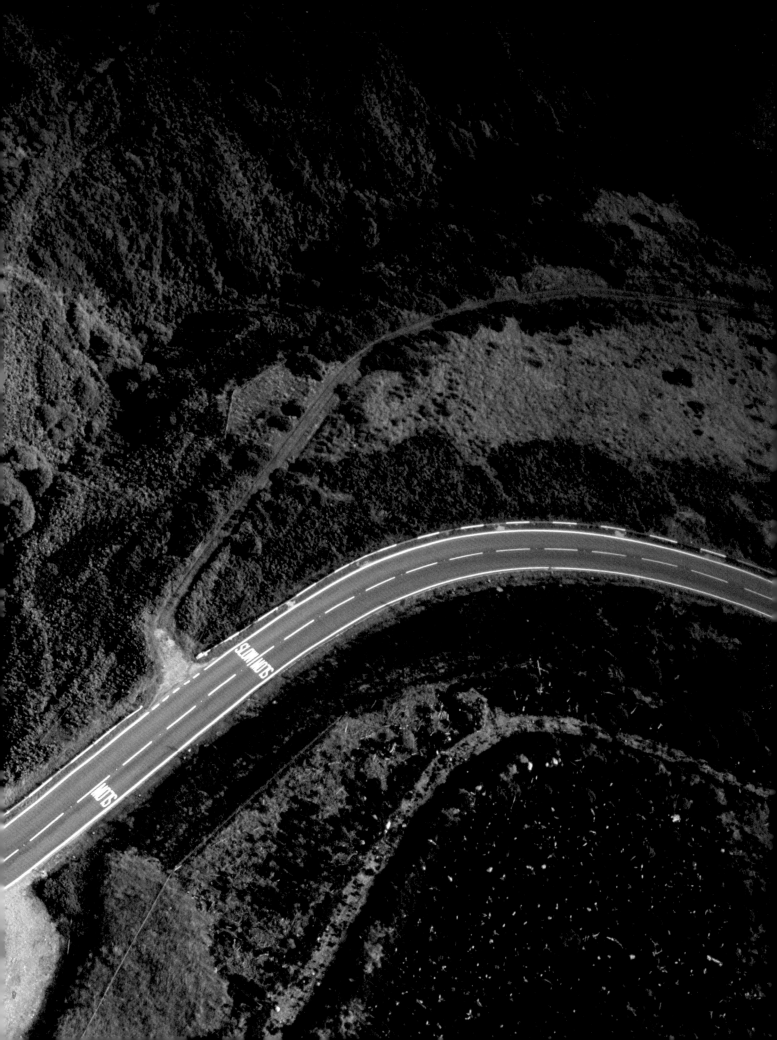

Britain's waterways are very rich in imagery. The fact that there are so many parks and buildings alongside rivers and lakes means that usually there are lots of people present – these picnickers are enjoying a sunny day by the Cam. The repeating pattern made by punts lined up at the top is quite eye-catching.

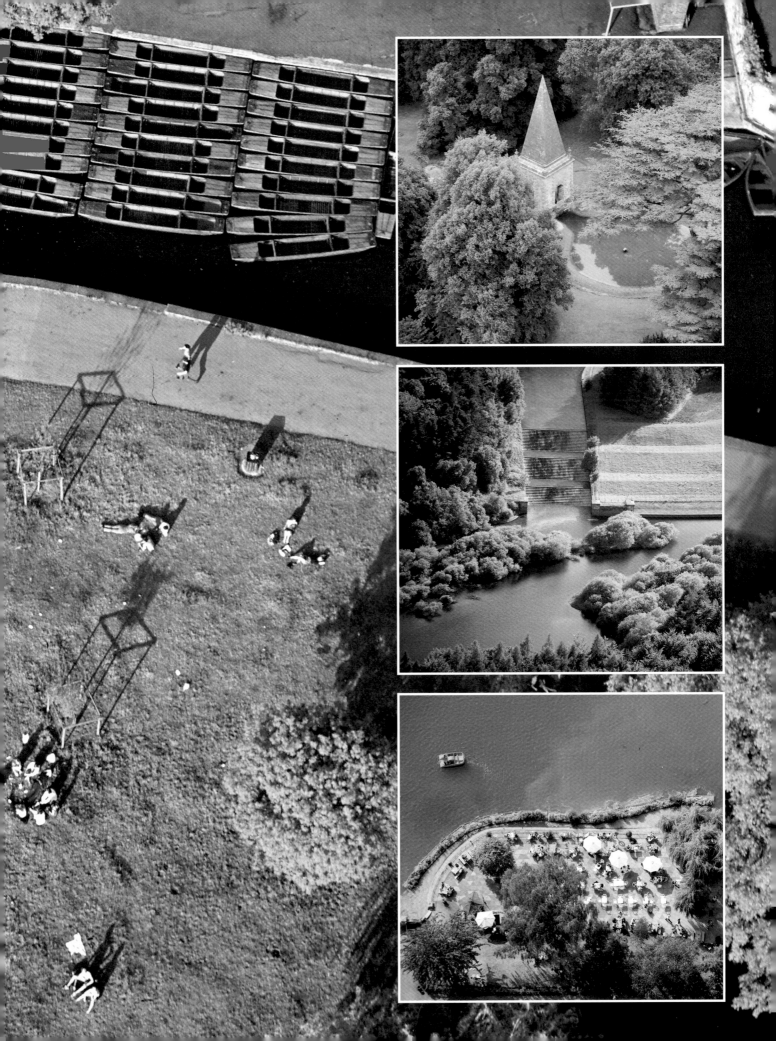

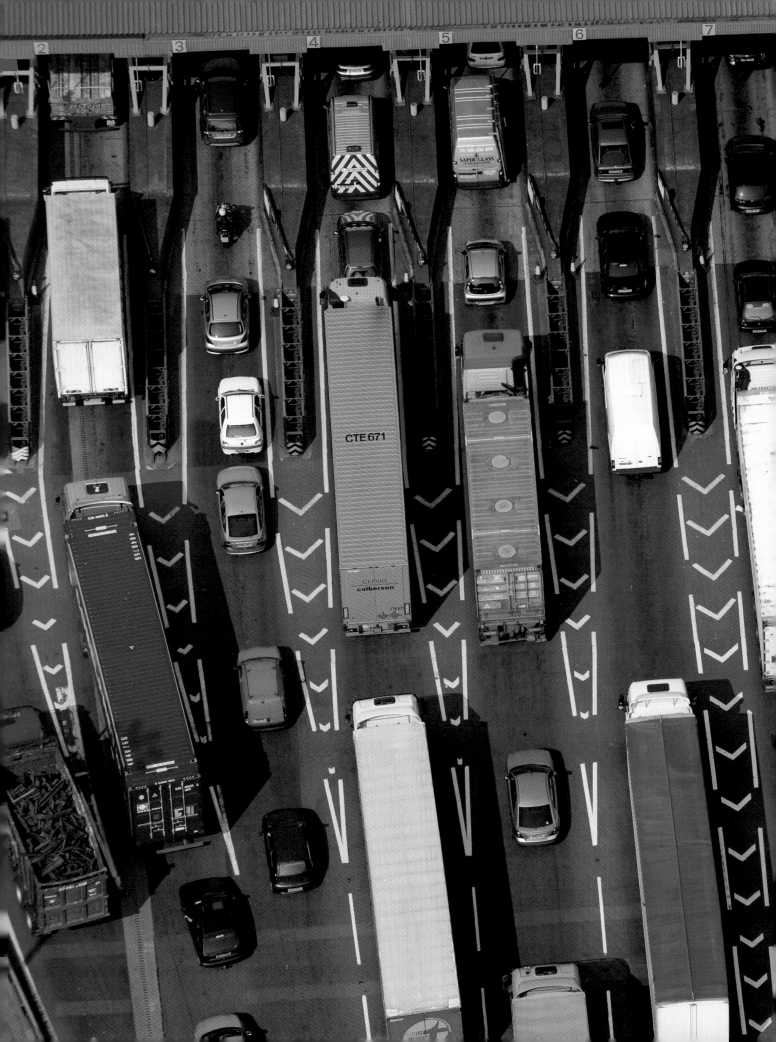

Queues of traffic always catch my attention, especially when I'm flying home and spotting the jams I'll be stuck in once I'm on the ground. The road markings at the Dartford Crossing make this scene look like a slot-car racing game, with the starting grid packed with vehicles of all shapes, sizes, and colours.

On its own, water is often spectacular, but it takes on a whole new life when boats come in to view. Whether it's fishing boats moored in the harbour, yachts weaving their way out to sea, a line of pedalos heading for shore, or a roaring speed boat, there's something satisfying about the sight of boats on water.

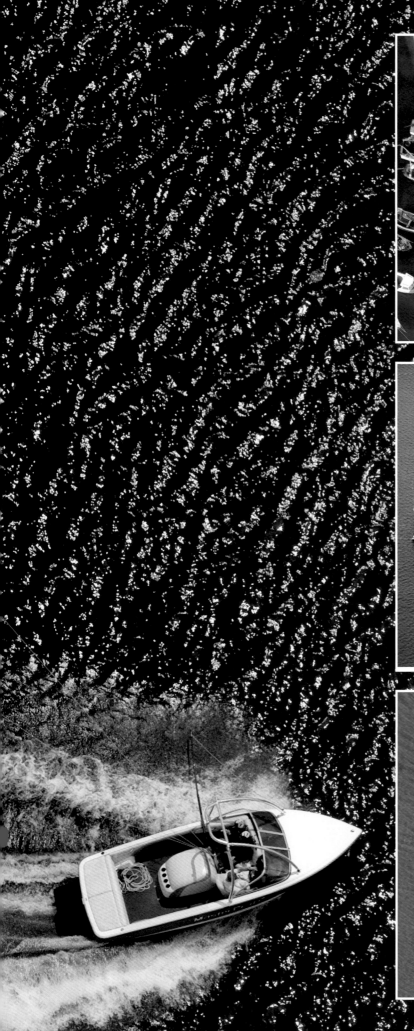
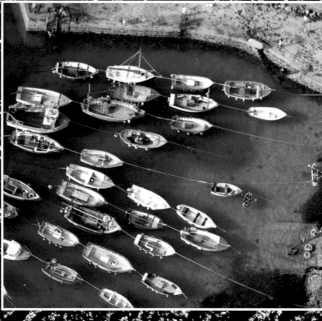
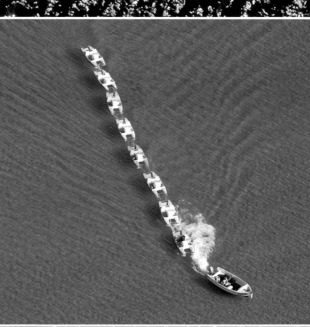

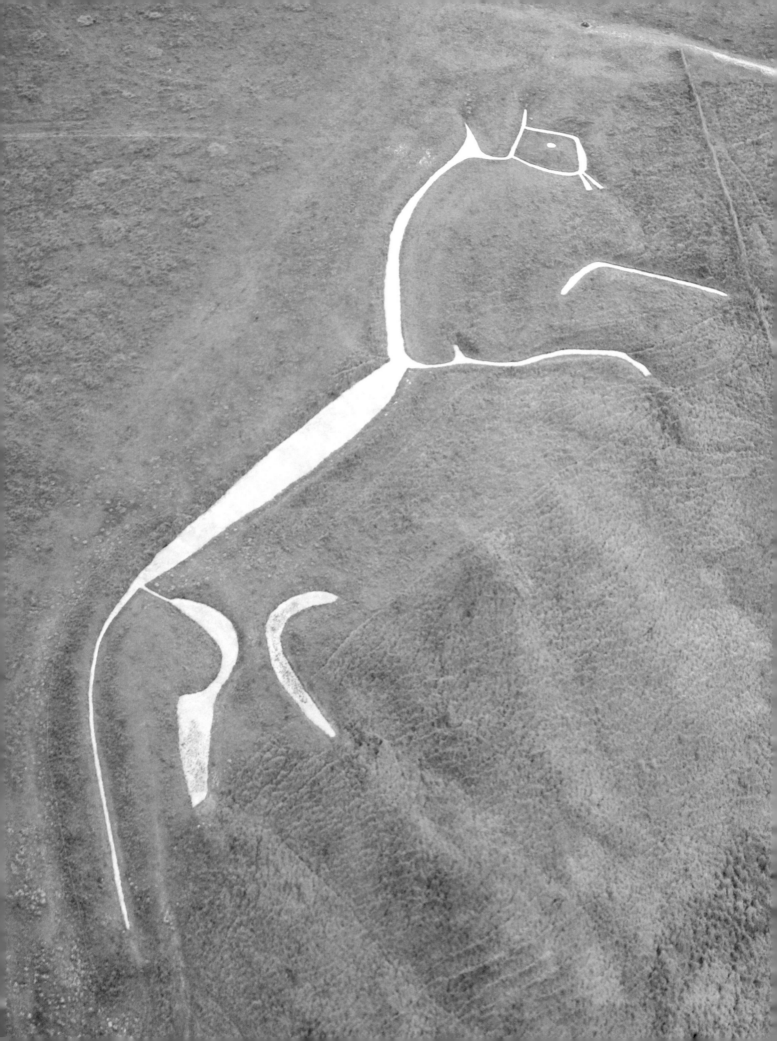

Chalk hill figures are best viewed from the air, but the people who created them would never have had the chance. The Uffington White Horse (opposite) dates back some 3,000 years to the Bronze Age. The Cerne Abbas Giant (this page) is a relative youngster, having been created just 400 years ago.

From directly above, the remarkable hexagonal volcanic columns of the Giant's Causeway, which number more than 40,000, look like a vast, intricate honeycomb. On the ground the effect is of a magnificent, if uneven, pavement. For an idea of scale, can you spot the person looking up at us?

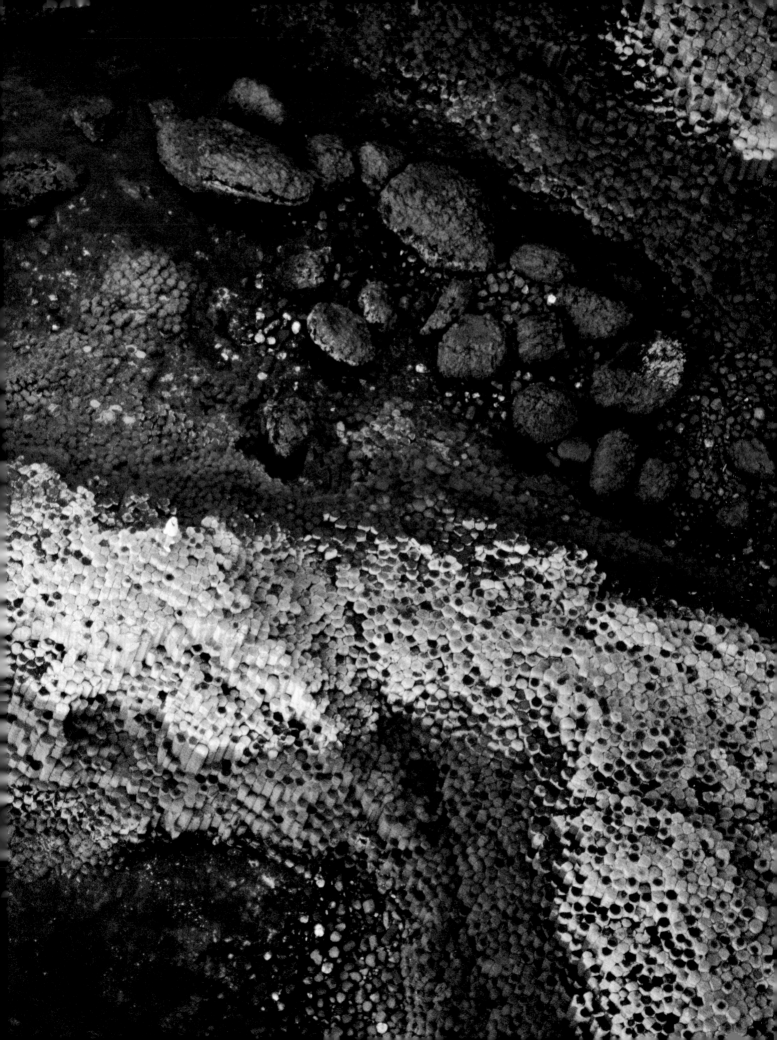

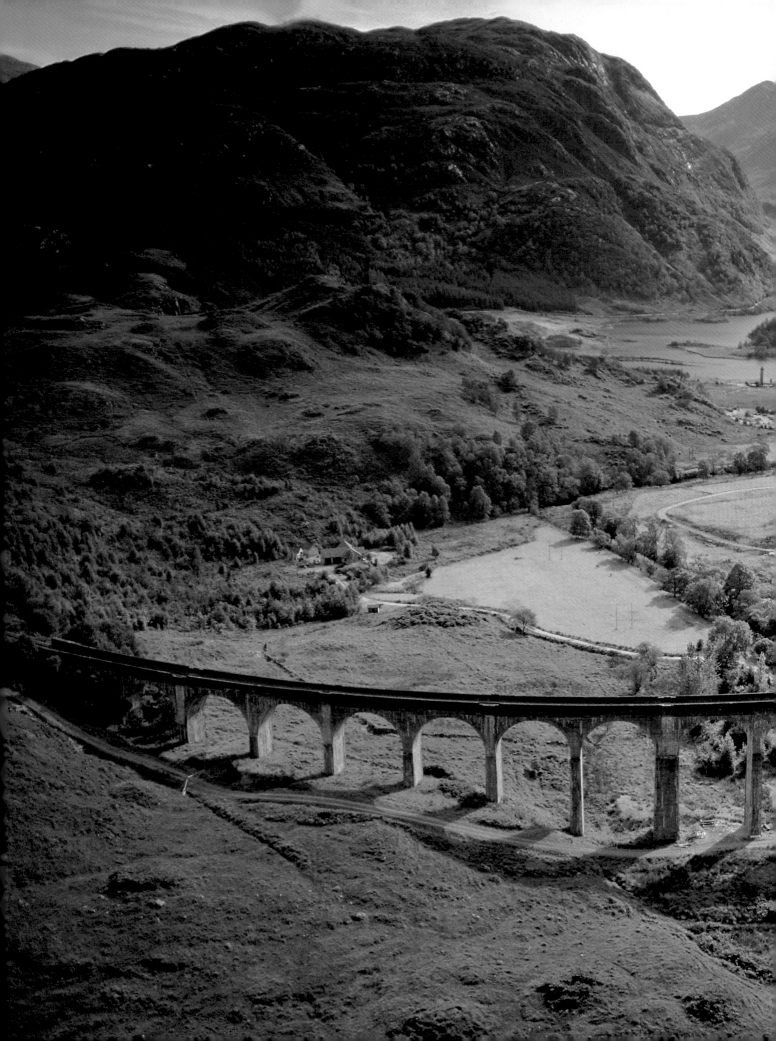

The Glenfinnan Viaduct was once renowned as the UK's largest concrete viaduct. Its appearance in the Harry Potter films, with the Hogwarts Express hurtling across it, has since made it world famous. Its location is so picture-perfect that the film-makers would have created it if it didn't exist.

The suburbs of major cities are absolutely huge, they go on for miles and miles. With its symmetrical street layouts and row upon row of identical buildings, this looks like an enormous Monopoly board. If you were walking past the houses you'd never imagine that there was so much hidden greenery.

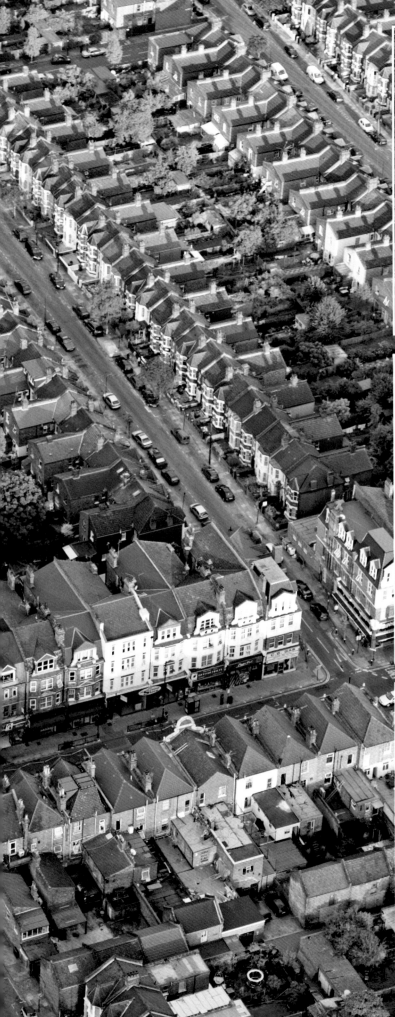
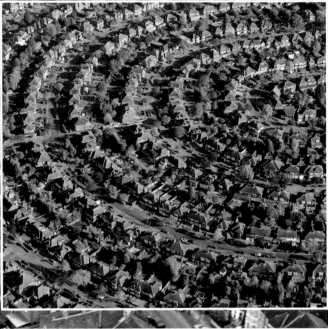
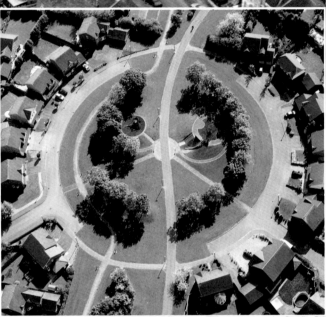

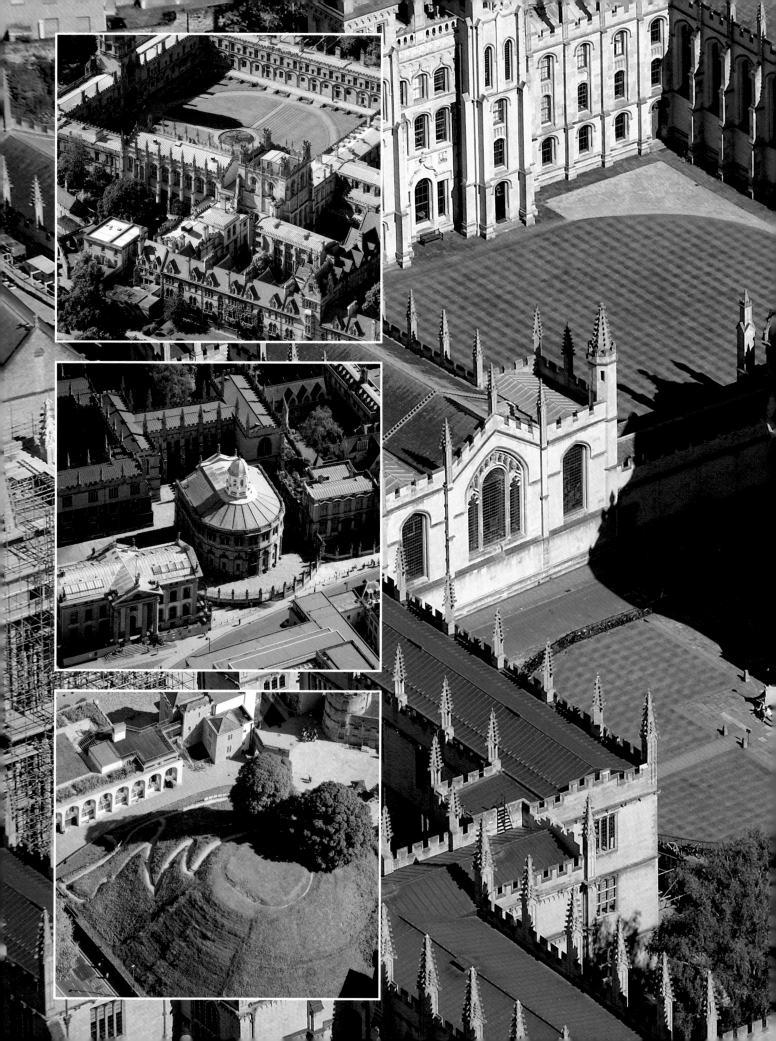

From the air, Oxford looks like the most peaceful little place in the world. With its ornate dome and gentle curves, the Radcliffe Camera, built in the 1700s, looks very content sitting among the dreaming spires. The zigzag path slicing its way up the Castle Mound seems a little incongruous in comparison.

When you're skimming the cliff tops at Beachy Head, and the ground beneath you falls away, it feels pretty scary. There are a couple of cables that stretch from this lighthouse to the cliffs behind, but you can hardly see them until you're right on top of them – which we discovered almost to our peril.

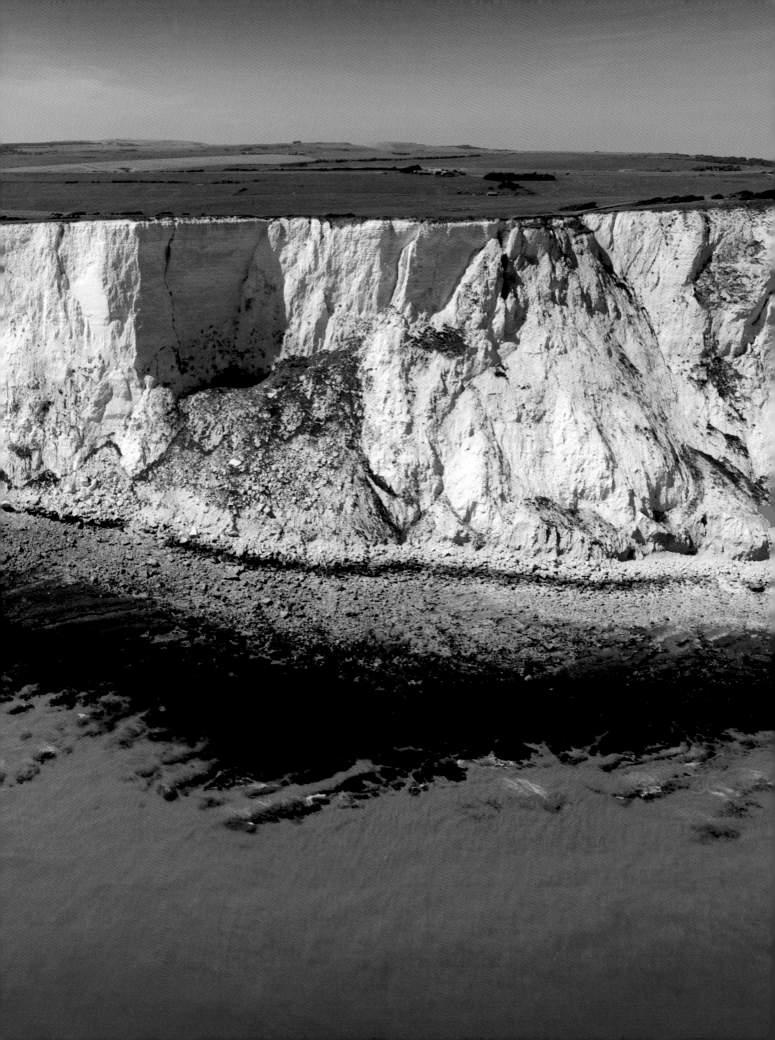

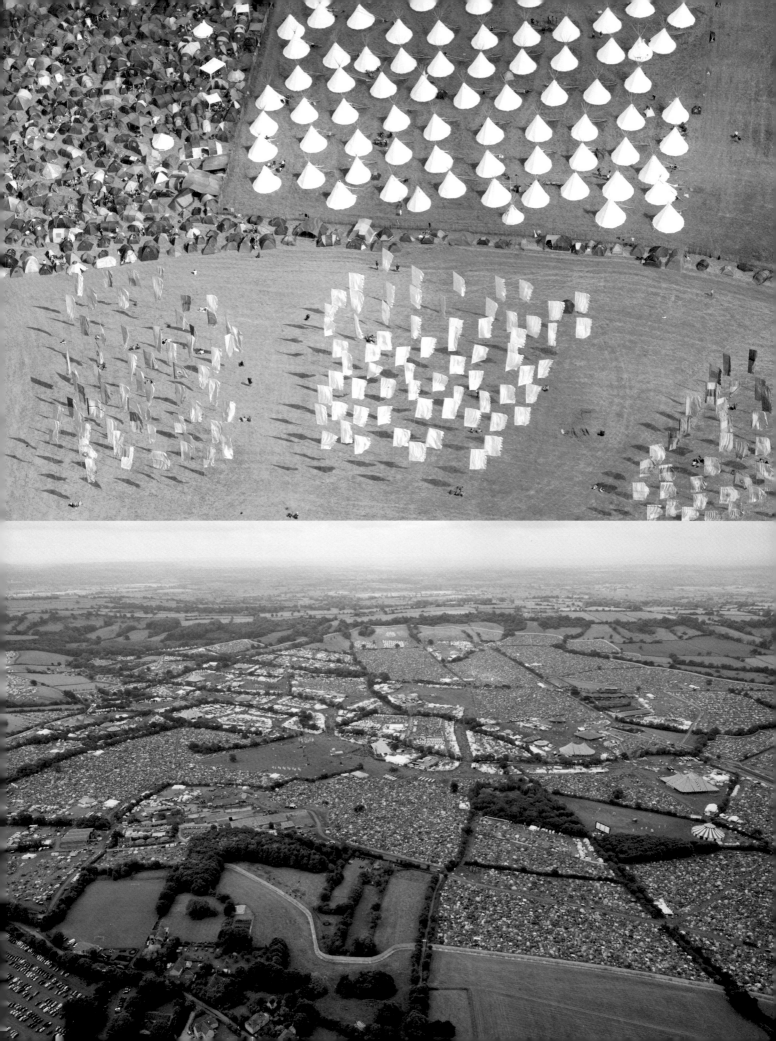

The Glastonbury Festival is like a small city that springs up out of nowhere each summer. It's got its own heliport and there are quite strict air traffic restrictions. We arrived there far too early one Saturday morning and hardly saw any people. We think they were all still asleep in their tents.

Because I'm always approaching landmarks from different angles and in varying weather conditions, they can often go unnoticed. I've flown over this park dozens of times without really registering that it's there. Now they've repainted the paddling pools in these vivid hues, I can't miss it.

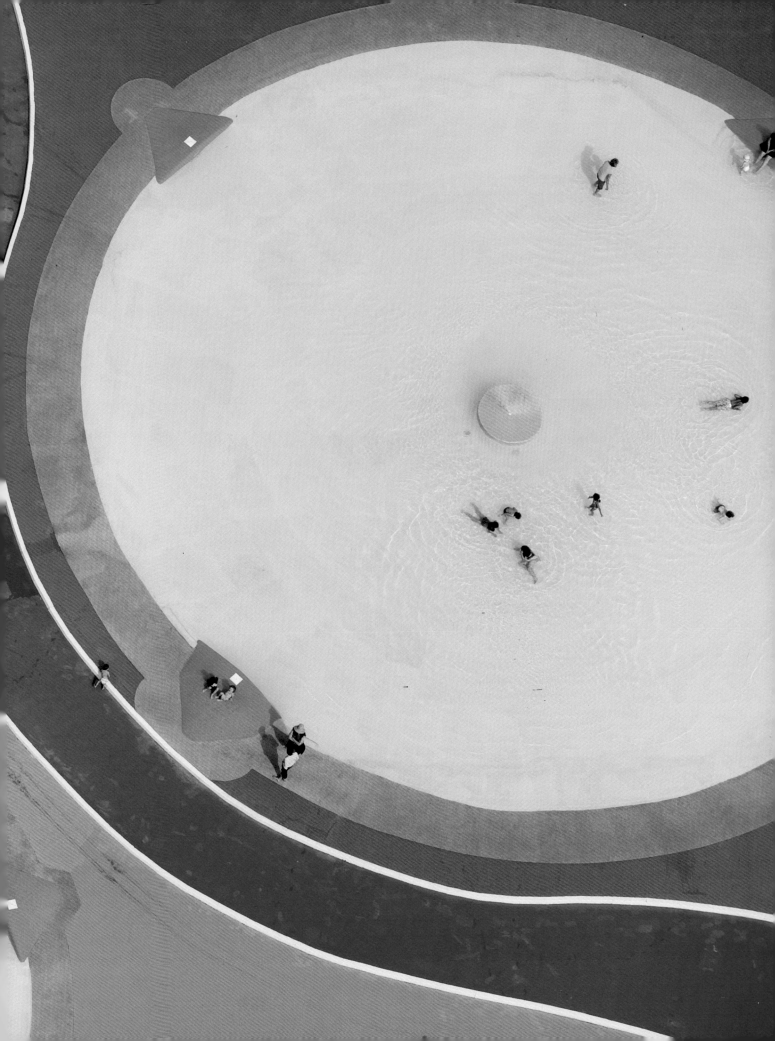

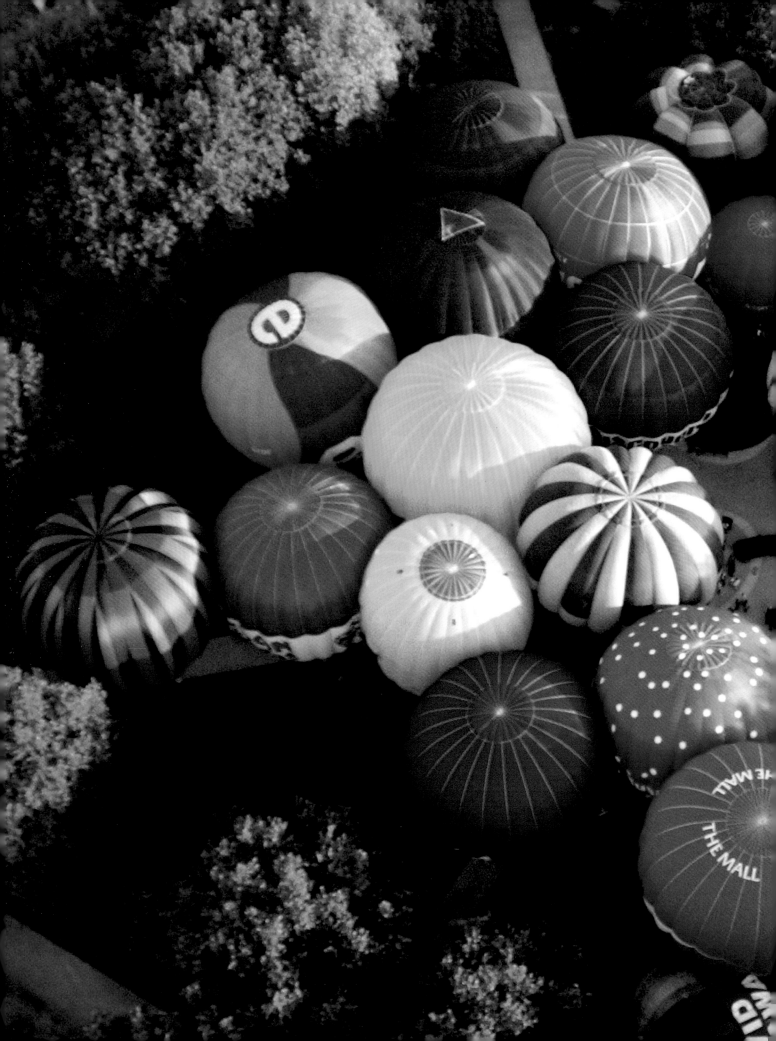

This isn't something I get to shoot often, as helicopters and hot air balloons don't really mix – for obvious reasons. This jolly bunch look as if they're hiding behind the trees in this Bristol city-centre park, waiting to sneak out while no one's looking and fill the early morning sky.

Although it looks like a tropical island, Samson is the largest of the uninhabited Scilly Isles. Today it's a protected wildlife site and home to a large colony of terns and gannets. A small community of people lived there from the late 1600s, but the last human inhabitants left in 1855.

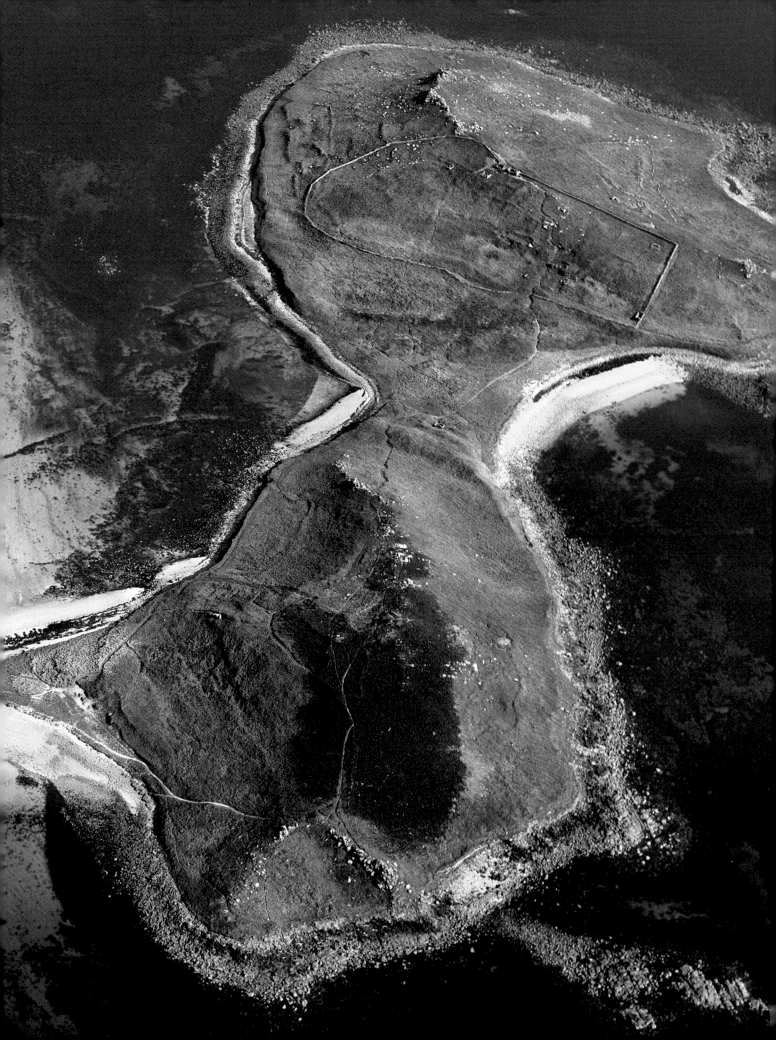

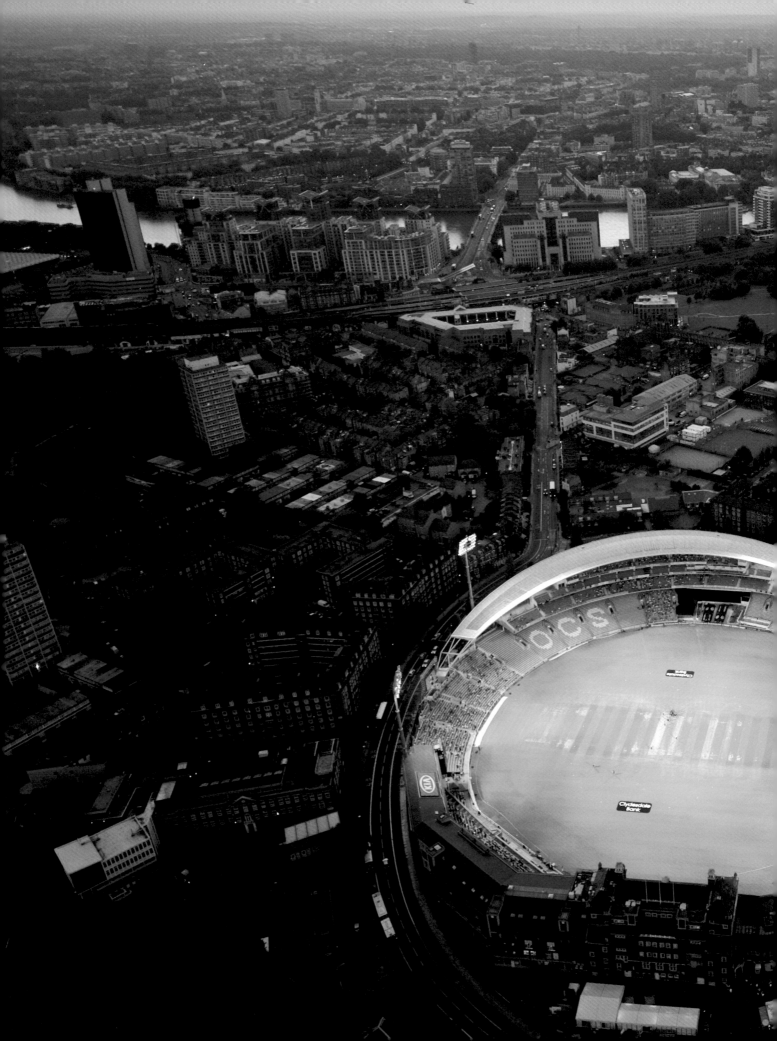

Late one summer's evening, we were heading back to base when the Oval Cricket Ground caught my eye. The floodlit, perfectly manicured grass has a vibrancy that makes it look like the focal point of the city. Looking north towards the Thames, the ground glows as all around darkness gathers.

Here are two very different peninsulas. Brighton Pier (this page), with its brightly coloured fairground, looks like a delightfully welcoming, perfectly placed outcrop, while Start Point (opposite) reaches into the sea like a gnarled finger, and is one of the most exposed strips of land in the whole of the UK.

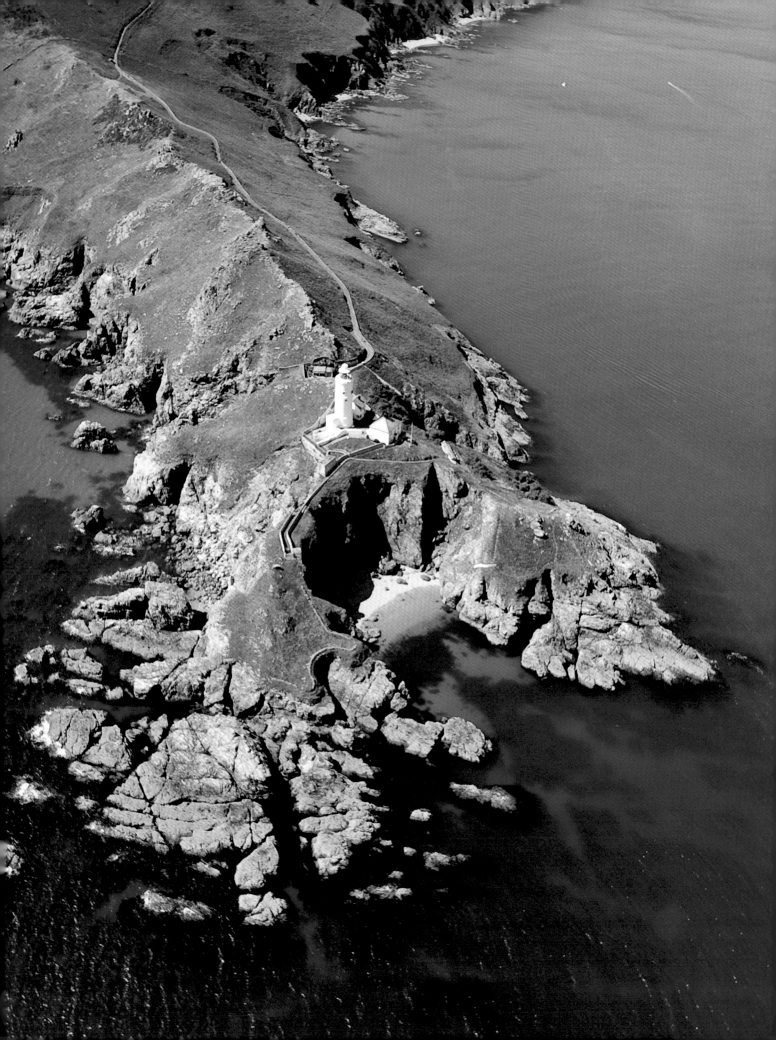

In the summer months, the heathlands of the Quantock Hills are carpeted with gorse and heather as far as the eye can see. As well as enjoying astounding landscapes like this, the whole area is steeped in history. It's been occupied since prehistoric times and is dotted with Bronze- and Iron-Age sites.

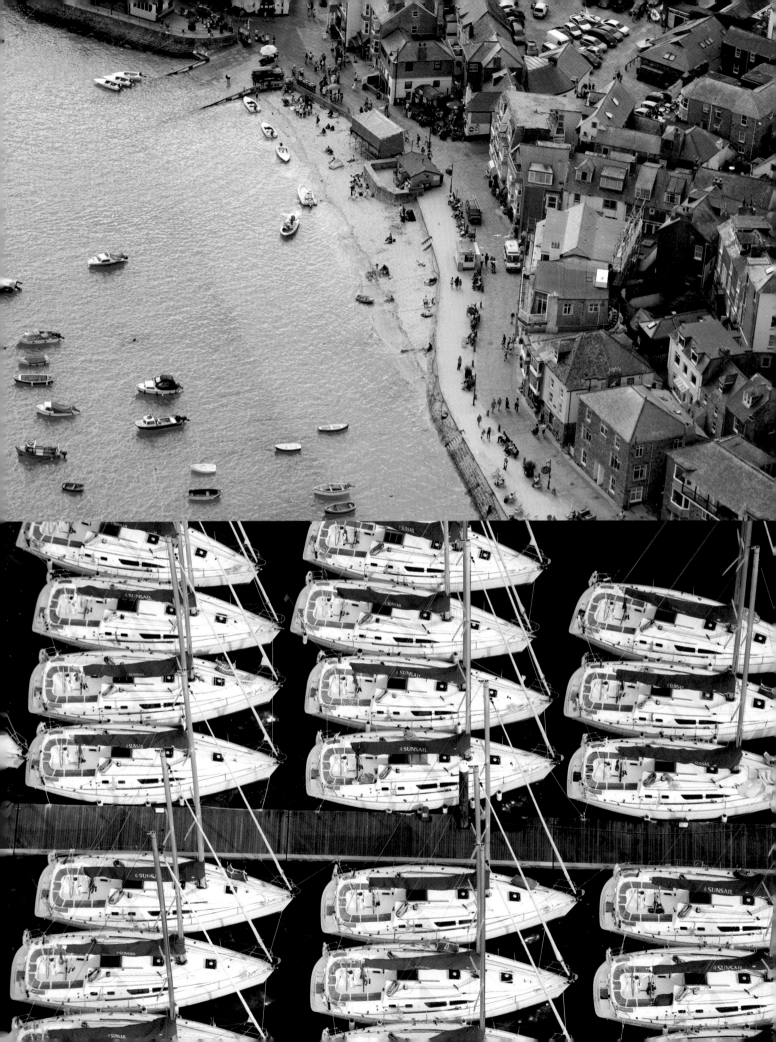

The coastline is such a rich source of imagery, especially in the summer. Whenever I see more than one of anything lined up, like the identical sailing boats, out comes my camera. The funny thing is, from the sky you don't ever see sailing boats moving. It's like the scene has already been frozen in time.

By helicopter, I can leave London at breakfast time, photograph stunning Welsh scenery, and be home in time for tea. After days like that I struggle to sleep because of all the amazing images in my head. Caerphilly Castle is hard to shake. With its slate-grey walls and huge moat it looks like the perfect toy fortress.

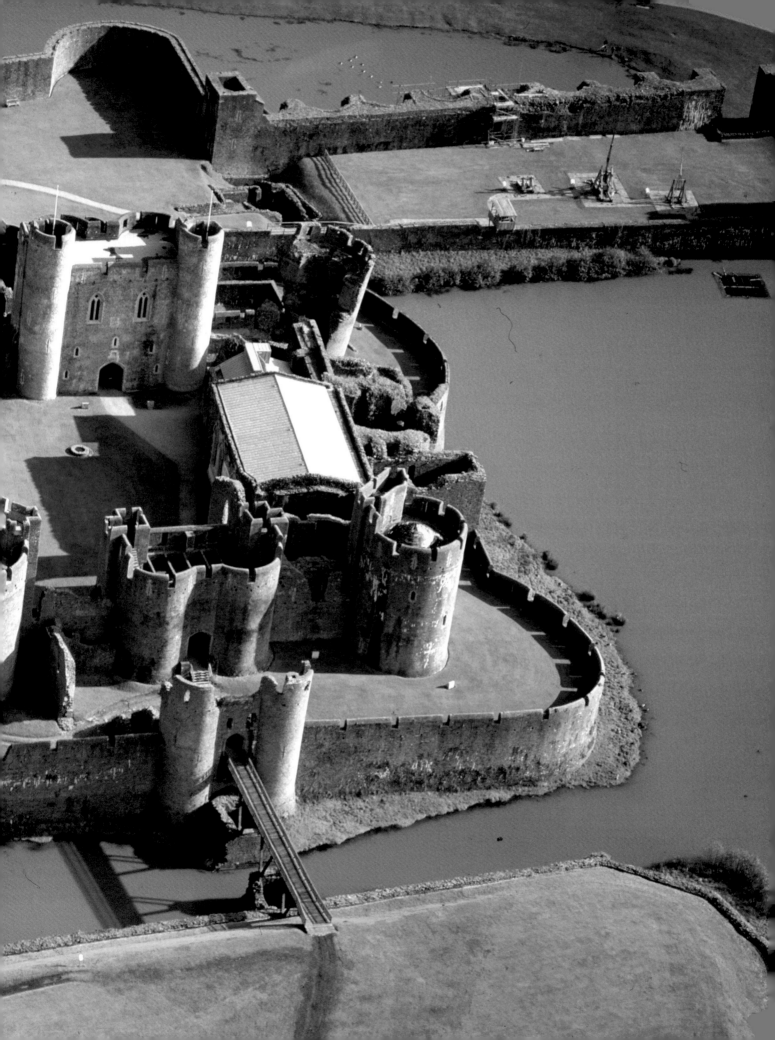

The first Tall Ships Race, in 1956, was intended as a farewell to the era of these magnificent vessels, but it proved so popular that today more than 100 ships like this gather each year to race. They're a majestic sight that attracts a huge flotilla of onlookers as well as curious photographers in helicopters.

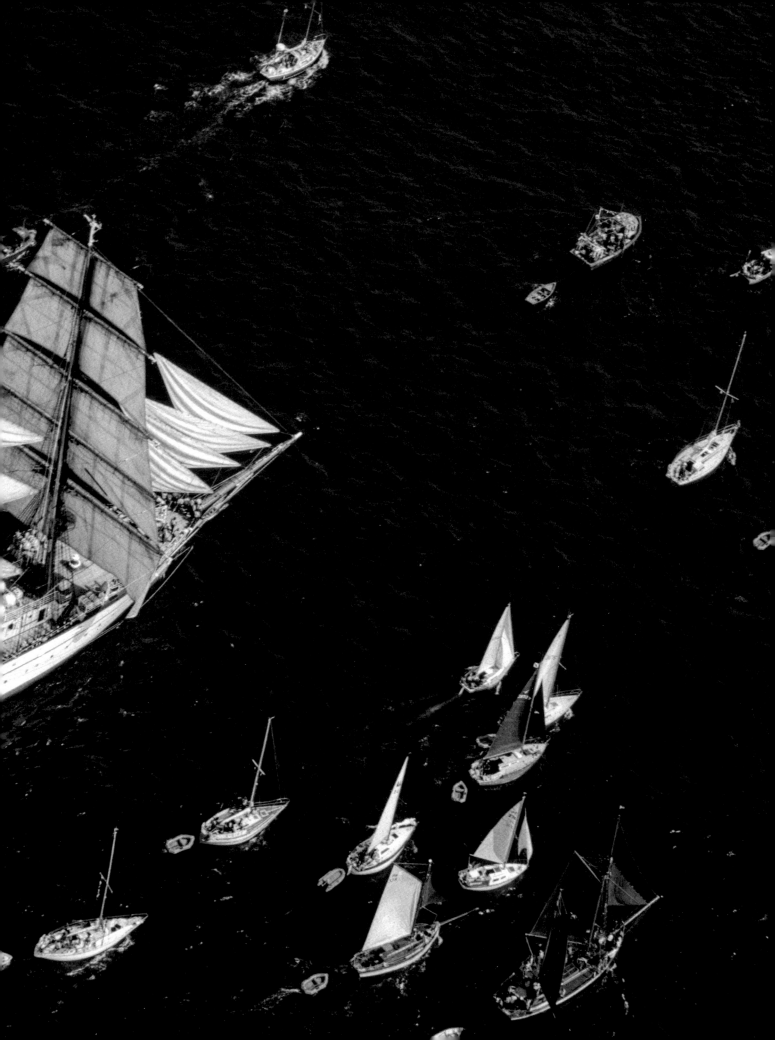

The bleak-looking Longships Lighthouse is located on one of a group of rocky islets just over a mile off Land's End. This is the extreme south-westerly point of the British mainland. The churning sea looks very dramatic, but the conditions can't have been too hair-raising as we don't fly in stormy weather.

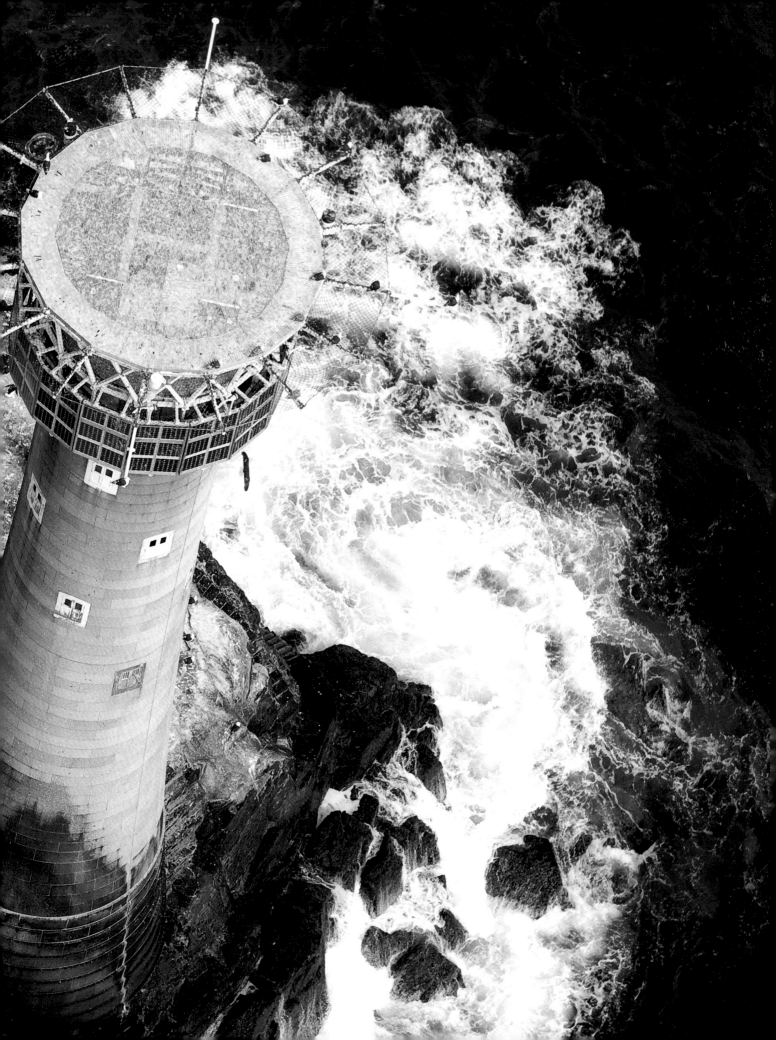

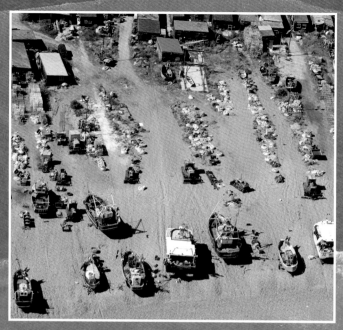
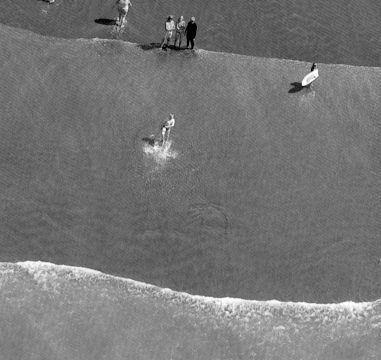

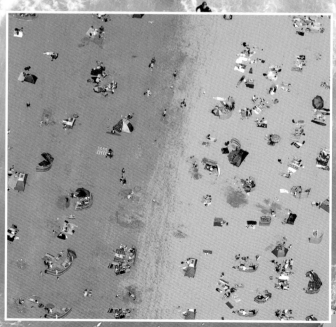
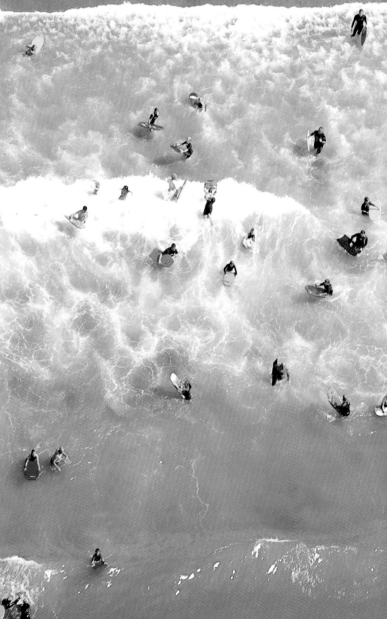

There's such a lot to catch the eye at the seaside – the gaudy beach paraphernalia dotting the sands; the foaming crests of the waves; fishing boats; windsurfer sails scattered like insect wings. Looking down on scenes like this I'm always amused to see how evenly people distribute themselves in a given space.

Getting a shot looking straight down involves putting the helicopter on its side, so you've only got a few seconds to get it right. It's an uncomfortable way of taking a picture, but entirely worth it when you get an image like this, with the slate-grey cliffs seeming to disintegrate into the swirling blue sea.

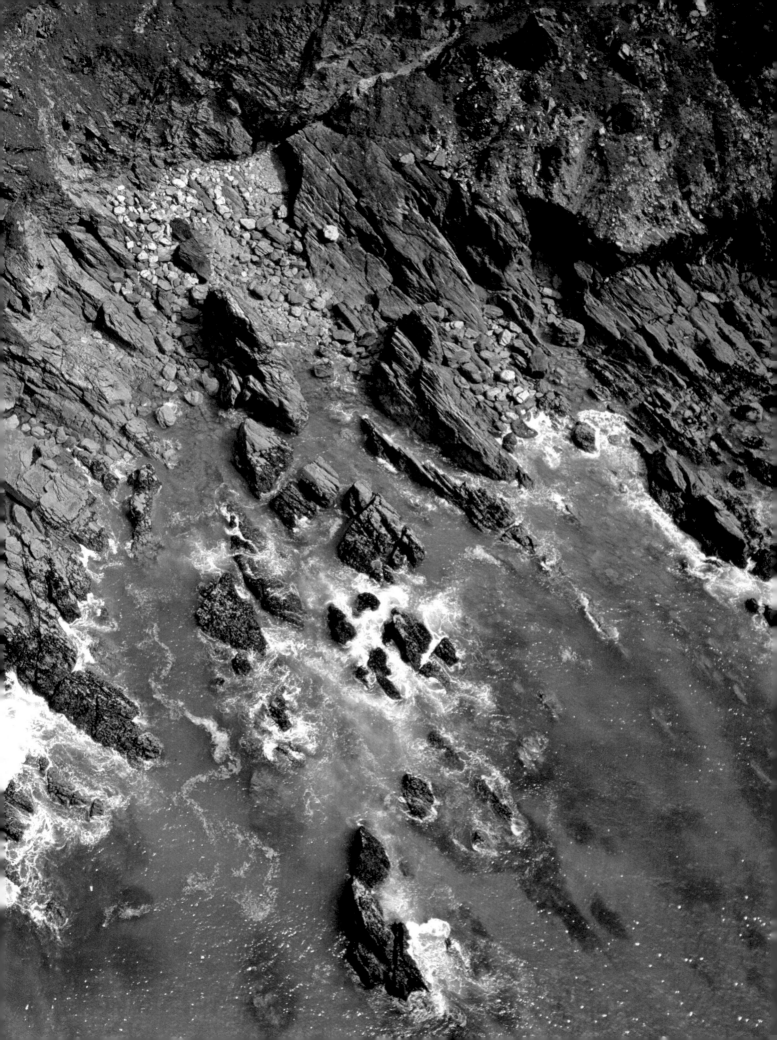

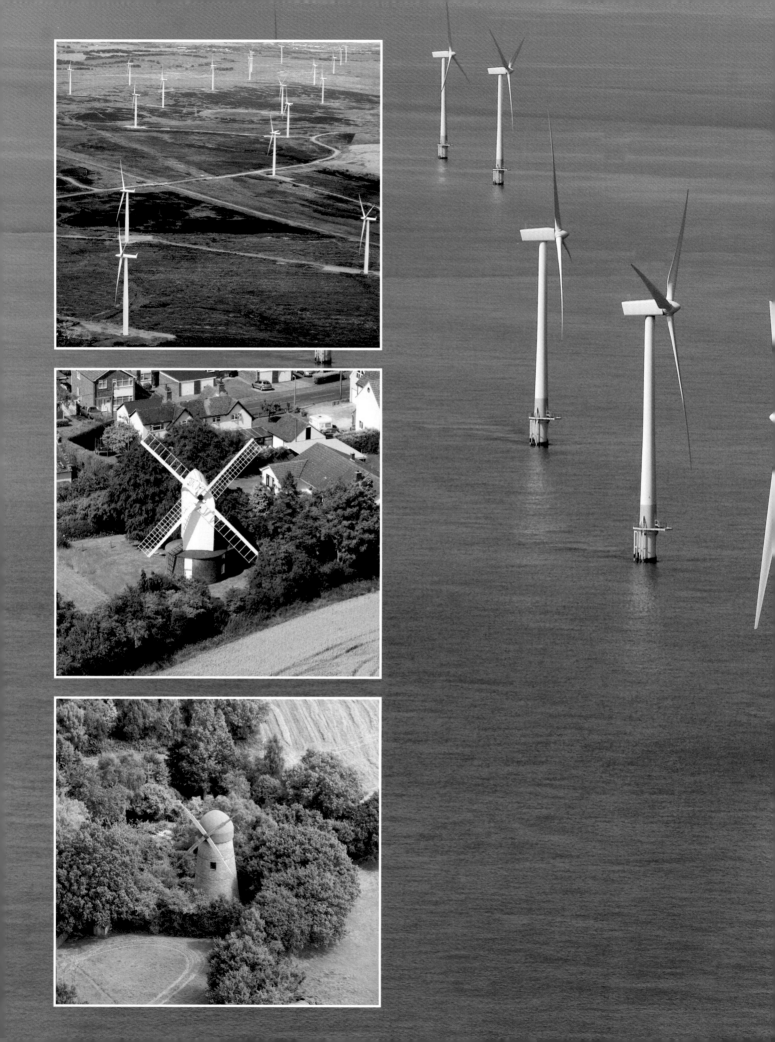

Traditional windmills are always photogenic, but modern methods of harnessing the power of the wind are no less impressive. Some consider wind farms a blot on the landscape, but I love them. Out at sea you have no sense of scale, so you can't tell if the turbines are 50 feet or 500 feet tall.

When you see the spiritual tranquility of Lindisfarne, it's not hard to understand why St. Aiden chose to found his monastery here in AD635, or why it became such an important site of Christian pilgrimage. It's a tidal island and visitors should beware – the access road is completely submerged at high tide.

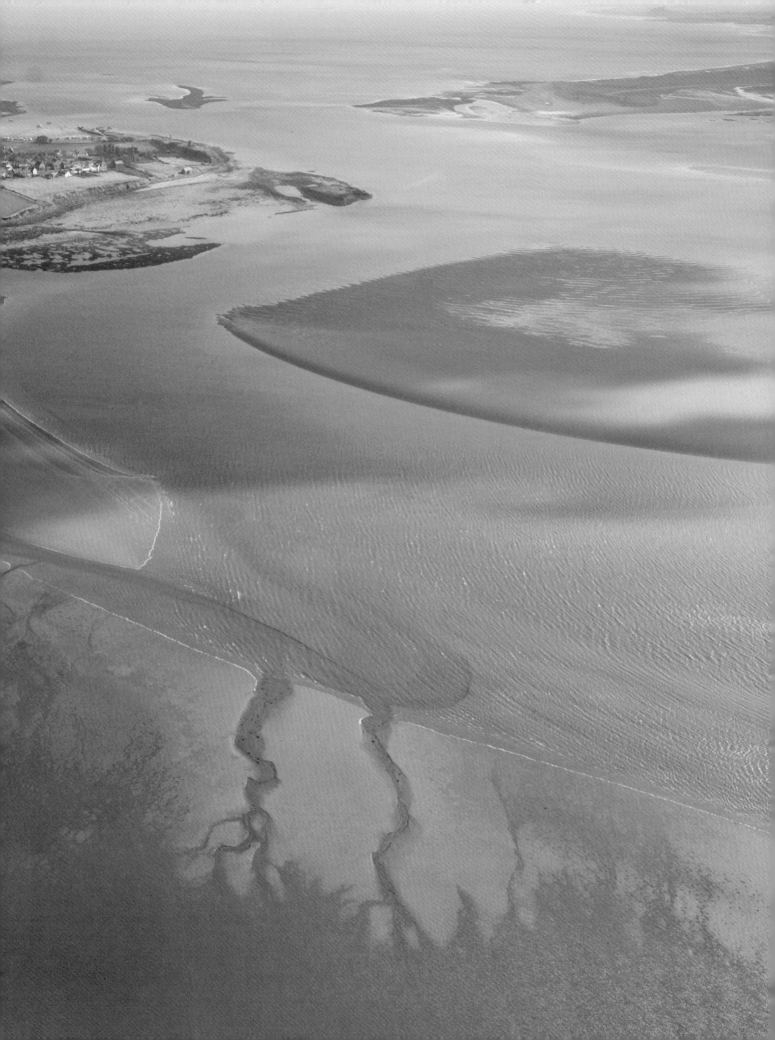

The annual Military Tattoo takes place on the esplanade of Edinburgh Castle every August. Featuring over 1,000 performers, it is the UK's largest gathering of military musicians. Day or night, the castle is a glorious sight, but to see it packed full of marching bands really brings this grand old building to life.

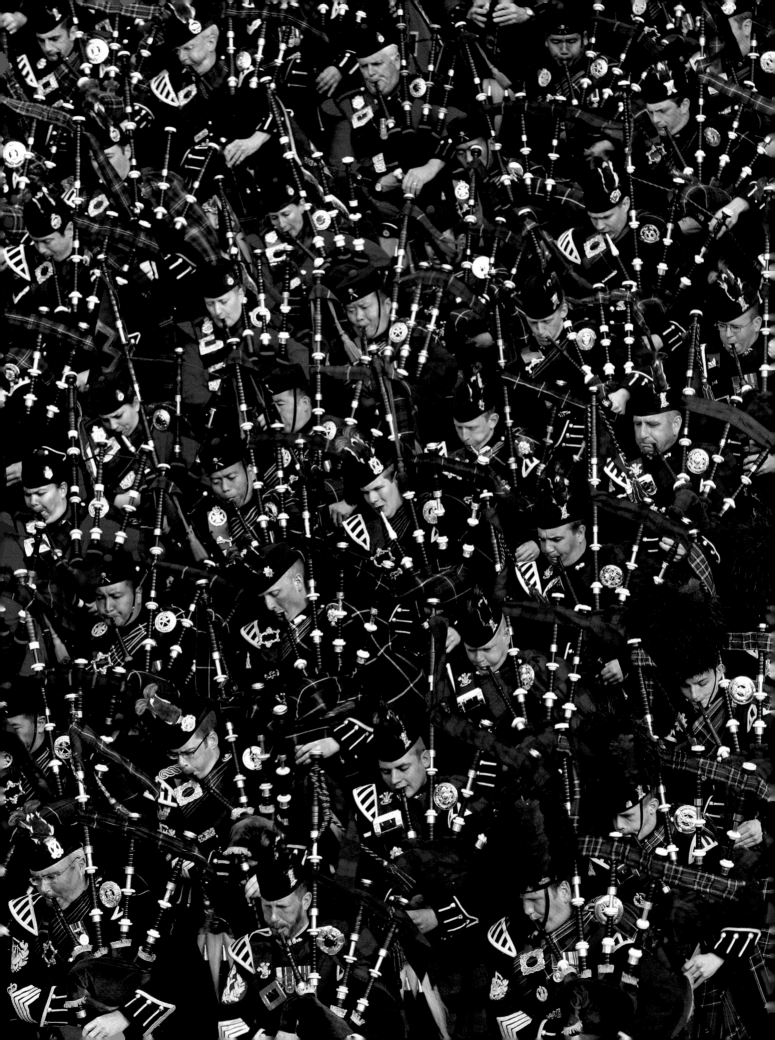

AUTUMN

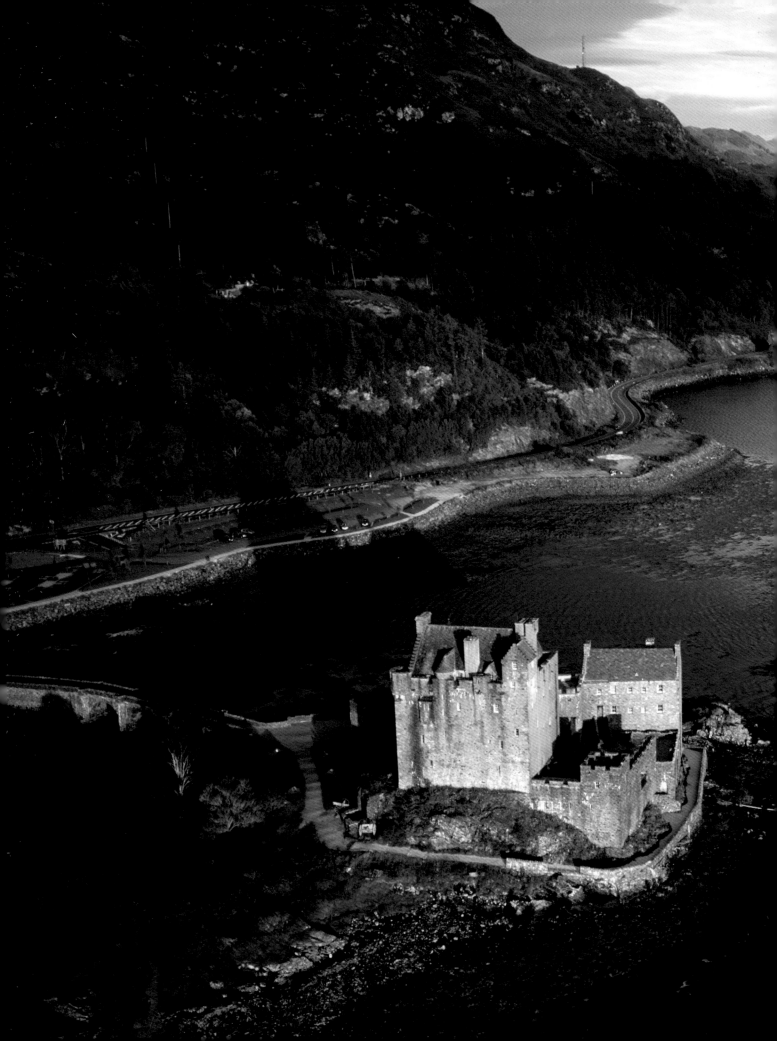

Eilean Donan Castle sits in a stunning location on the west coast of Scotland at a point where three lochs converge. If you're lucky enough to be here in the "golden hour" just before dusk, you'll see the castle caught in the last rays of the setting sun, as if illuminated by a spotlight.

The rooftops of city office blocks sometimes reveal the most unexpected sights. More and more often I'm spotting these green oases high above the hustle and bustle of the streets. Because they're built into existing spaces the design of these gardens in the air tends to be really inventive.

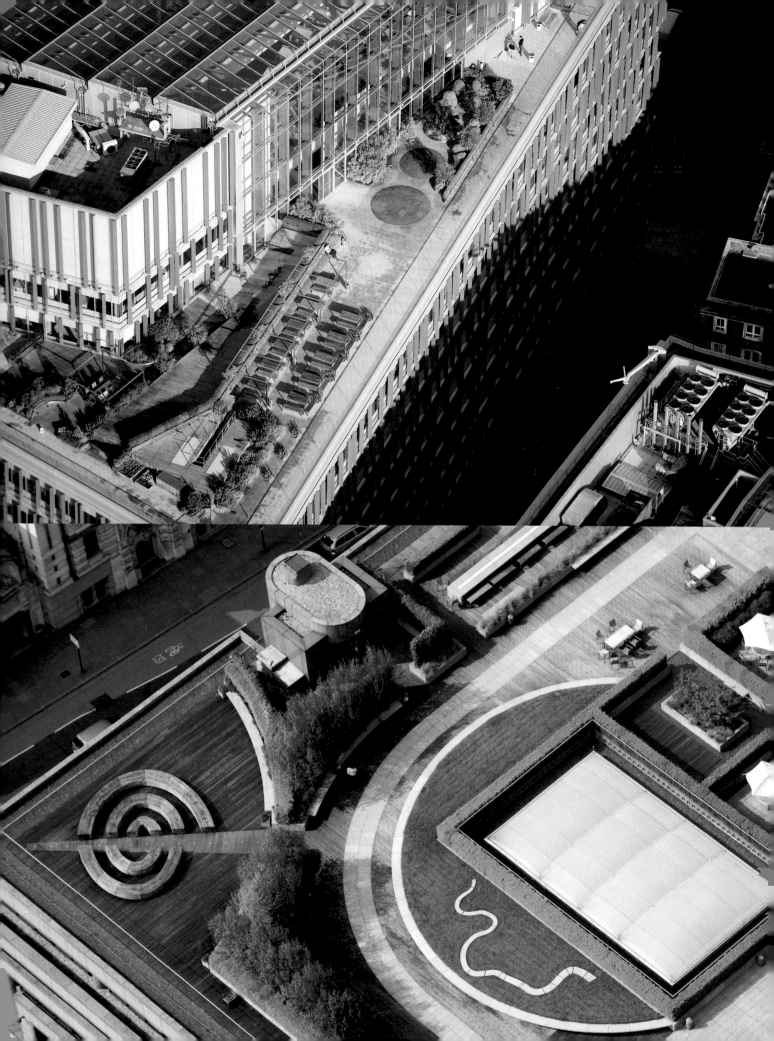

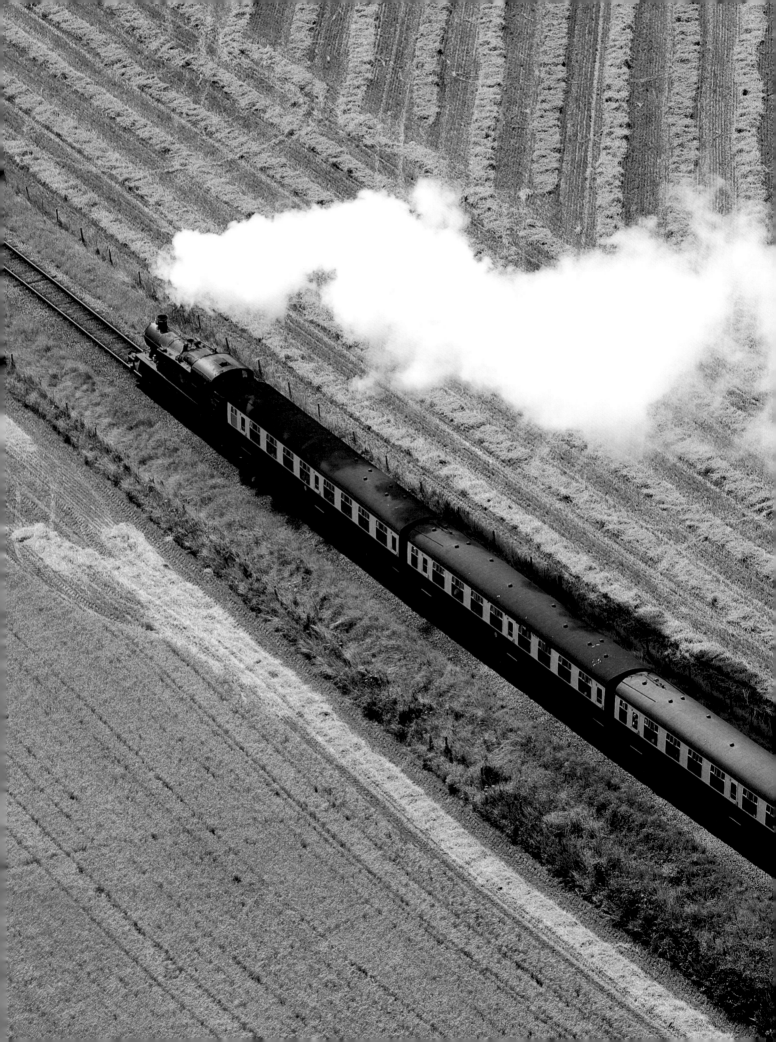

When we noticed the pure white plumes drifting skywards we had to take a closer look at this steam train making its way through the Somerset countryside. The West Somerset railway is a very pretty heritage line, so I was spoilt for choice when it came to capturing the engine with a perfect backdrop.

We spotted these colourful diggers and tractors from miles away, and I couldn't resist taking a closer look. It turned out to be the sale ground for an agricultural auctioneer, but from up here it looks just like row upon row of the Matchbox toys that I used to play with as a child.

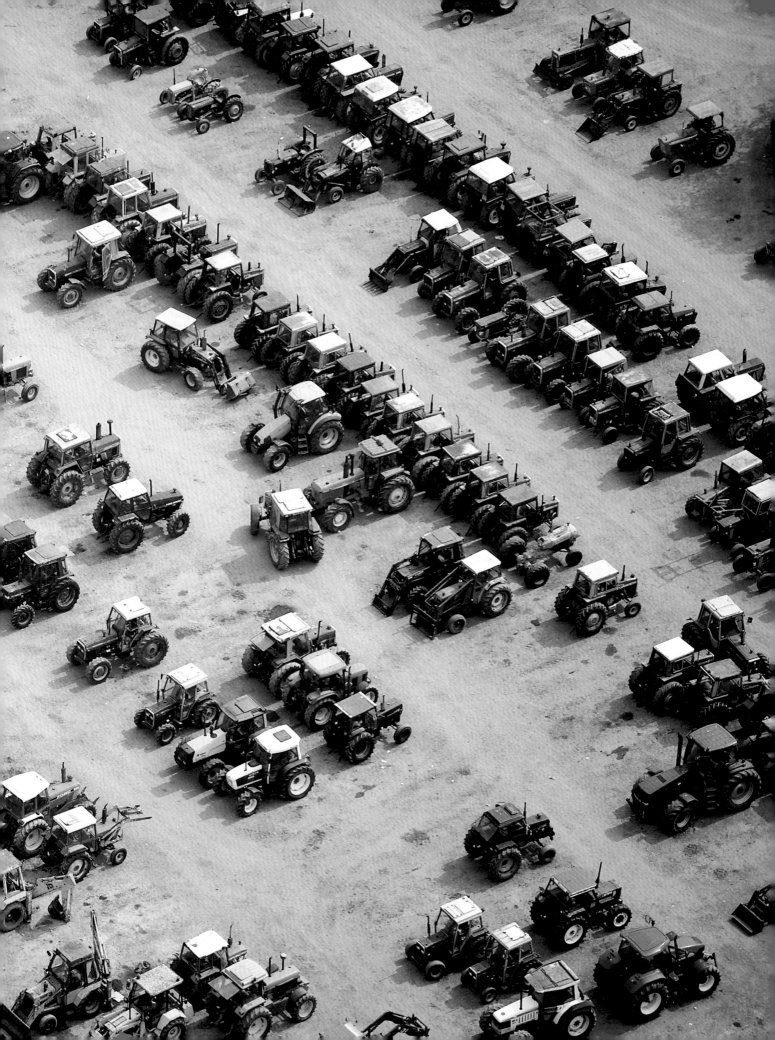

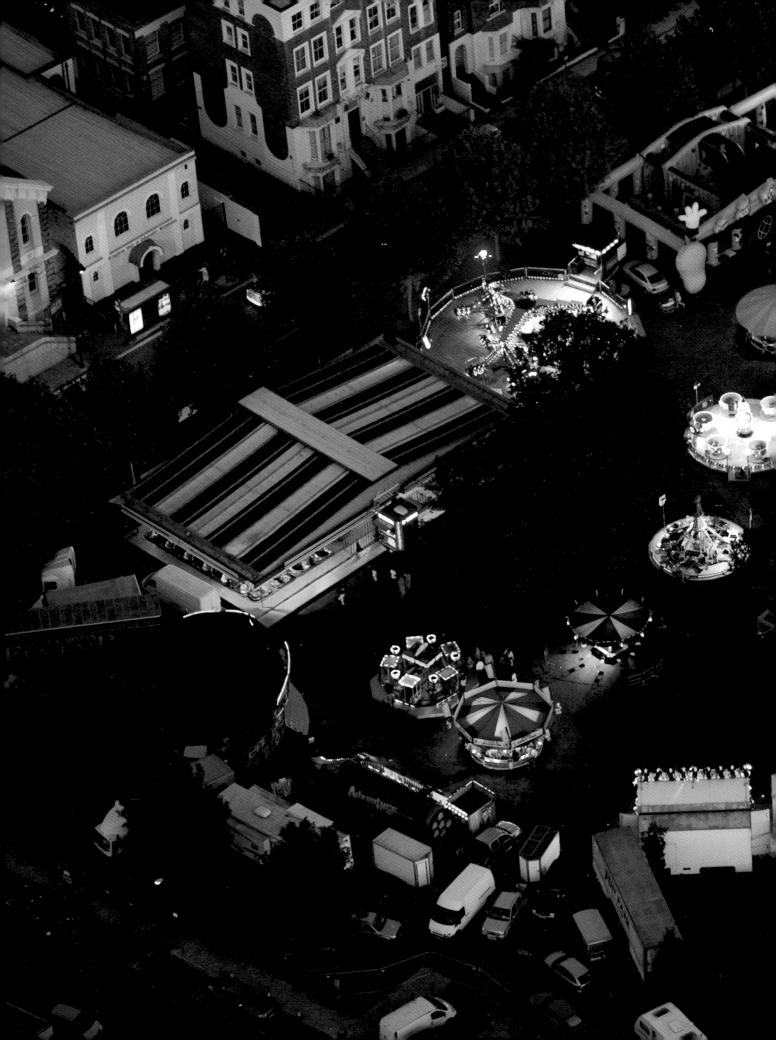

Suddenly stumbling across a fairground all lit up and glowing among otherwise grey surroundings is always such a lovely treat. They really come as a surprise when you spot them slap bang in the middle of the suburbs – it's like discovering a magical little oasis of light and colour.

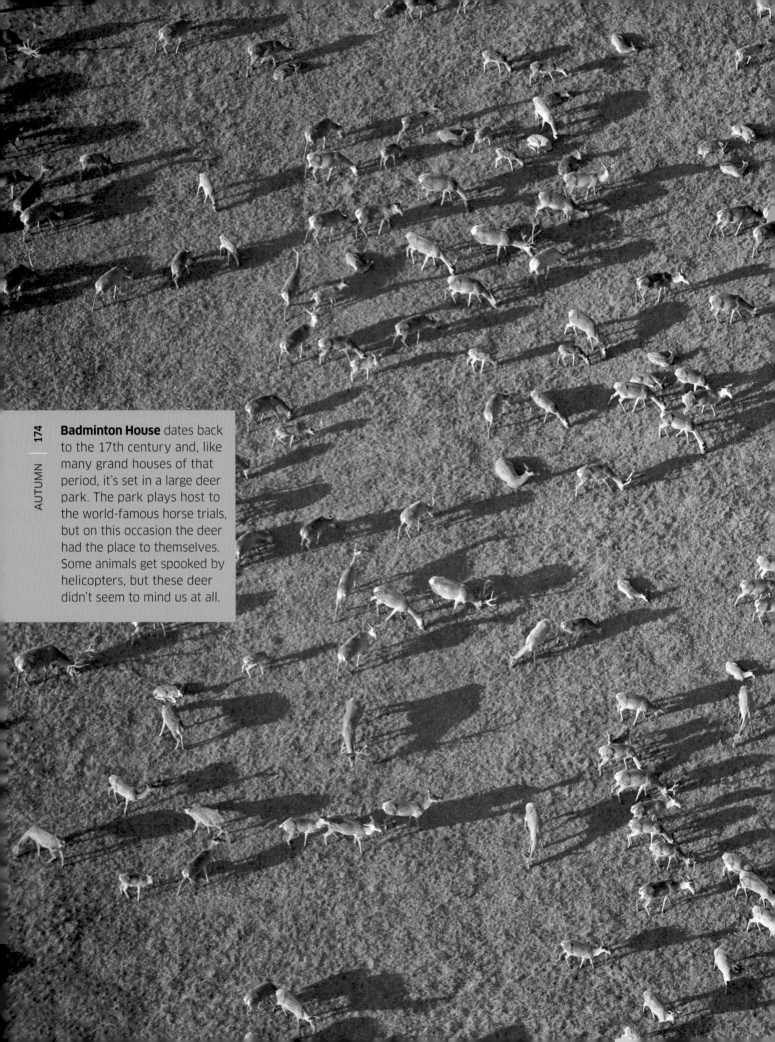

Badminton House dates back to the 17th century and, like many grand houses of that period, it's set in a large deer park. The park plays host to the world-famous horse trials, but on this occasion the deer had the place to themselves. Some animals get spooked by helicopters, but these deer didn't seem to mind us at all.

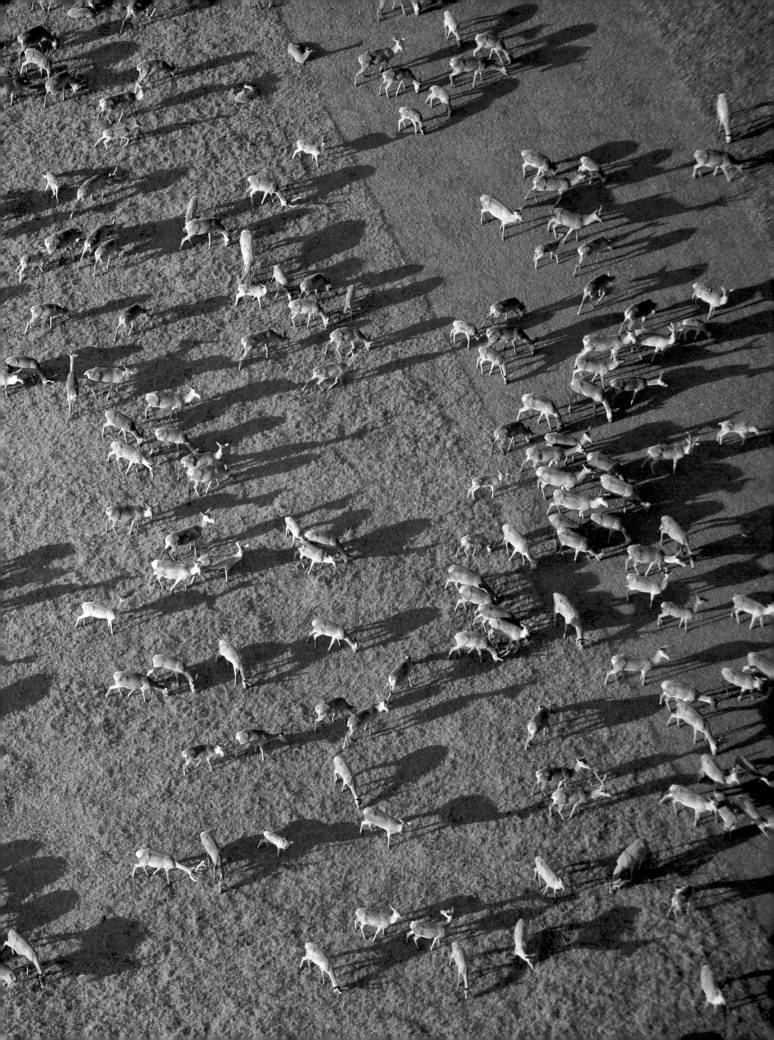

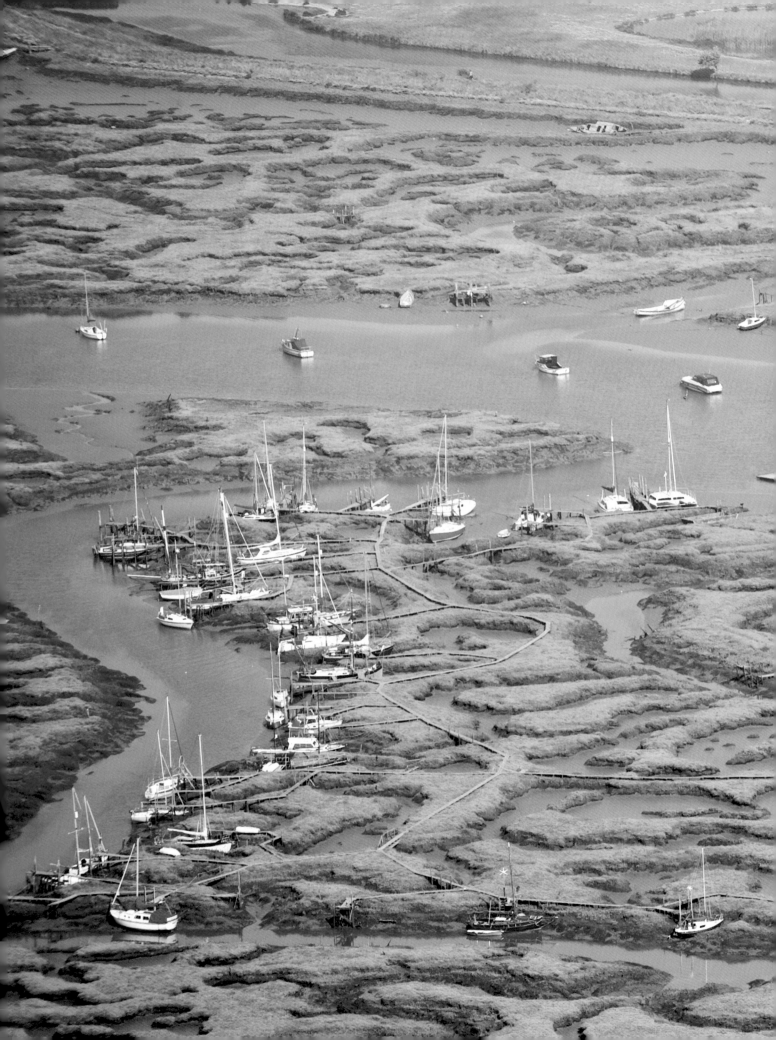

It was views like this, of the Essex Marshes with its maze of inlets, that first inspired me to take up aerial photography for a living. The large red boat is the Trinity lightship, which spent its working life warning shipping of the presence of sandbanks off the coast of Wales and was retired here in 1988.

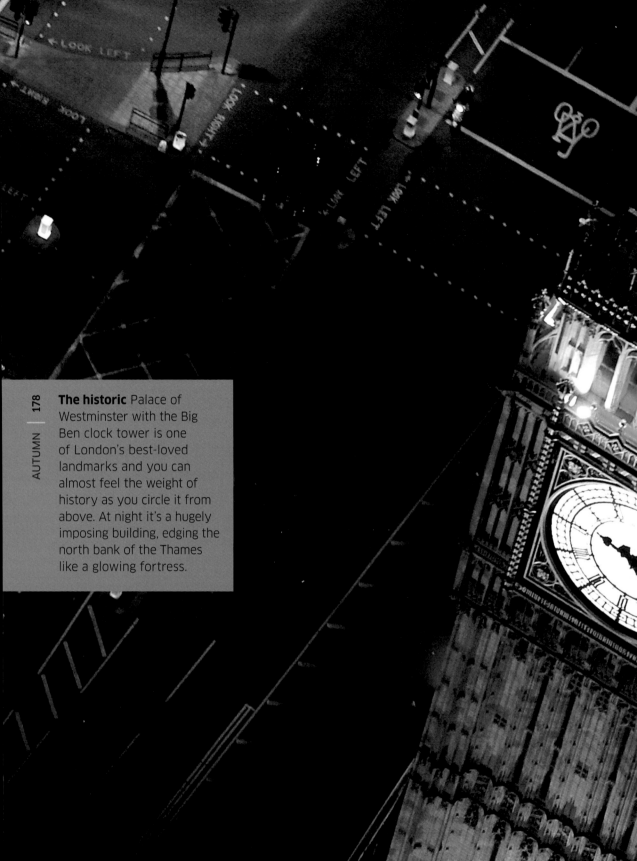

The historic Palace of Westminster with the Big Ben clock tower is one of London's best-loved landmarks and you can almost feel the weight of history as you circle it from above. At night it's a hugely imposing building, edging the north bank of the Thames like a glowing fortress.

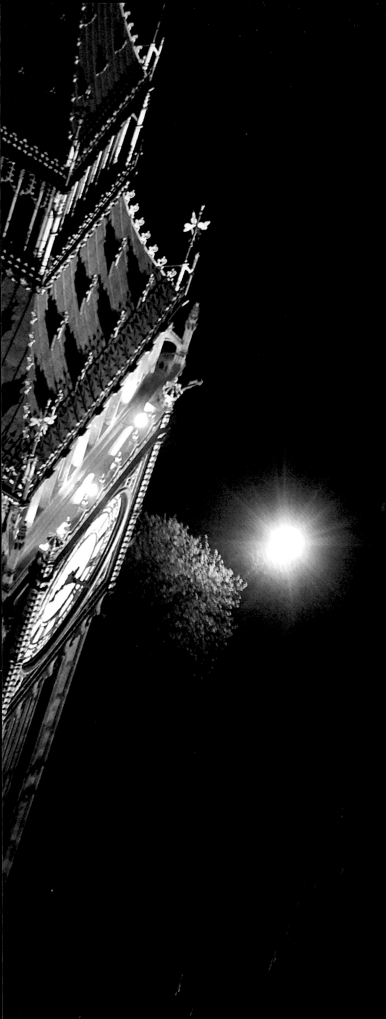
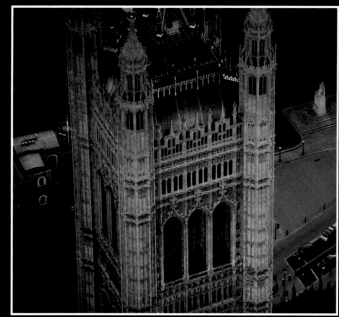
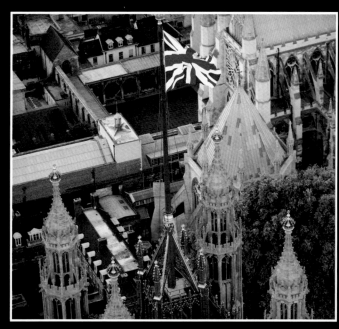
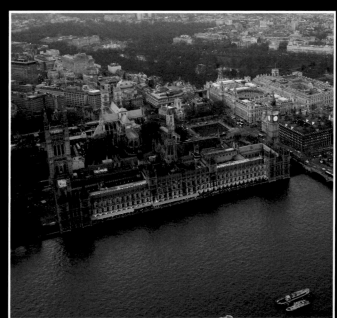

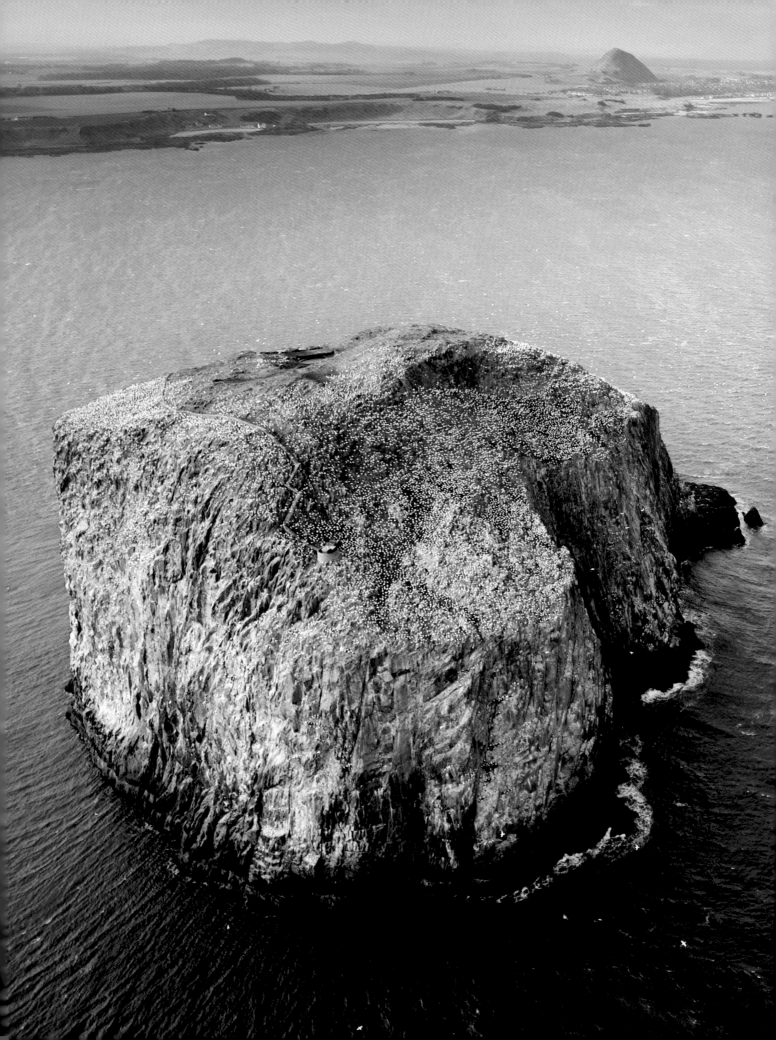

Situated just over a mile offshore in the Firth of Forth, Bass Rock is a Site of Special Scientific Interest. It's home to a colony of some 150,000 gannets that live above sheer cliffs more than 100m (330ft) high. As you approach by helicopter and the birds take off en masse, it looks as if the whole rock is rising up.

Ancient sites like this are endlessly fascinating, I always try to imagine what they must have looked like in their heyday. Dating back 5,000 years, Old Sarum was an Iron Age hill fort and was the site of Salisbury's first cathedral. From the top of the mound you can see the current cathedral 2 miles away.

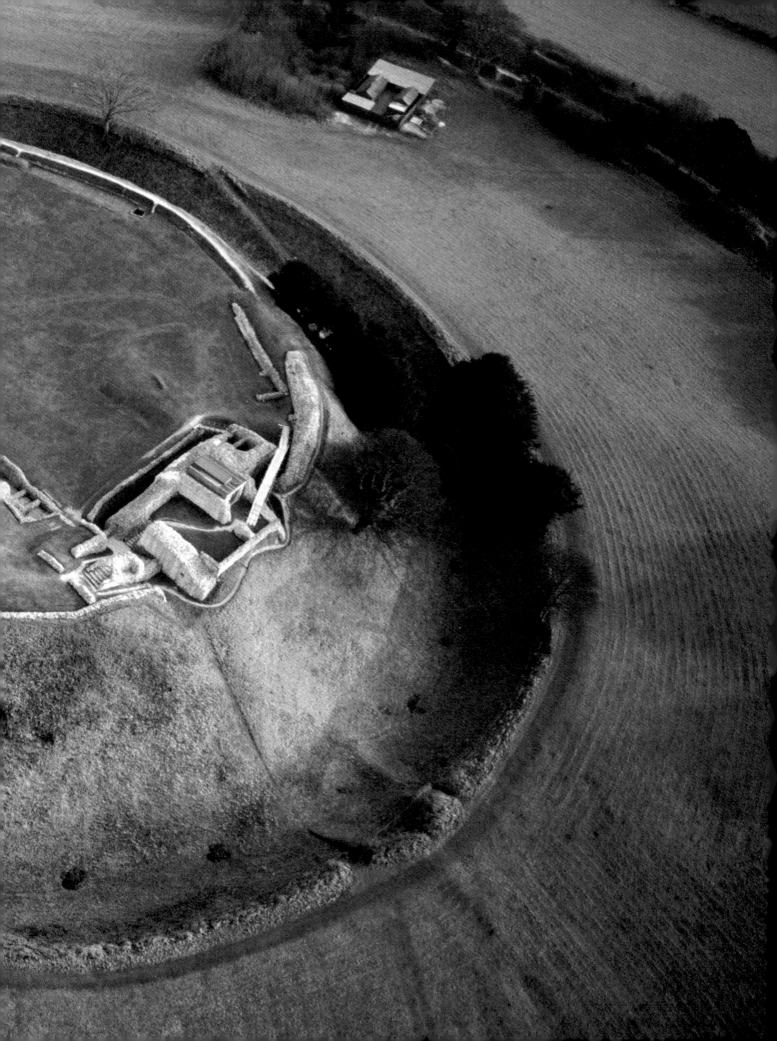

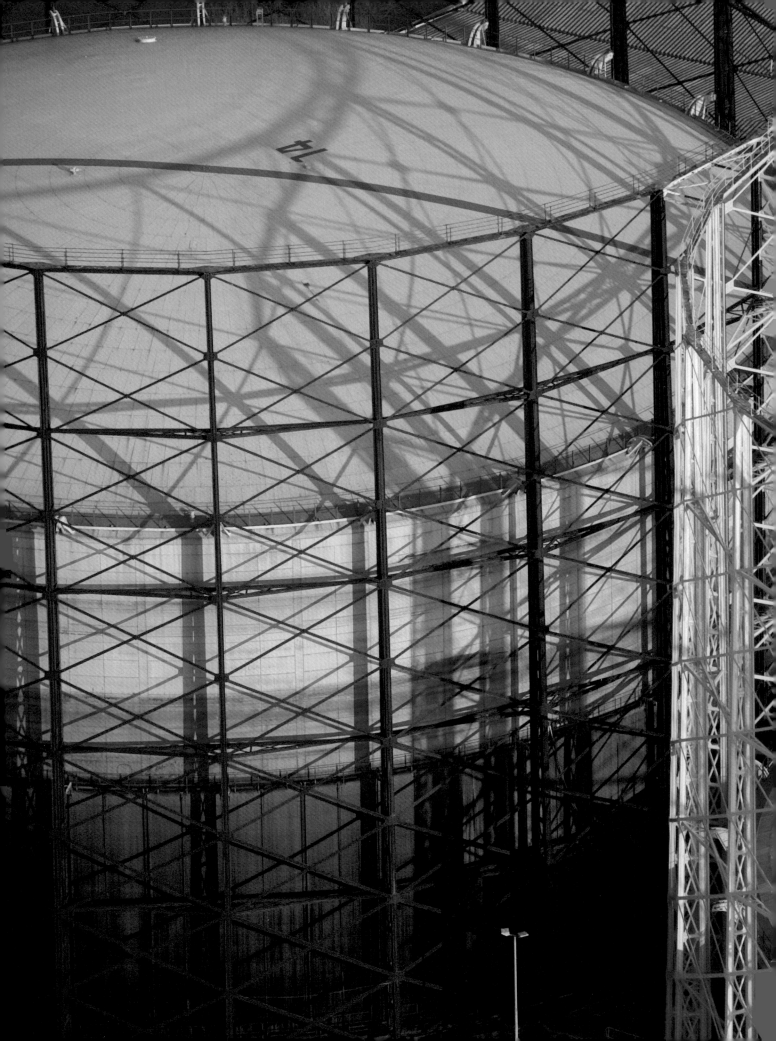

These intricate-looking structures are gas holders that store gas ready for domestic use. This spindly, brightly coloured pair in Birmingham are relatively modern compared with some gas holders around the country that date back to the 19th century and have listed-building status.

Drax Power Station looks like the perfect image for a global warming campaign, but the only pollution comes from the black-tipped chimney in the centre. The others are actually cooling towers, spewing only water vapour into the air. The blanket of low cloud enhances the ominous atmosphere.

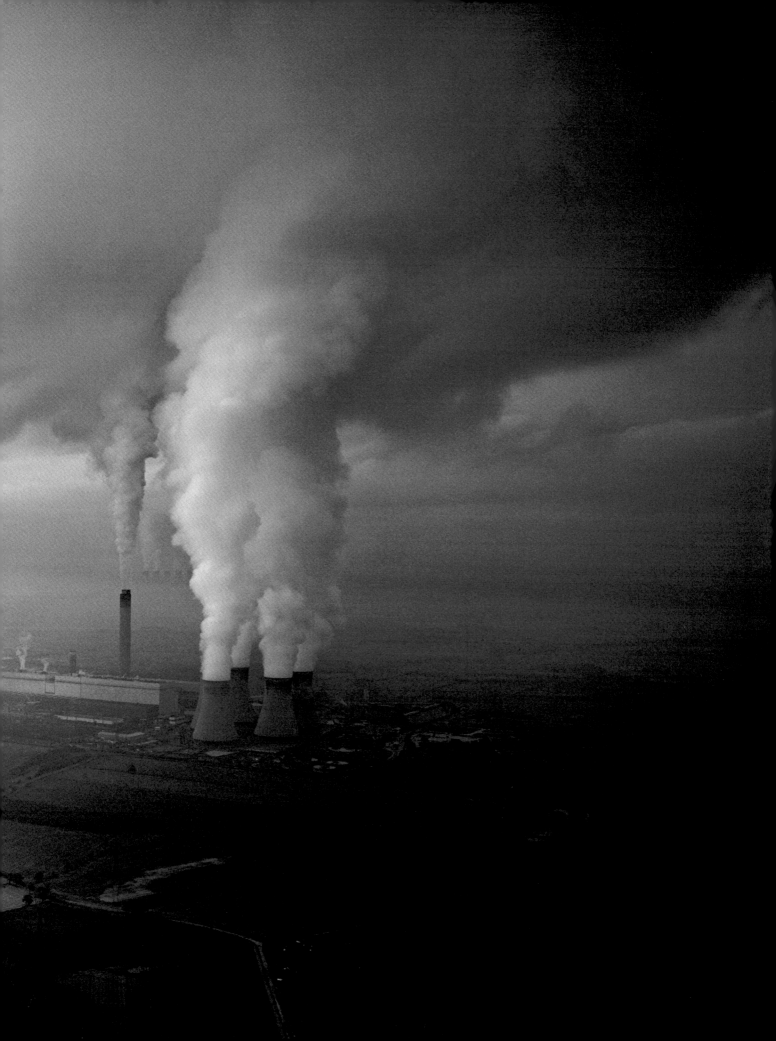

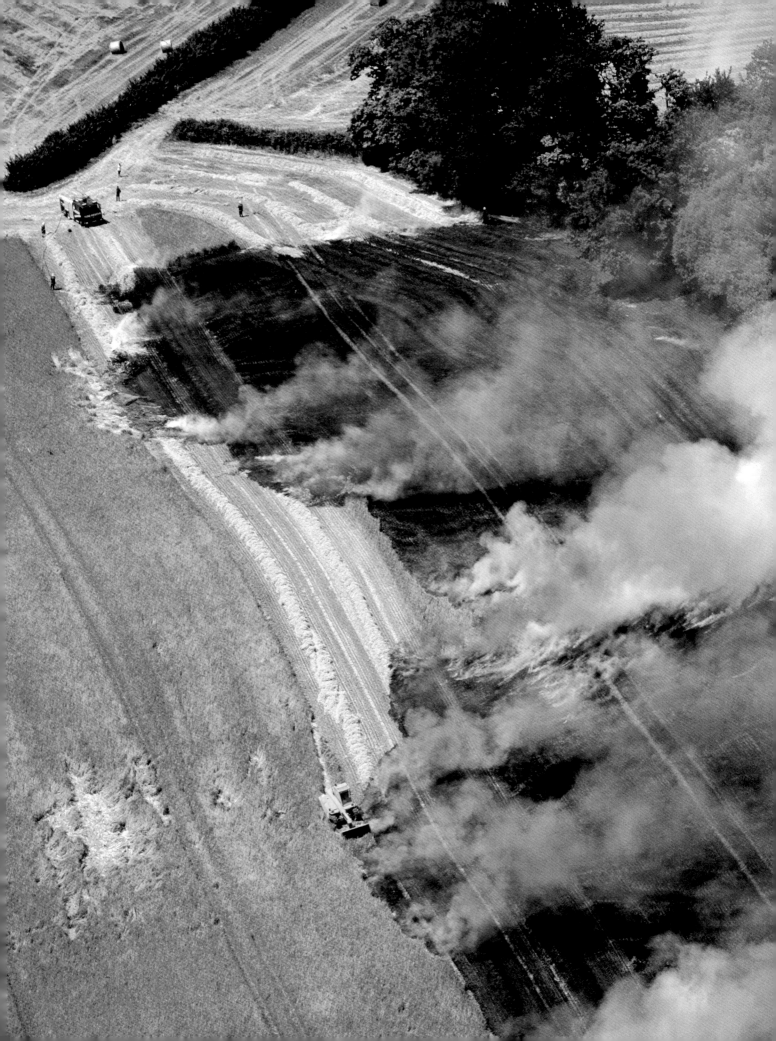

Stubble-burning used to be commonplace, once grain had been harvested, but this scene is puzzling. In the burning field much of the crop is still growing, there's a fire engine in attendance, and what looks like a digger is very near the seat of the flames. There's a story here, but I don't know what it is!

London at night is an almost infinite visual feast. The illuminated bridges look like sparkling necklaces draped across the Thames, while close-up shots of office blocks fascinate me. There's so much going on inside that you almost wish you could swing the front open like a doll's house and reveal all.

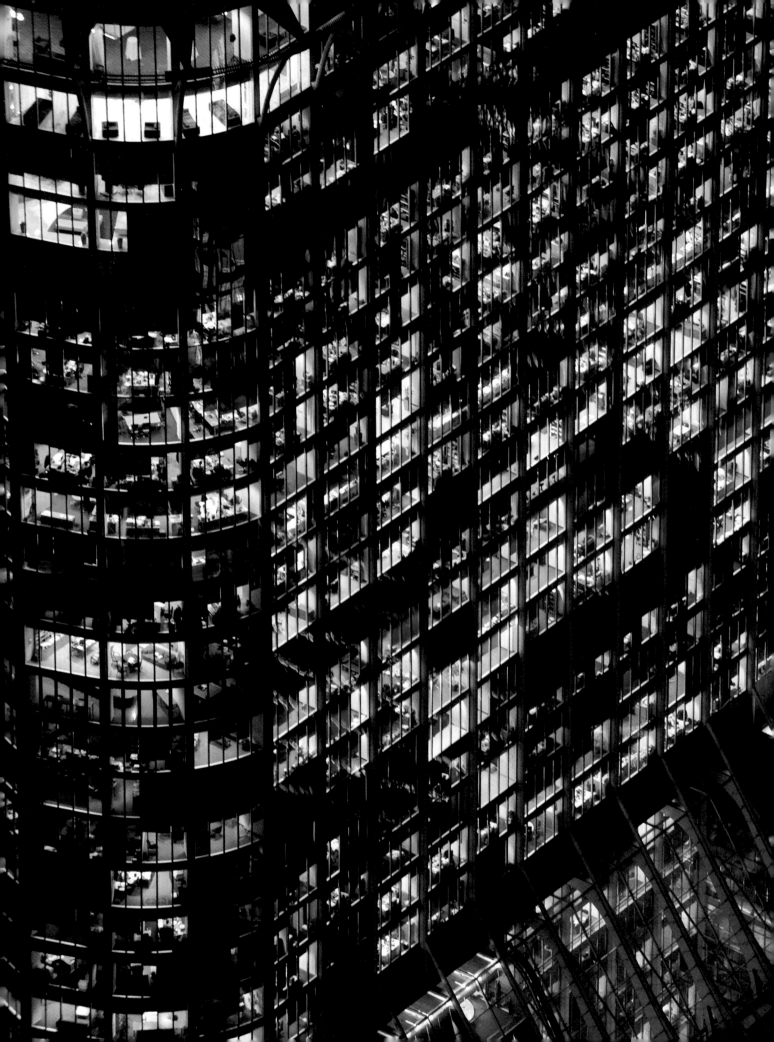

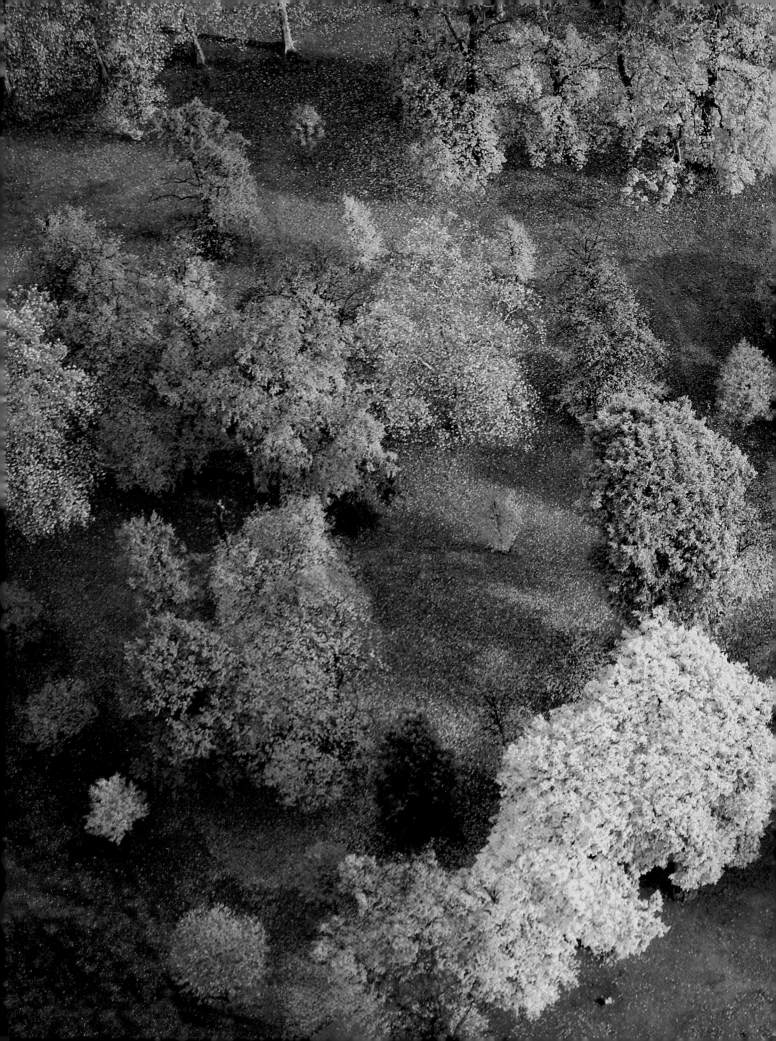

AUTUMN

It feels as though autumn is arriving later every year – this picture was taken in early November and most of the trees are still in leaf. If it wasn't for the path and the lone jogger, you could imagine that this was an underwater landscape of exotic corals, such is the extraordinary range of colours and textures.

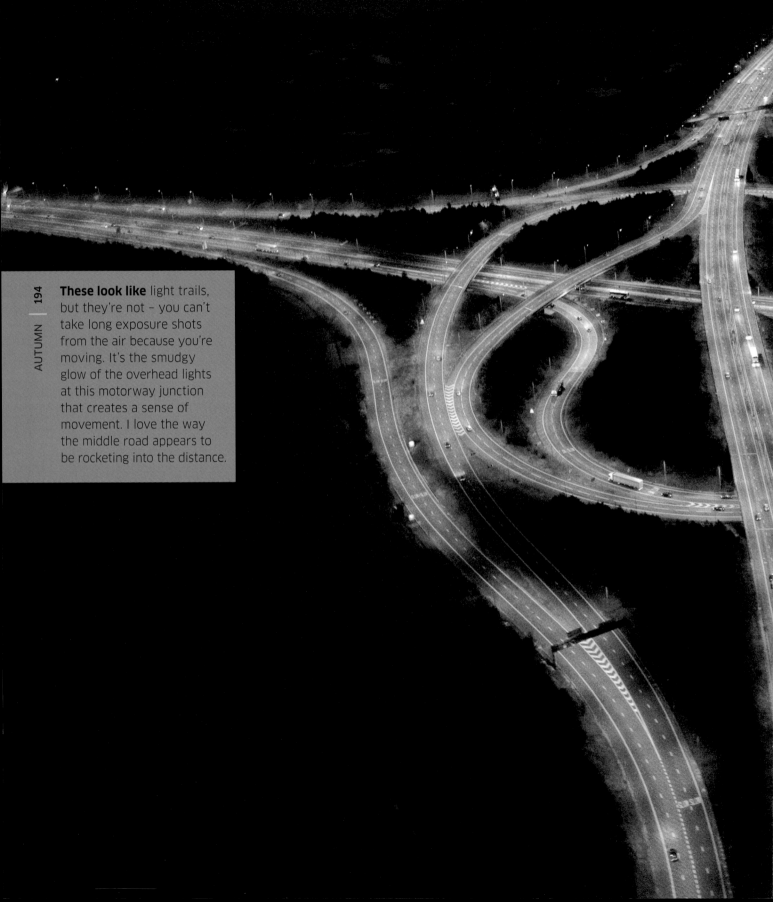

These look like light trails, but they're not – you can't take long exposure shots from the air because you're moving. It's the smudgy glow of the overhead lights at this motorway junction that creates a sense of movement. I love the way the middle road appears to be rocketing into the distance.

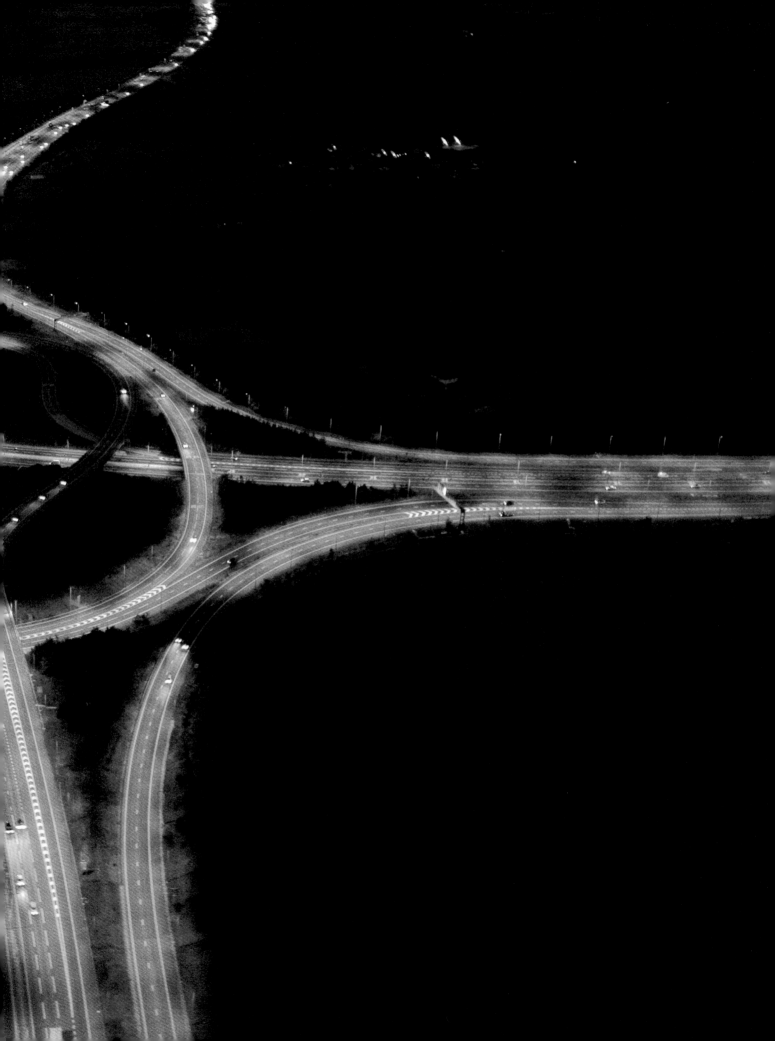

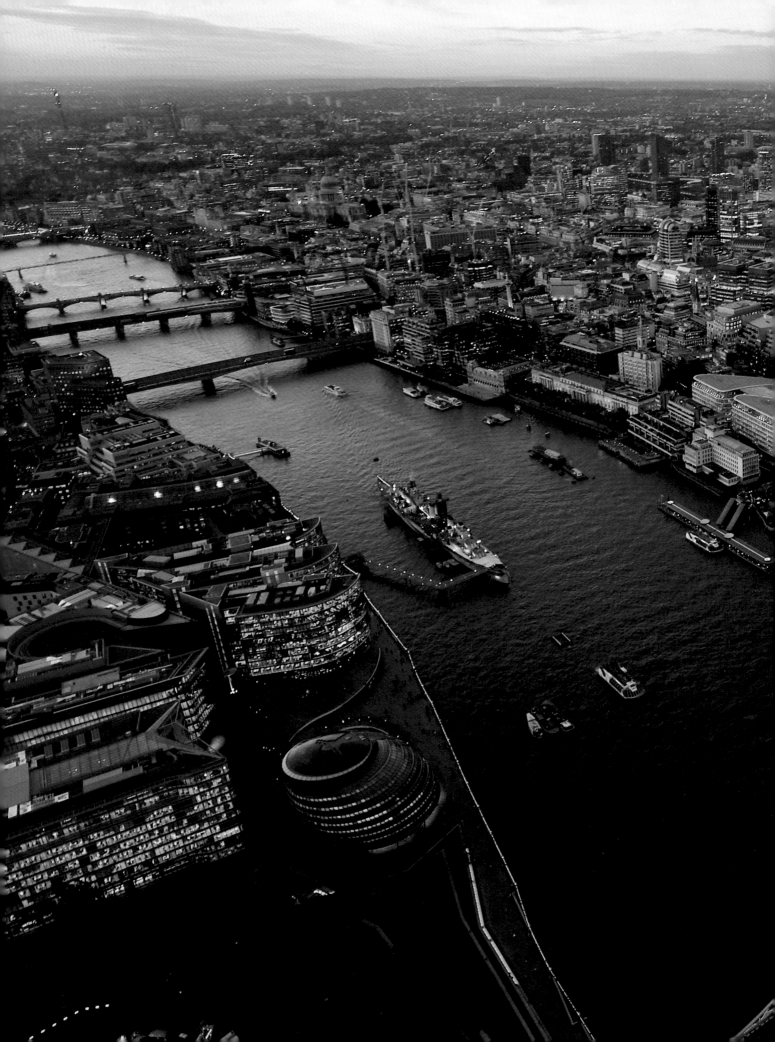

Dusk is one of my favourite times to fly. The change in light creeps up on you and all of a sudden the city is transformed. There's a magic moment just before darkness descends and the twinkling buildings and bridges are bathed in a soft blue light. But you have to be quick to capture it.

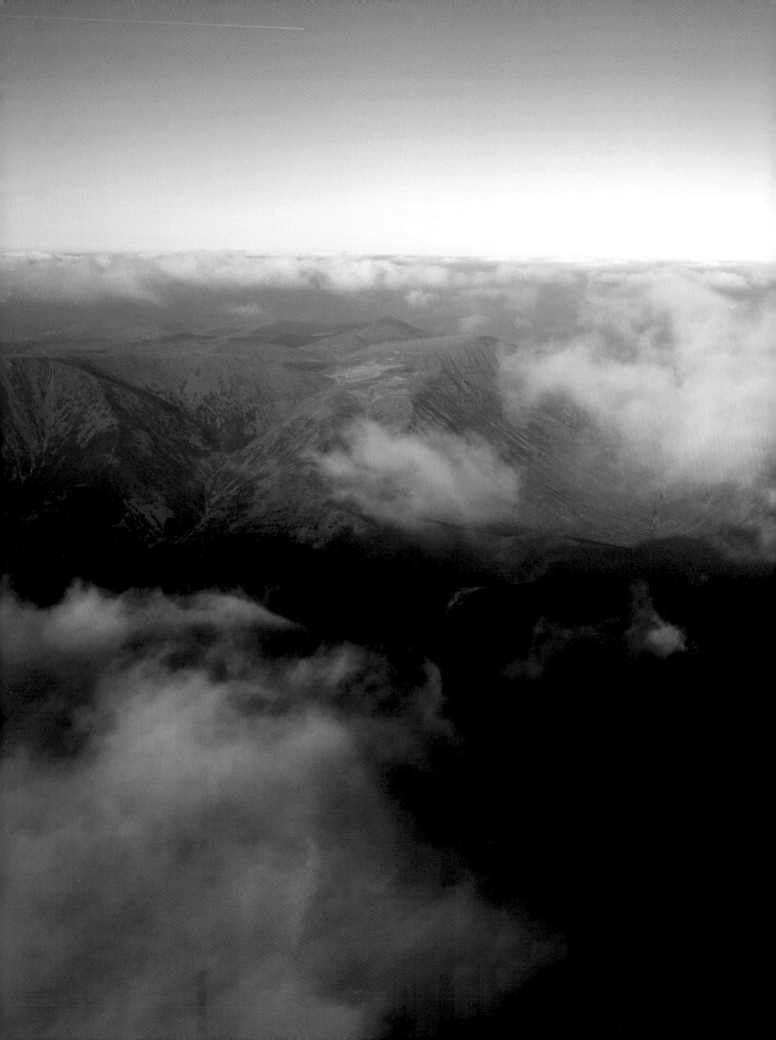

Climbing above the clouds in a helicopter is not something you do very often. As well as being potentially hazardous, there's a chance that they'll close up and you won't see anything at all. However, it's worth it when you get to glimpse a view like this, with the clouds casting their huge shadows on the landscape.

WINTER

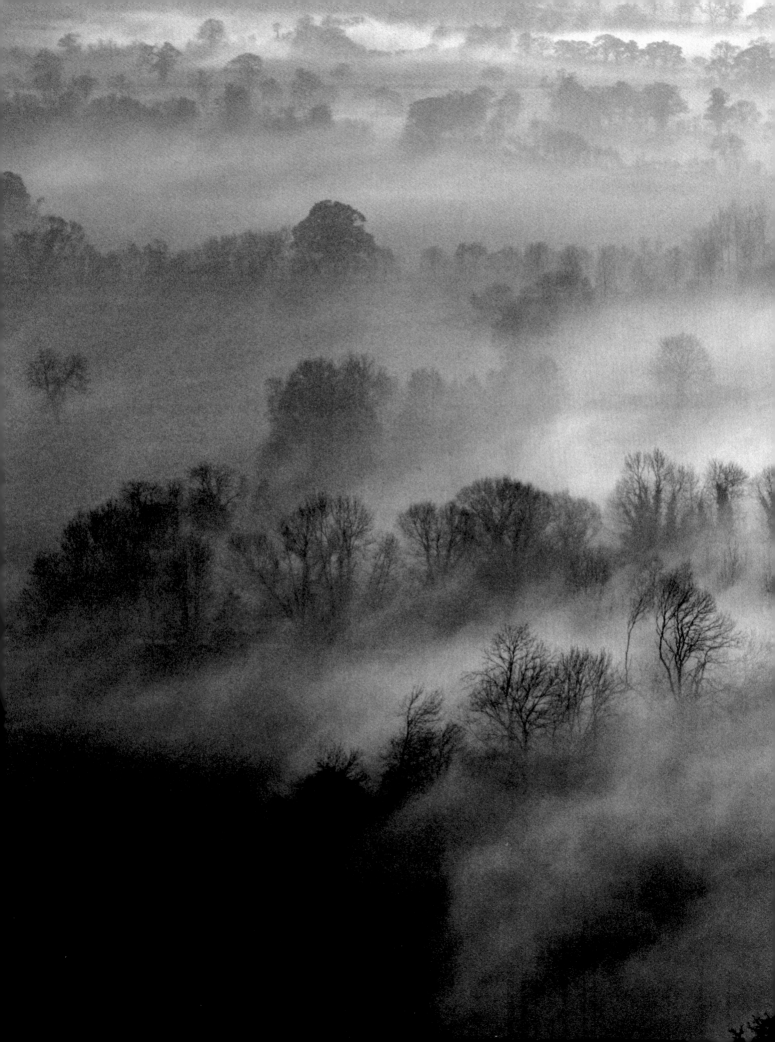

Flying over fog is generally not recommended because you need to be able to see the ground in case you have to land quickly. But nature often throws up surprises, and I'm always glad to find myself in situations like this with my camera so I can capture these atmospheric, ethereal images.

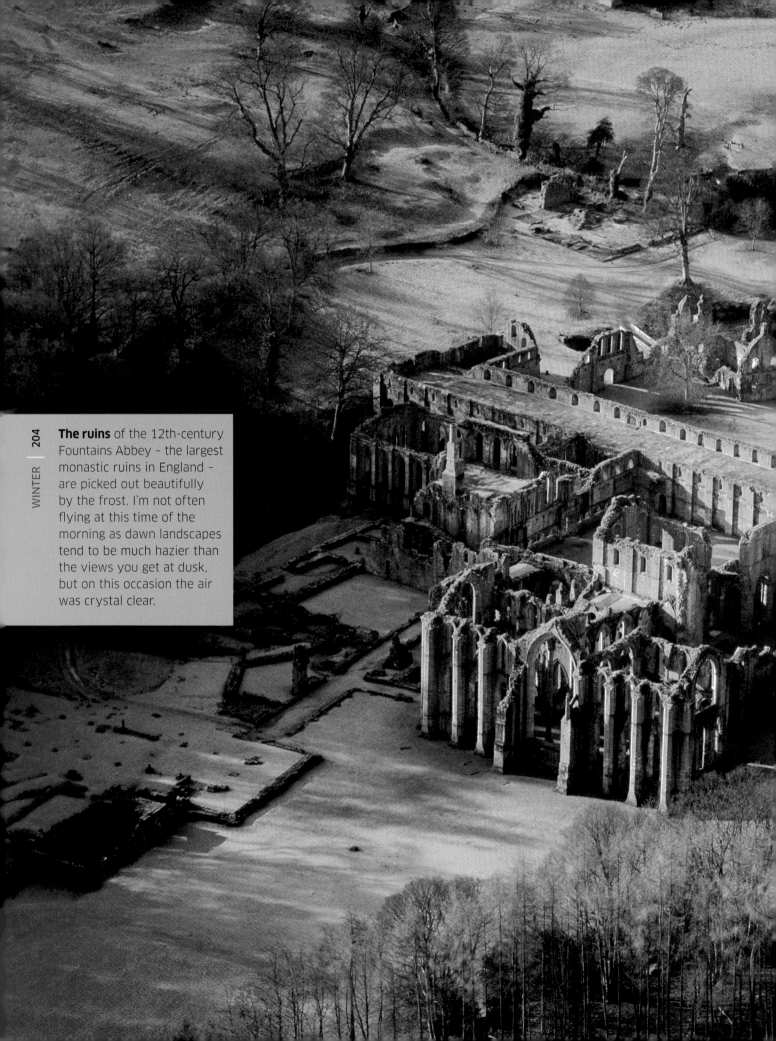

The ruins of the 12th-century Fountains Abbey – the largest monastic ruins in England – are picked out beautifully by the frost. I'm not often flying at this time of the morning as dawn landscapes tend to be much hazier than the views you get at dusk, but on this occasion the air was crystal clear.

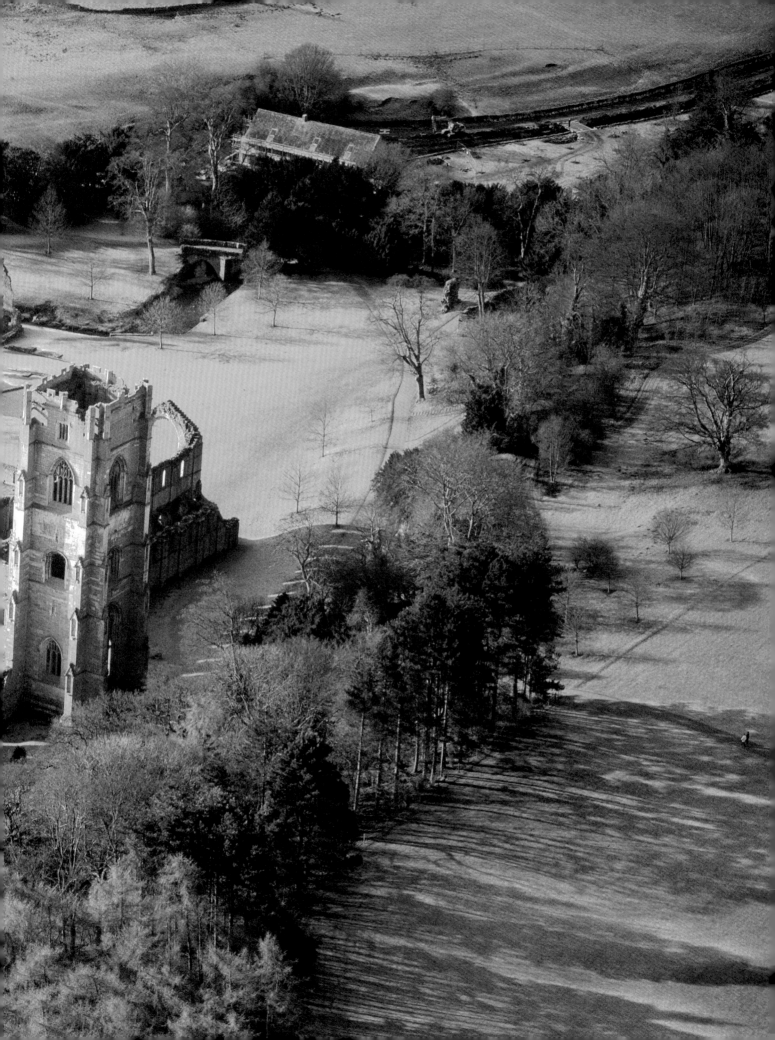

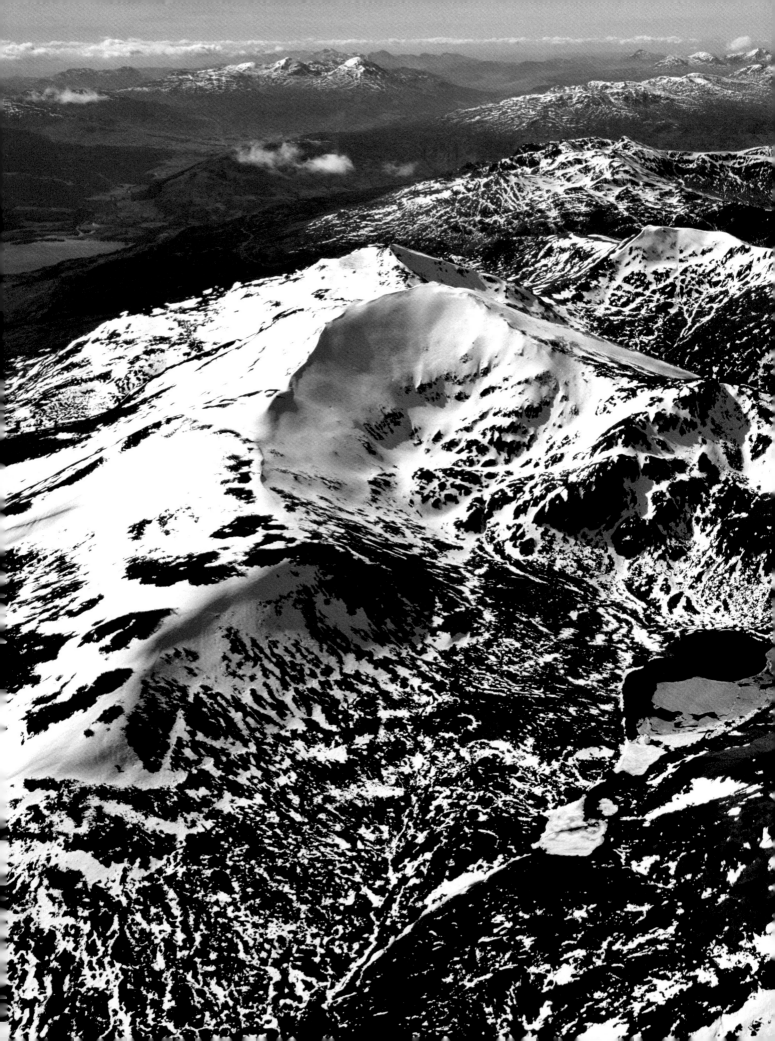

To capture this image of Scotland's Grampians we climbed to about 2,000 feet above ground level. I don't often take pictures from this high up, but this landscape demanded a panoramic framing. The way the white snow gently fades off into a blurry purple horizon in the far distance was irresistible.

The work that took place in and around the Olympic Park in readiness for London 2012 was incredible. The landscape changed so quickly that it was hard to keep up with. Watching the dramatic regeneration of East London has been absolutely fascinating.

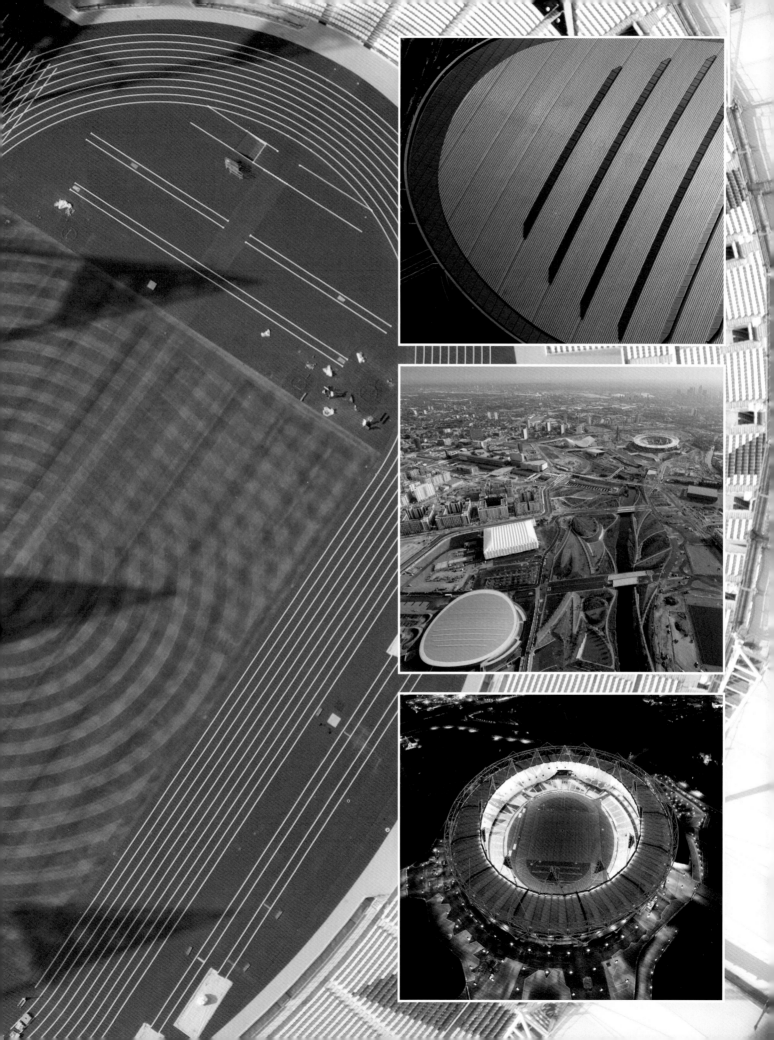

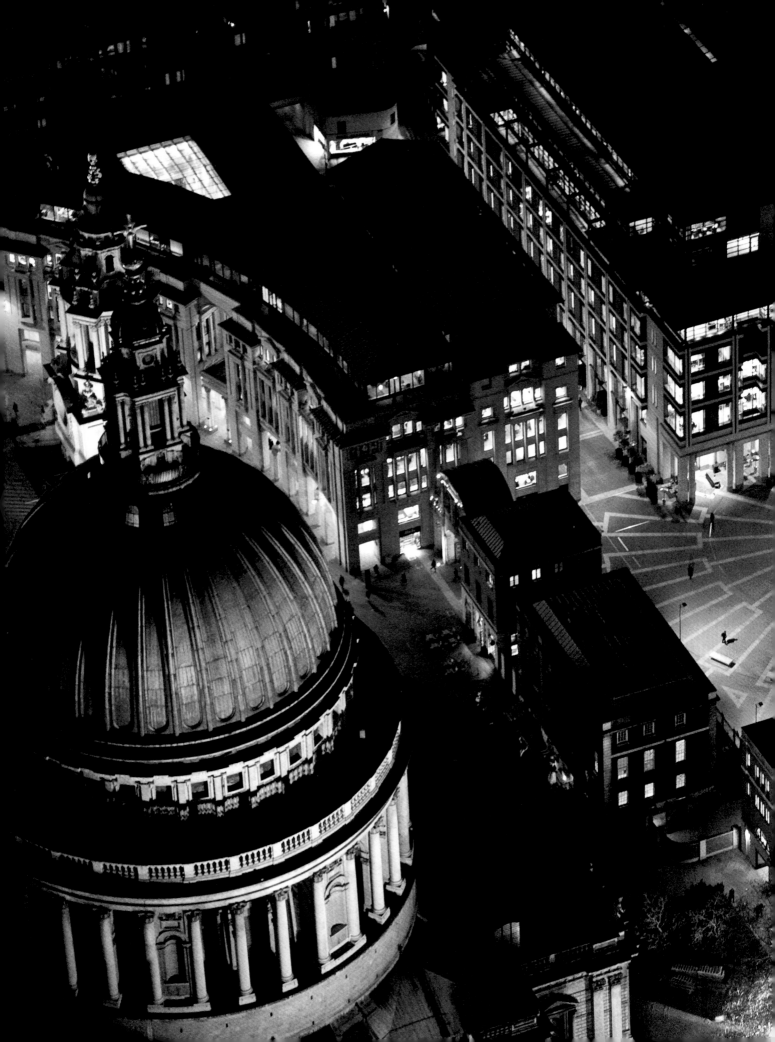

I love the way Paternoster Square radiates light at the centre of this photograph. It even manages to draw your eye away from the imposing dome of St. Paul's Cathedral. The square looks as though it's been there forever with the modern buildings pressing in on all sides, but, in fact, it's a fairly recent development.

Icons or eyesores? Whatever your point of view, there's no denying that these pylons striding through the winter fog do have a certain delicate beauty. The oil rigs (opposite), might dominate the view of Cromarty Firth, in Scotland, but to me these marvels of engineering somehow enhance their surroundings.

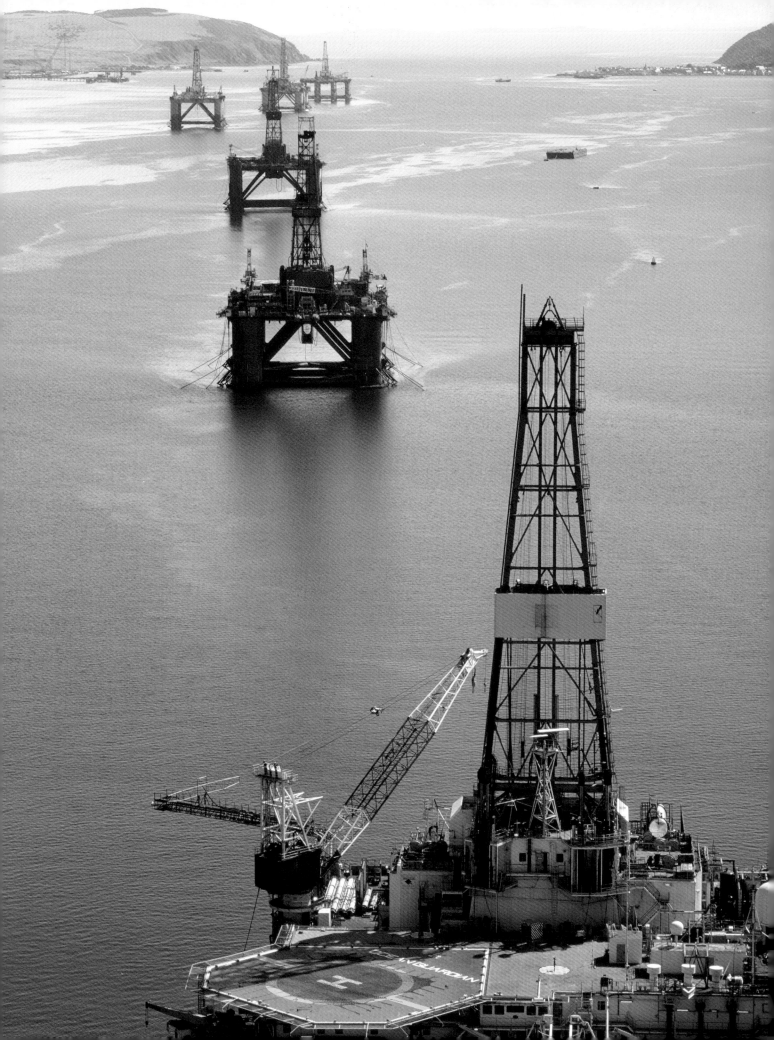

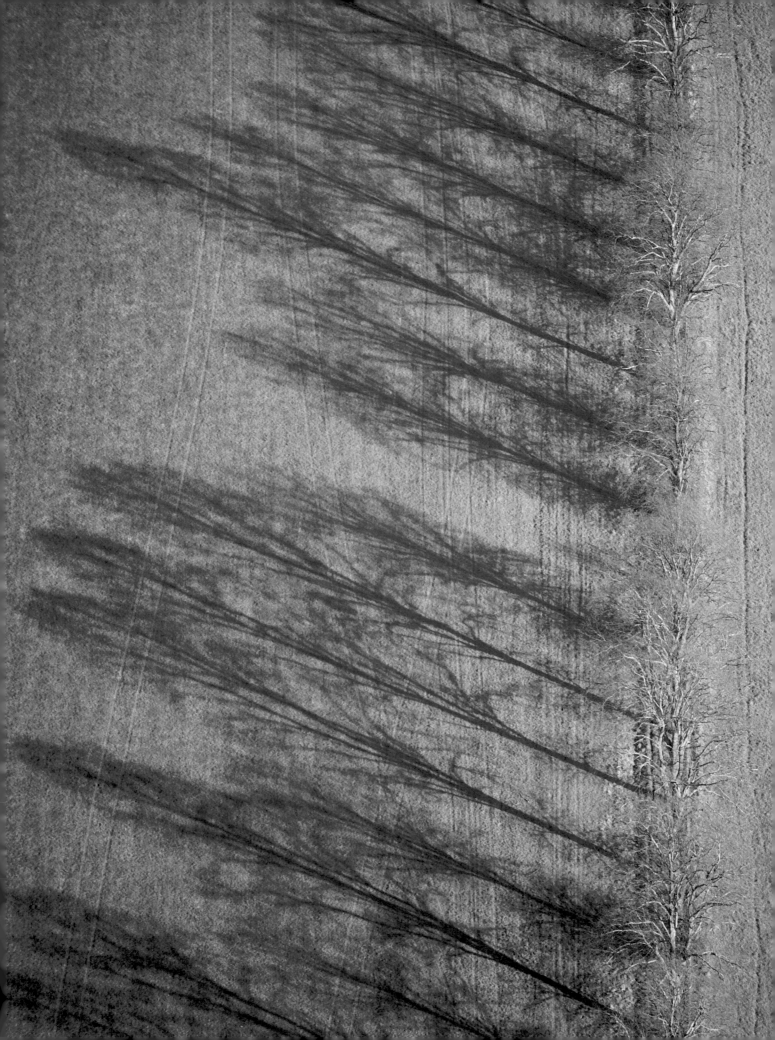

These shadows are quite intriguing. You barely notice the soft line of trees that edge the field (opposite), yet their long shadows dominate the landscape. The furrows (this page) – remnants from the Middle Ages – cast subtle shadows, punctuated by the white dots and grey dashes of grazing sheep.

A pod at the top of the London Eye is one of the few places where you can get a view similar to those I enjoy from my helicopter. On a clear day you can see Windsor Castle, 25 miles away. This fairly recent addition to the city's skyline has quickly become an iconic London landmark.

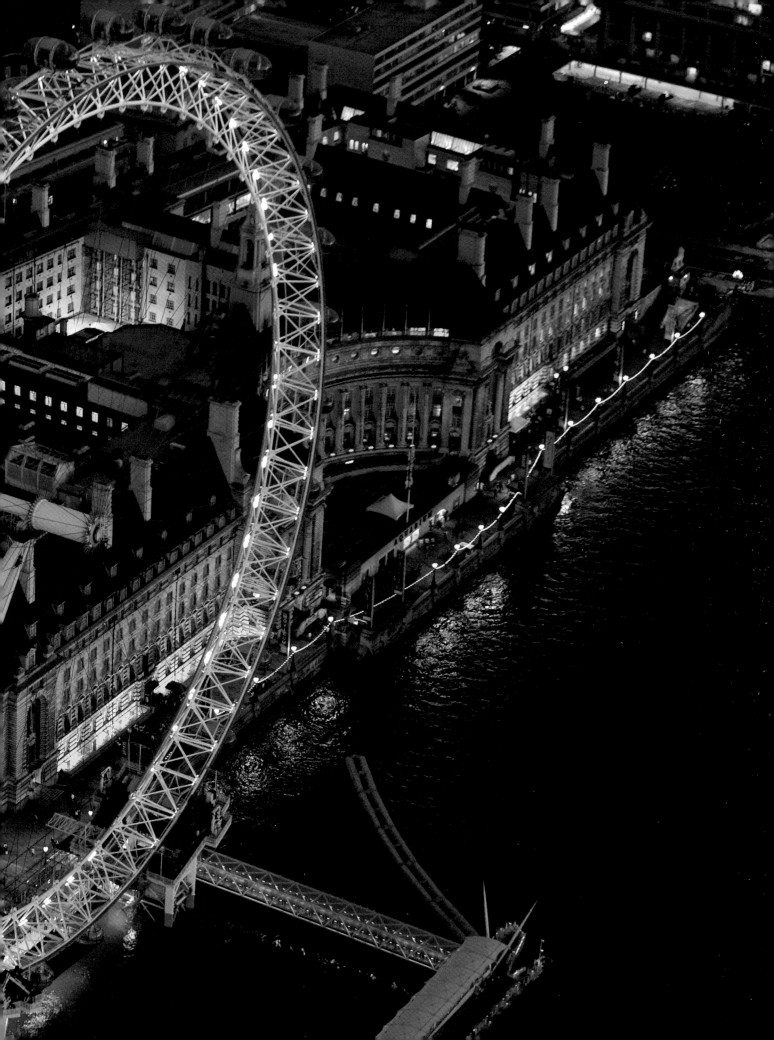

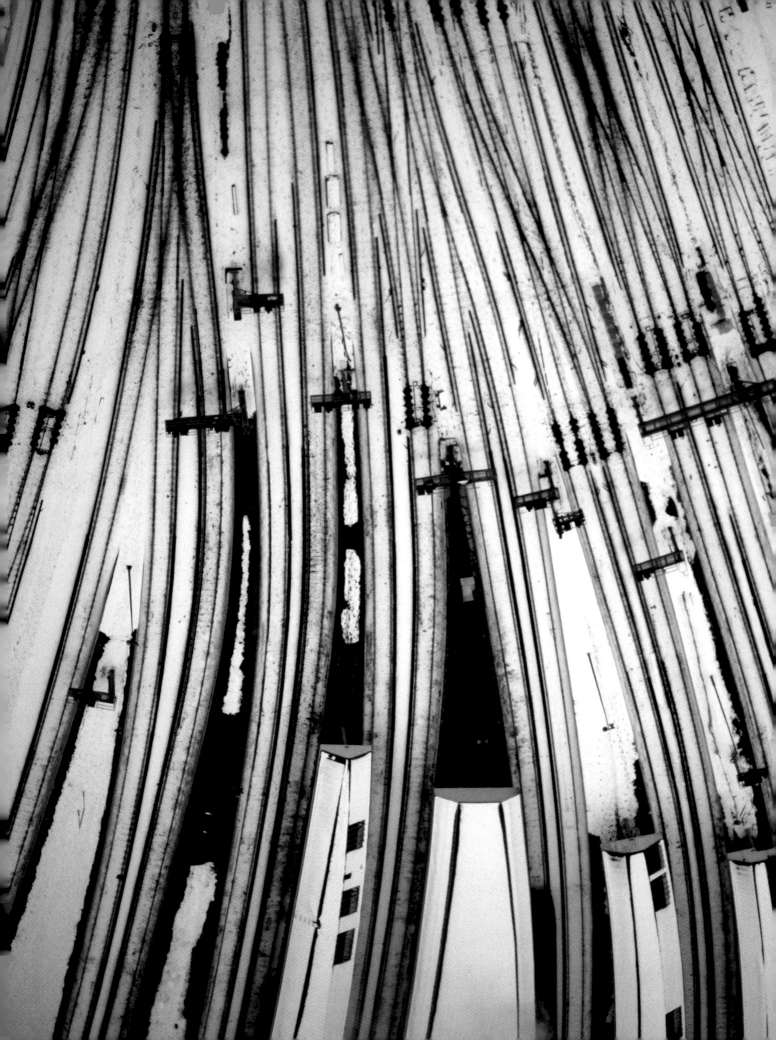

Photographing snow in Britain is an unpredictable business – so when it arrives you have to be ready. But it's worth it to get shots like these, where features in the landscape, whether city rail tracks or ancient monuments, are transformed into simple lines, like brushstrokes or the marks of a calligraphy pen.

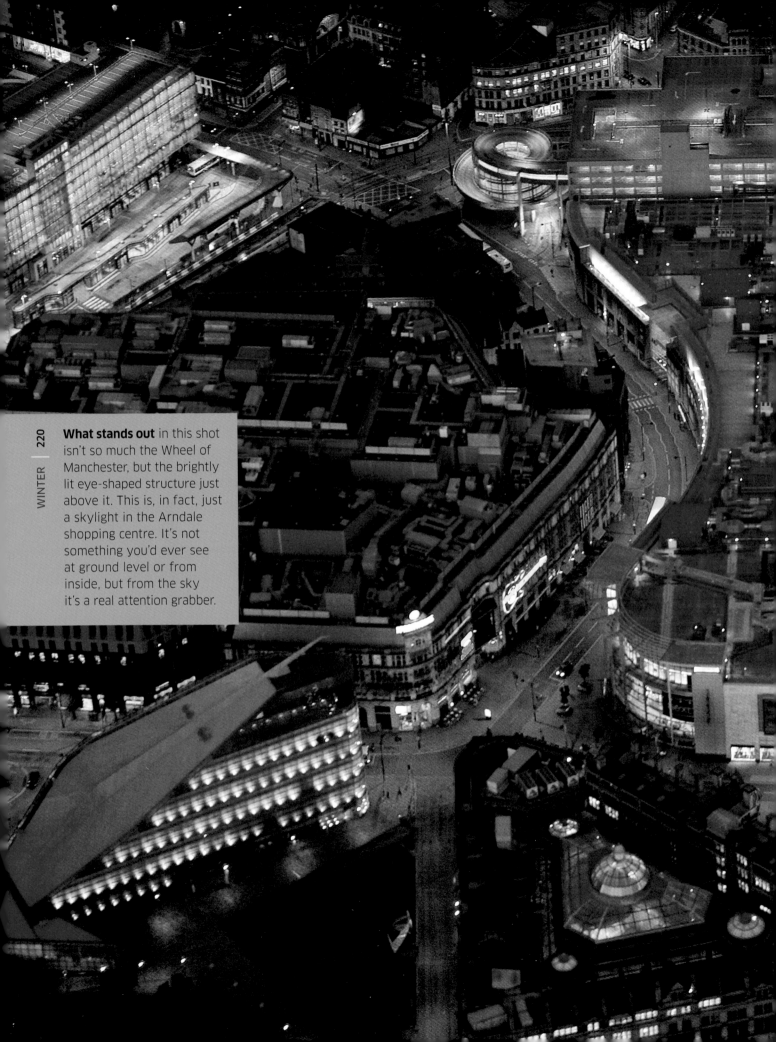

What stands out in this shot isn't so much the Wheel of Manchester, but the brightly lit eye-shaped structure just above it. This is, in fact, just a skylight in the Arndale shopping centre. It's not something you'd ever see at ground level or from inside, but from the sky it's a real attention grabber.

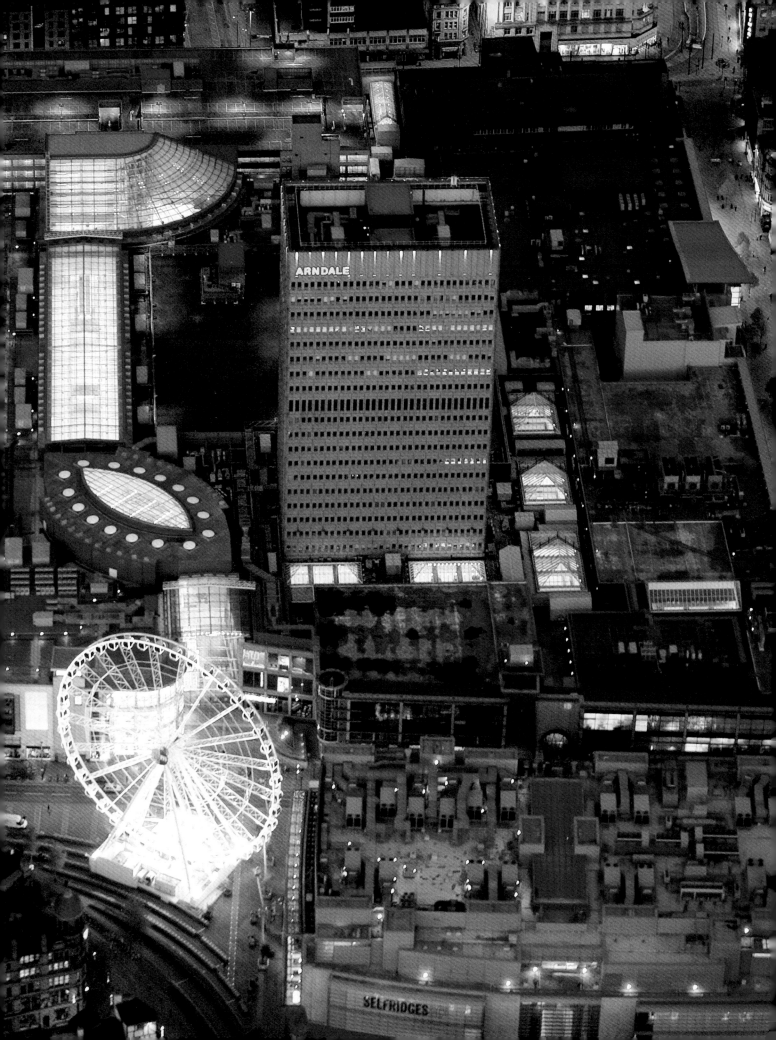

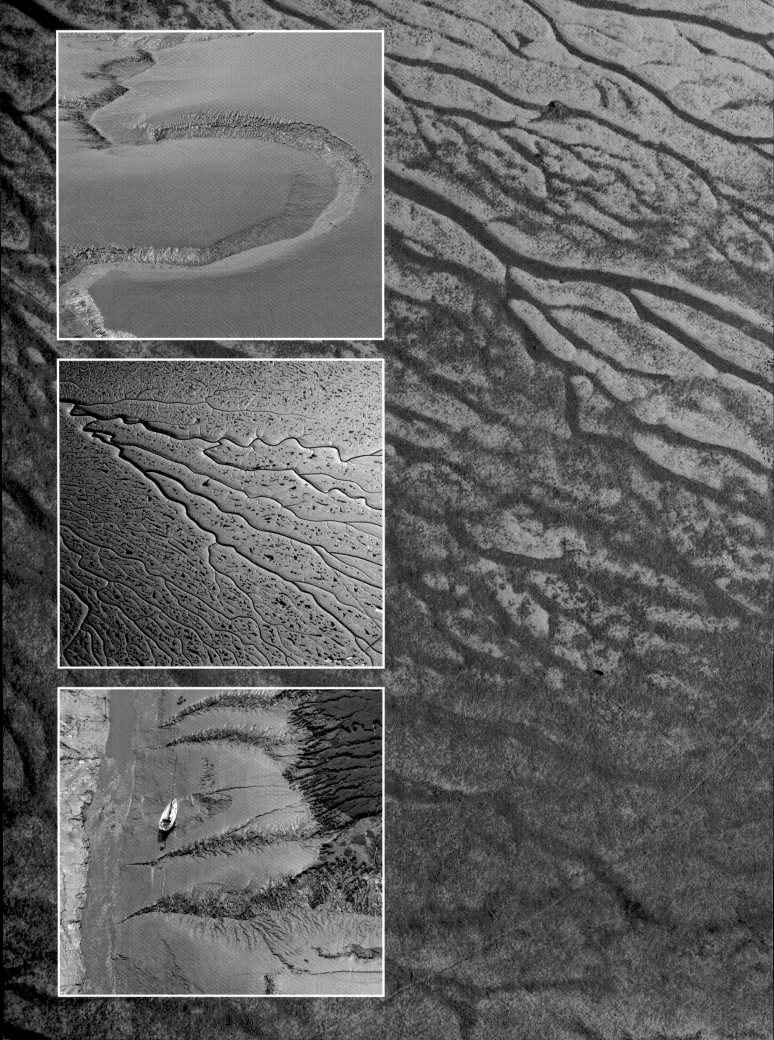

The imprints left by a retreating tide are like moonscapes. If it wasn't for the odd boat you wouldn't know what you were looking at. And without reference points there's no sense of scale. You could be looking at a satellite image or standing on the ground looking at the beach beneath your feet.

West London has a very distinctive look; Belgravia (this page) in particular is full of quite low-level buildings. When it's covered in snow it could be Moscow. You know the festive season's underway when Winter Wonderland, complete with ice rink and ferris wheel, arrives in Hyde Park (opposite).

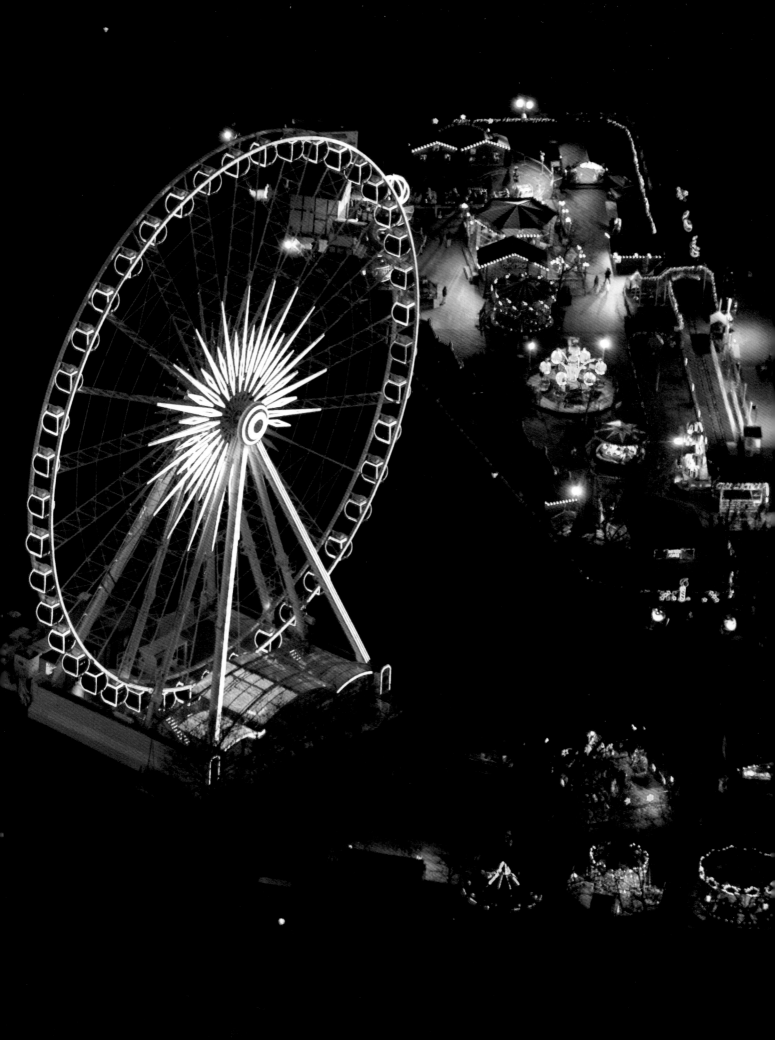

It's hard to appreciate how large London's O_2 Arena actually is – even from the air it looks gigantic. You might just be able to pick out two workers in high-visibility vests in the centre of the roof. Originally known as the Millennium Dome, it's one of the world's most famous contemporary structures.

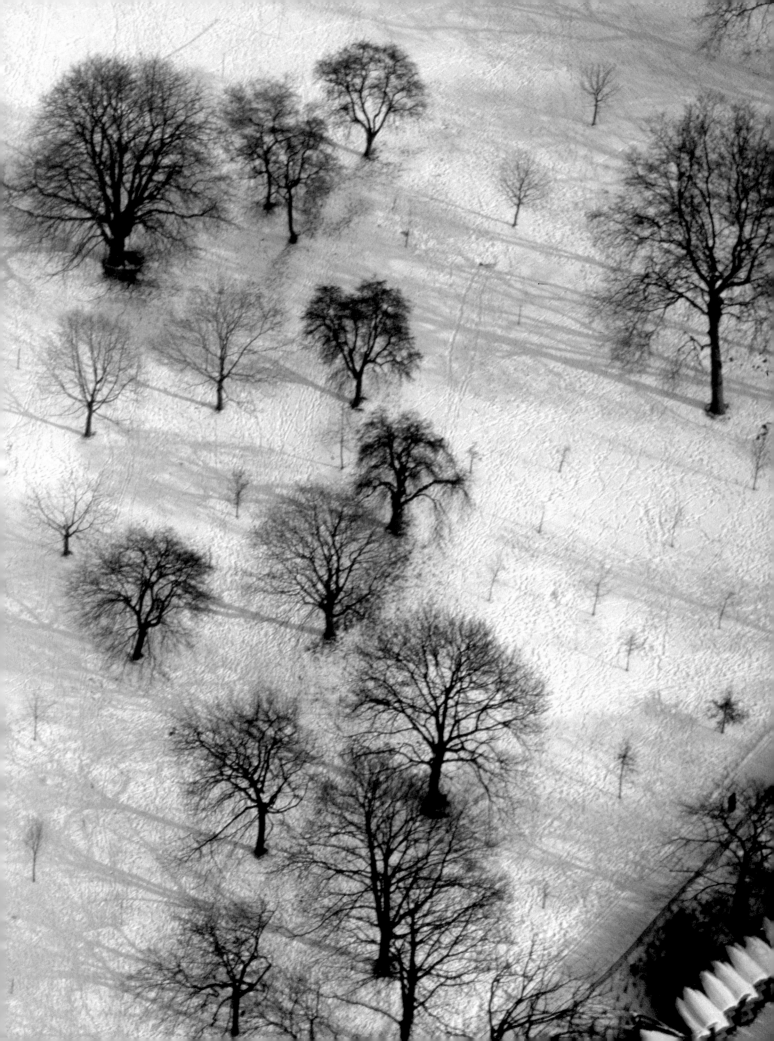

There's something so cleansing and calming about snowfall in the city. In just a few hours the landscape is reduced to a quiet monochrome palette – with nothing to distract or disturb the eye. Open spaces such as Hyde Park (opposite), look particularly inviting when the snow is untouched.

Sports stadiums are fantastic to photograph during a game: the crowds of fans, the luminous glow of the turf, and the players giving it their all. The perfect shot would be looking straight down into Manchester United's famous Old Trafford stadium, but for safety reasons you're not allowed any closer than this.

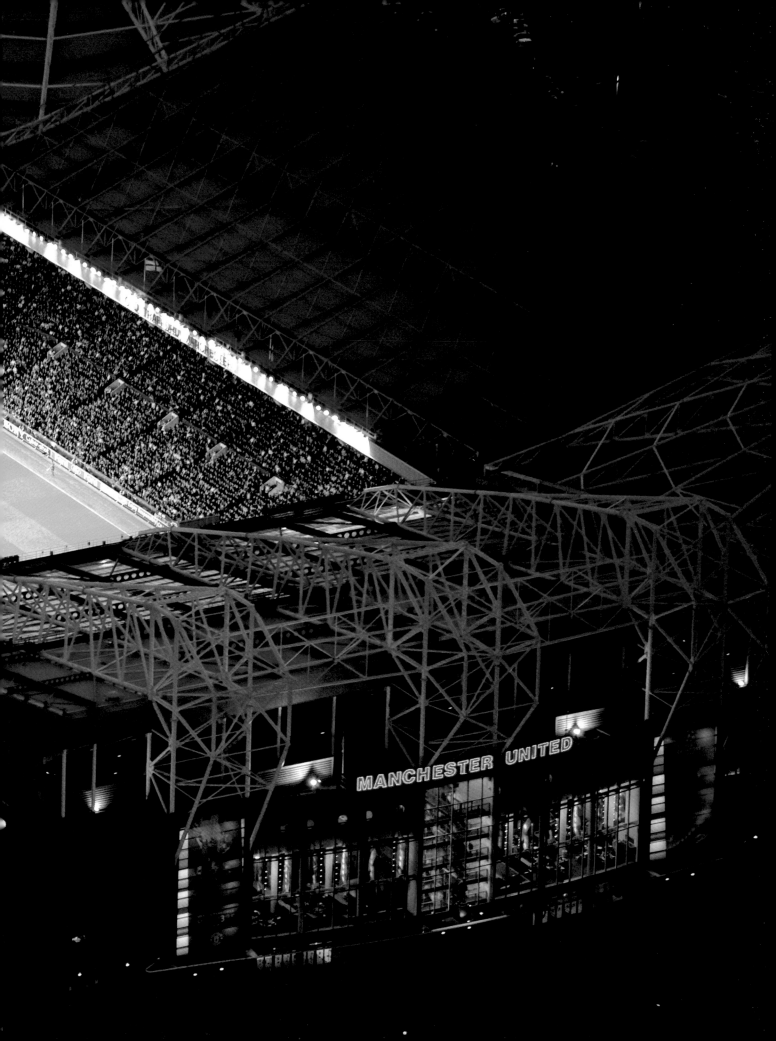

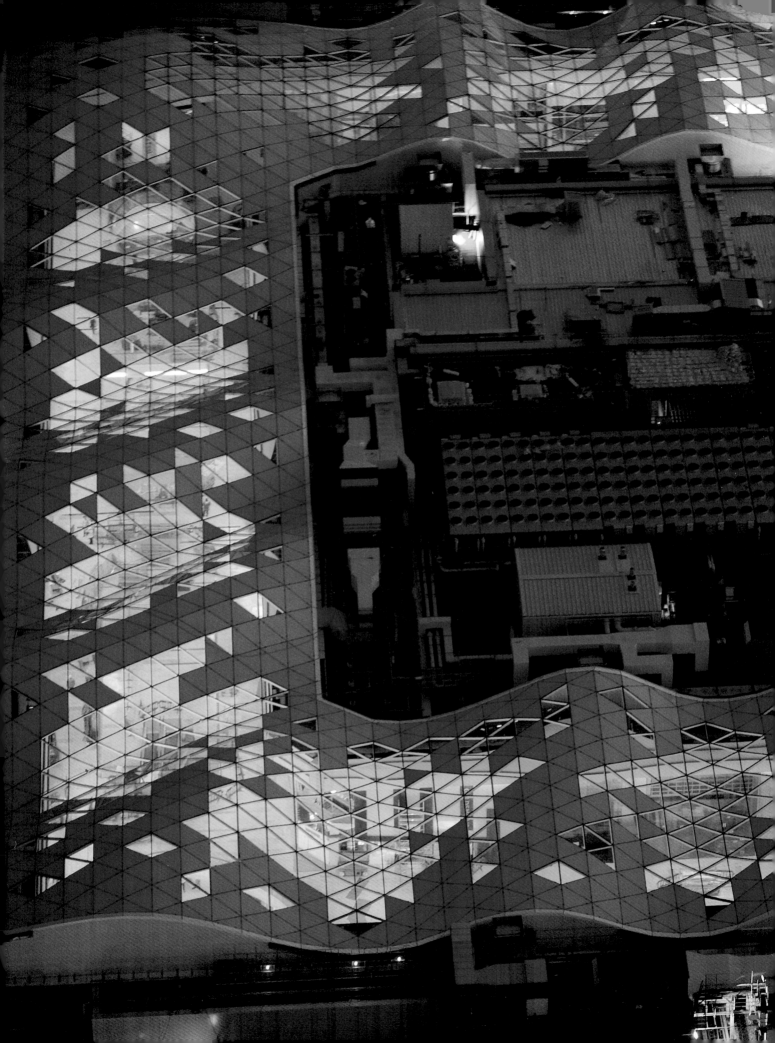

The roof of the Westfield Shopping Centre in West London is beautiful, especially at night when it shimmers like fragments of gold leaf. The developers spent a great deal of money on this amazing structure, which makes it something of a modern-day folly, since it's rarely seen like this.

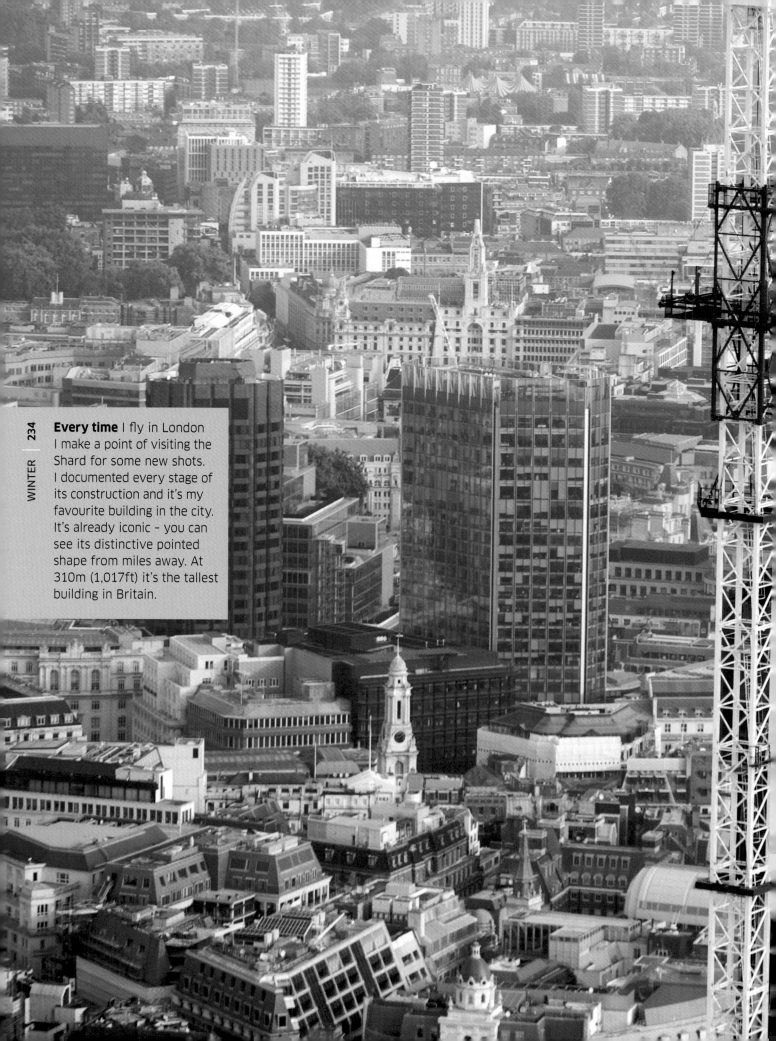

Every time I fly in London I make a point of visiting the Shard for some new shots. I documented every stage of its construction and it's my favourite building in the city. It's already iconic – you can see its distinctive pointed shape from miles away. At 310m (1,017ft) it's the tallest building in Britain.

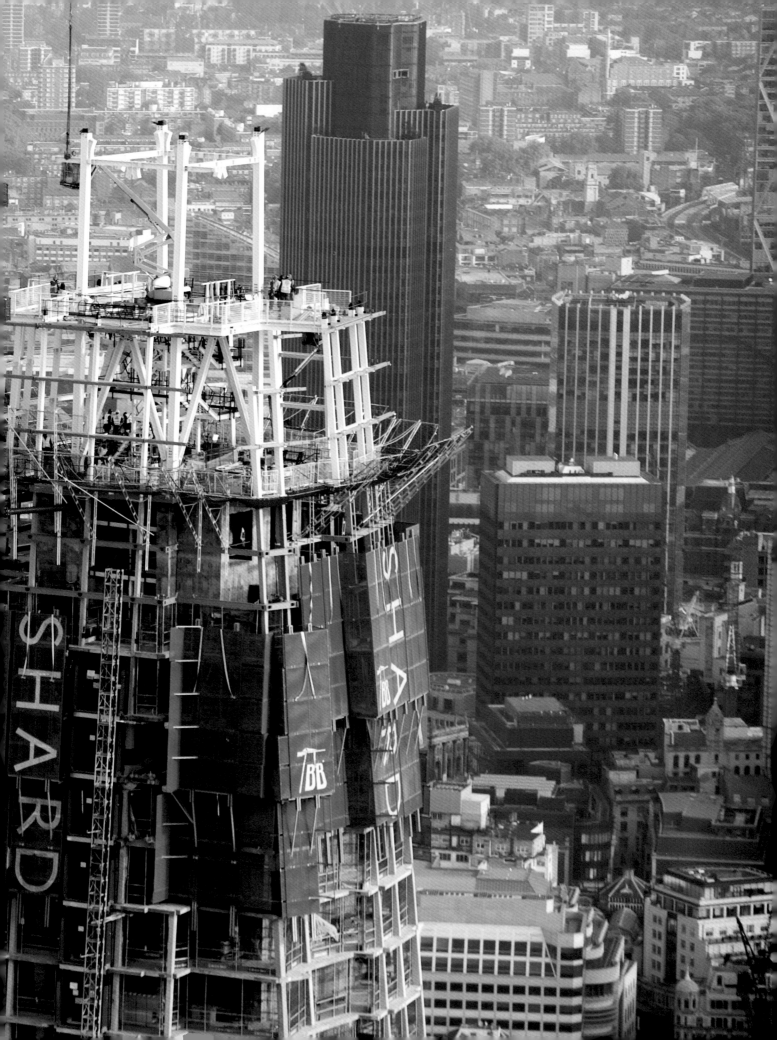

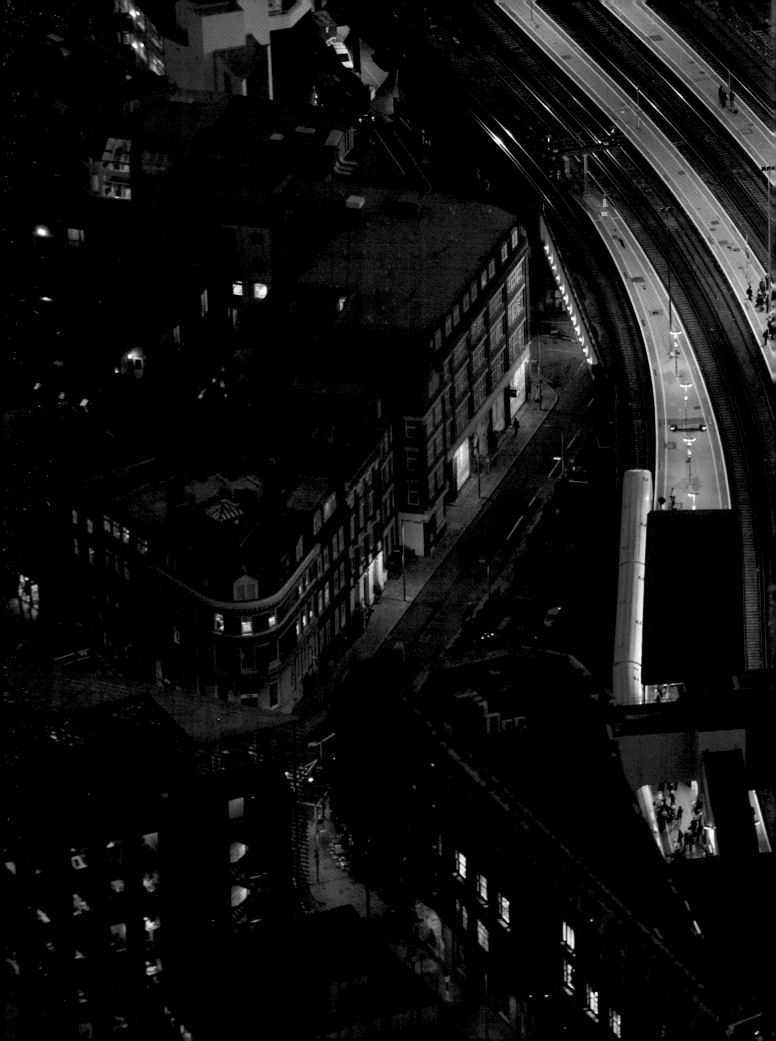

From this perspective, railway stations at night are transformed into things of beauty. With their sweeping tracks and platforms glowing with amber light, they seem a world away from the harried commuter's daily experience. Seen like this they reflect the wonder of the golden age of rail travel.

Leeds Castle in Kent is the quintessential English castle. Sitting proudly in the middle of a lake and surrounded by 500 acres of parkland, many consider it the most beautiful castle in the country. From this viewpoint the complex puts me in mind of some huge creature, nosing its way through the icy water.

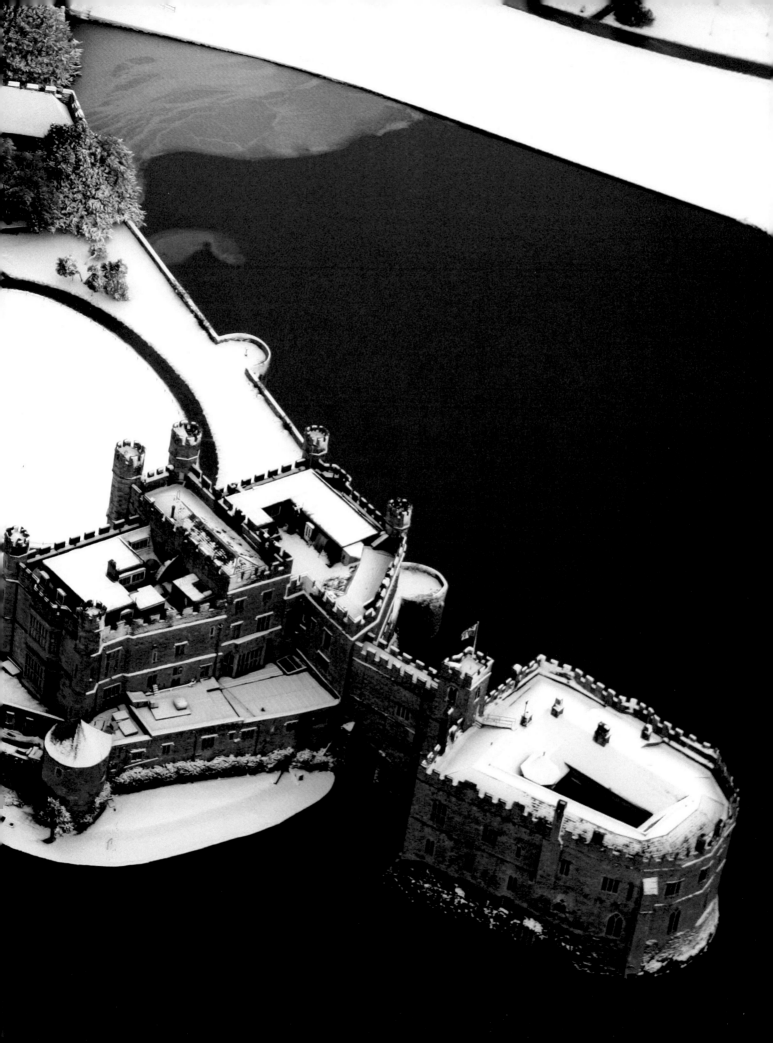

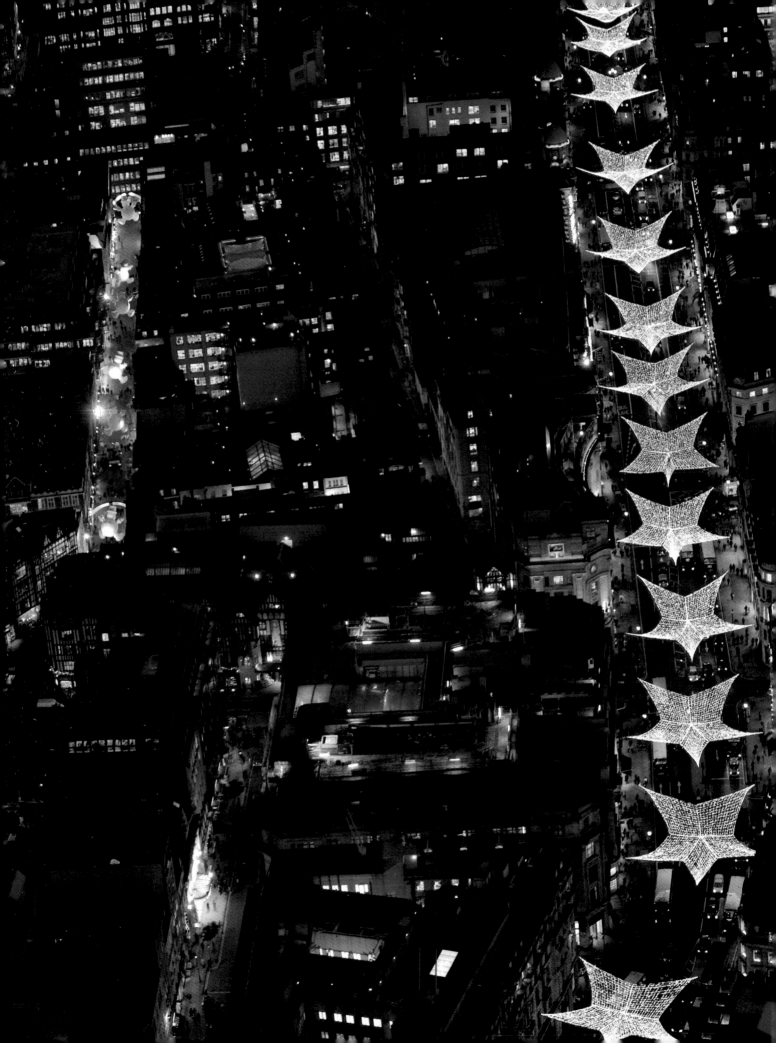

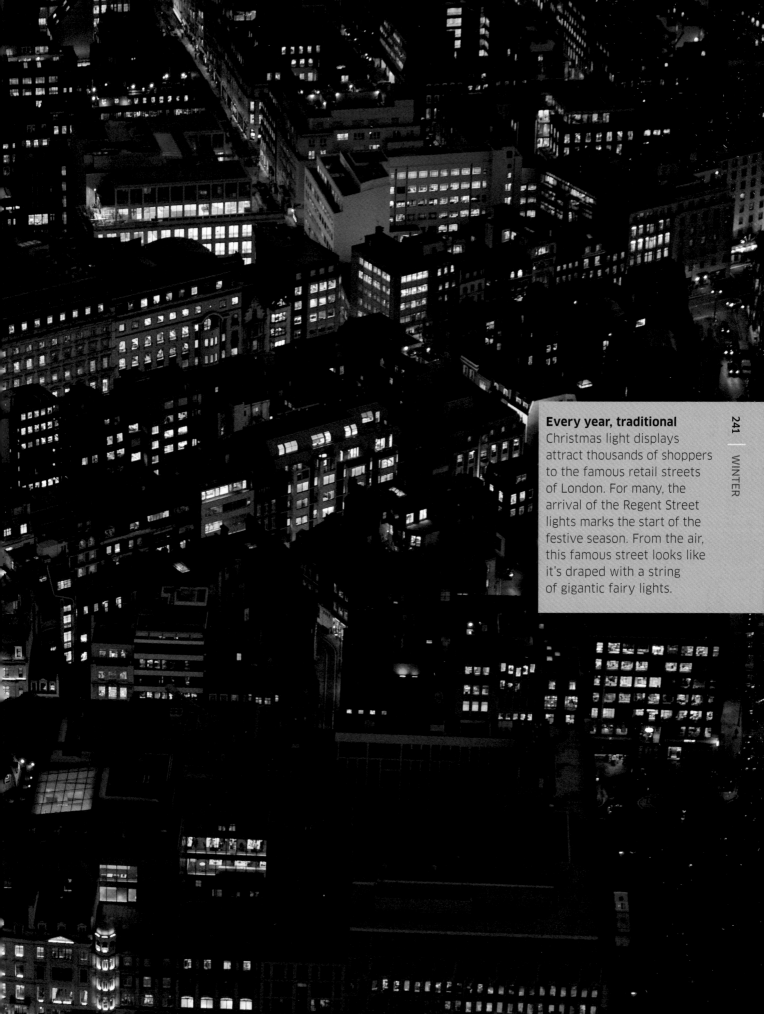

Every year, traditional Christmas light displays attract thousands of shoppers to the famous retail streets of London. For many, the arrival of the Regent Street lights marks the start of the festive season. From the air, this famous street looks like it's draped with a string of gigantic fairy lights.

Index of images

WINTER

(Key: m-main; t-top; c-centre; b-bottom)

Acknowledgments

FROM THE AUTHOR
To my lovely wife and children, thanks as always for all your support, I love you all. Thanks to everyone at DK for all their amazing hard work pulling the book together, particularly, Jill, Nicky, Phil, Lee, Stephanie and Jonathan.

Lastly, to the pilots, without whom I couldn't do what I do.

FROM THE PUBLISHER
Dorling Kindersley would like to thank the following people for their help in the preparation of this book: Neil Mason and David Summers for editorial assistance; and Myriam Megharbi for additional picture research.

PICTURE CREDITS

The publisher would like to thank the following for their kind permission to reproduce their photographs:

(Key: a-above; b-below/bottom; c-centre; l-left; r-right; t-top)

014-015 Skyscan; **026** Roger Keech **027** Roger Keech; **029** © Corbis: Skyscan (b); **134-135** Getty Images: Matt Cardy; **136-137** Getty Images: Last Refuge/Robert Harding World Imagery; **148-149** Alamy Images: E Clack/Skyscan Photolibrary; **160** Getty Images: Jeff J. Mitchell; **161** Getty Images: Jeff J. Mitchell; **219** Alamy Images: Robert Harding Library Ltd; **238-239** Getty Images: Nick Obank/Barcroft Media.

All other images © Jason Hawkes

www.jasonhawkes.com